SHEDDING

THE

SHACKLES

HERBERT PRESS
Bloomsbury Publishing Plc
50 Bedford Square, London, WC1B 3DP, UK
29 Earlsfort Terrace, Dublin 2, Ireland

BLOOMSBURY, HERBERT PRESS and the Herbert Press logo are trademarks of
Bloomsbury Publishing Plc

First published in Great Britain in 2021

A catalogue record for this book is available from the British Library

UK ISBN: 978-1-789940-15-2

2 4 6 8 10 9 7 5 3 1

Designed and typeset by Plum5 Limited
Printed and bound in China by Toppan Leefung Printing

To find out more about our authors and books visit www.bloomsbury.com
and sign up for our newsletters

SHEDDING THE SHACKLES

Women's Empowerment Through Craft

Lynne Stein

H E R B E R T P R E S S
LONDON · OXFORD · NEW YORK · NEW DELHI · SYDNEY

Dedicated to my husband,
Robbie Wolfson.

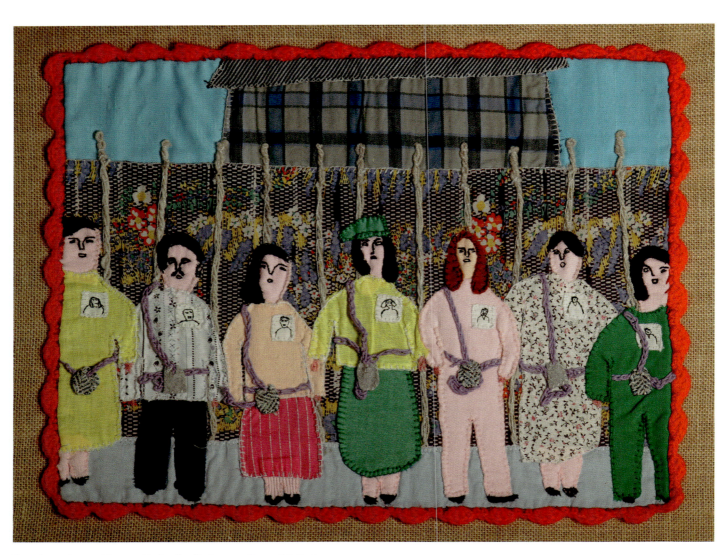

Encadenamiento – Women Chained to Parliament Gates. 1980's Anonymous.
Courtesy of Conflict Textiles Collection, CAIN, University of Ulster, Northern Ireland.

Michelle Obama:

"The difference between a broken community and a thriving one is the presence of women who are valued."

State Department Women of Courage Awards 2009.

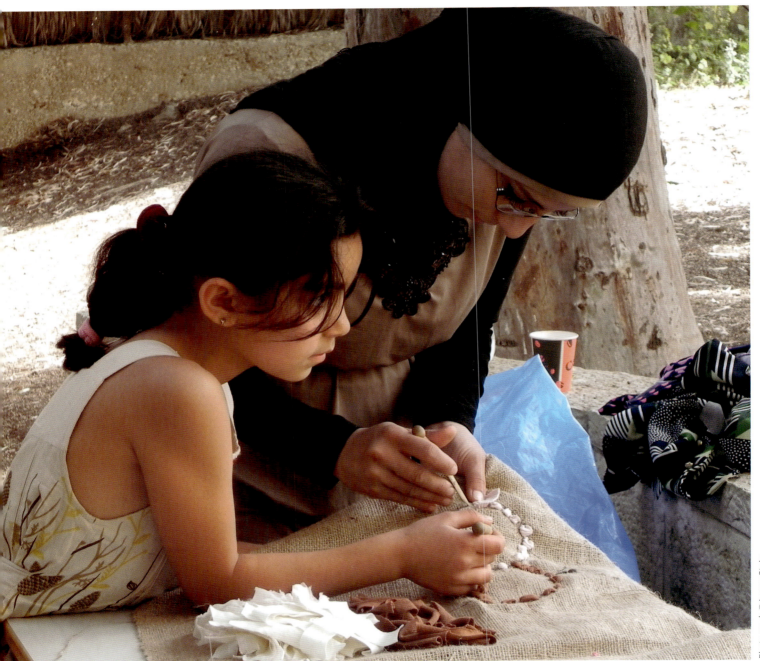

CONTENTS

INTRODUCTION

DUCTION

I am often conscious of the fact that my main motivation for choosing holiday or travel destinations is not especially influenced by the promise of constant sunshine, or by incomparable cuisine, but more often deeply connected to being able to witness local craft practices and cultural traditions. Although frequently regretting not having an additional suitcase to accommodate my magpie habits, I have long delighted in collecting what I consider to be the most aesthetically interesting objects and artefacts, including Yoruba tribal beadwork, Rajasthani textiles, flamboyant Portuguese pottery, Middle-Eastern metalwork, and hand-painted Dutch Folk Art.

Much of the work requires outstanding patience and attention to detail, and a respect for traditions and methods which have been preserved for generations, often within strong feminocentric cultures. With locally available materials, and patterns and motifs commonly informed and influenced by fascinating histories, the makers' hands fashion and tell their stories in their chosen medium. Their distinctiveness and hand-made charm, usually accompanied by an intuitive sense of colour and form, frequently make the pieces irresistible!

Virtually on our way to Mexico, the advent of the Coronavirus stopped us in our tracks. I had, of course, intended to visit particular collectives and co-operatives, and enjoy occasionally translated in-depth conversations with so many of their artisans: weavers at their backstrap looms, embroiderers, spinners, potters. Inhaling the vibrant atmosphere, I anticipated being able to examine a whole range of unique textile articles and handcrafted items, and observe them in the very process of their making. The considerable limitations that arose once the pandemic took over, not least of all becoming ill with the virus myself, forced my reliance upon the good will and co-operation of people at a geographical distance, providing me with the stories of their craft. As with other enterprises featured, I hope that I have somehow managed to do justice to a region so steeped in ancient tradition, with such a phenomenal wealth of creativity, and with so many exemplary women.

It has gradually become clear to me that much of the work I collect and enjoy has been made by women, sometimes individually, but very often within female co-operatives and collectives. Particularly whilst I was travelling around the Western Cape in South Africa, I became increasingly interested in the back stories of both

the women themselves, and the development, and social and economic impact of their initiatives. This naturally led to my interest in investigating the narratives surrounding the making of craft by other indigenous communities, and in certain individual female artists and craft practitioners, whose work somehow connects with issues of empowerment.

I was reminded halfway through researching and writing this book that its title echoes something of my own story. Having suddenly lost my mother just days before my tenth birthday, and having experienced a lengthy and difficult divorce process in my early forties, creativity has been the constant in my life, sustaining me both emotionally, and, as a single parent, economically too. Creativity is at the very core of being human, and is the trait that is at the heart of imaginative and innovative thinking, and some of civilisation's most significant achievements.

Albert Einstein talked about the importance of "awakening the joy in creative expression". During my practice as a textile artist over the last 30 years I have continually witnessed in others both the creatively and socially therapeutic power of facilitated creativity. In many of the workshops

I have run it is thanks to that creative buzz, involving busy hands and unleashed imaginations, and a process I have come to regard as the "mindfulness of making", that intimate and easy conversations amongst women who were not previously acquainted are so readily enabled.

My own practice is somewhat process-driven, with an interest in the behaviour and manipulation of fabric, and its construction and transformation. It often utilises reclaimed and recycled fabrics, threads, objects and artefacts. Much of the work included in this book is partially a reflection of my long-held interest in folk art; and, admittedly, my ability to be constantly seduced by colour, pattern and texture! But in every case the work also exemplifies my interest in the skills and making methods of the artists and artisans, and indeed the stories behind the work.

CHAPTER ONE

Women
and
Craft

Fresh interpretations are sometimes inspired by traditional skills which have a lengthy history.

INTRODUCTION

In the first part of the twentieth century, suffering from a legacy inherited from the Victorian era, craft skills, such as weaving, sewing, embroidery, and quilting were regarded largely as women's domestic pastimes, and remained undervalued and marginalised. Still associated with a class of stay-at-home women with leisure time on their hands, it took several decades for attitudes to change, for the boundaries between "fine art" and craft to blur, and for textile crafts to be given the same respect and recognition as other "fine art" media. In the past, it would be true to say that women's cultural contributions had been largely sidelined and overlooked. However, today, women have achieved a significantly increased visibility within the field of art, craft, design, and the creative industries generally. The number of museum and gallery directors and curators, and consequently perhaps, the number of exhibitions featuring female artists and craft practitioners, has grown, and become increasingly embraced and accepted by the art world.

With a new fascination in the qualities of fabric, and a desire to explore their aesthetic rather than utilitarian potential, the 1960s and 70s revolutionised fibre art, sometimes applying boundary-pushing media and methods. Since the 1980s, influenced by postmodernist ideas, the medium has found an increasingly conceptual voice. Reaffirming handicraft and needlework as permissible art practice, textile processes such as knitting and crocheting started to become employed as both material, and subversive, feminist tool. In the 1990s Louise Bourgeois began creating autobiographical work, which incorporated and re-purposed her own clothing and that of her friends; transforming and investing essentially decorative items with powerful and personal meaning. Defying popular notions of scale and application, Portuguese artist Joana Vasconcelos, who represented her country at the 55th Venice Biennale in 2013, creates large scale, vibrantly coloured, sculptural structures and site-specific works, which include an expansive vocabulary of textile processes, such as tassel making, knitting, crochet, beading, and braiding.

"Necessity is the mother of invention". Creatively speaking, and with their "folk art" origins, there are many examples to illustrate this adage. The elaborate exterior decoration of Poland's Lace Pavilion for Shanghai Expo 2010 was inspired by Polish papercuts or "Wycinanki". Made predominantly by female peasants, during the last half of the nineteenth century, using sheep-shearing scissors to depict scenes of daily life, the craft represented the sole affordable means of decoration for their homes. The Benedictine nuns

on the Croatian island of Hvar extract and spin the fibres from the agave plant and, earning a valued extra source of income from their craft, remain the only people creating "aloe lace". Historically, both the Quilters of Gee's Bend and the Freedom Quilting Bee created their wonderfully intuitive and influential work, now highly collectable and impacting positively on the socio-economic status of poor Black American communities.

Fresh interpretations are sometimes inspired by traditional skills which have a lengthy history. As well as referencing certain traditional and cultural practices, many of the artists and makers featured create or facilitate work that addresses particular or varied agendas. These include responses to local cultural patterns and inter-generational practices; employing processes which embody "slow" and "mindful" ideals; ecological productions which explore inventive ways of recycling; and collaborations with communities, which act as creative interventions, protest "performances", or tackle questions of race, gender, and class, and powerfully address issues of homelessness, displacement, and sex trafficking. Prompting dialogue around a range of political issues, women participants are given a voice. Some works have narrative, informative content, which occasionally implies a level of catharsis for the maker.

Some of the works illustrate craft's role as a means of collective engagement, which has the capacity for accessing healthy dialogue, restoring a sense of meaning and quality to life, and improving self-esteem. Research has proven its effectiveness during illness, as a means of coping with discomfort and other symptoms; and in bereavement, facilitating expressions of anxiety and loss. Social bonds and a sense of community are fostered in situations where women are sharing creative skills and ideas, and perhaps in the telling of personal and family histories, whilst involved in the art of making together. In this arena, the imagination also has a greater capacity for empathy, prepared to challenge assumptions and respect differences.

With increased awareness and concern for sustainable, eco-friendly practices, there is an ever-growing interest and demand, both domestically and internationally, for hand-crafted products. The connection between the maker and the work made is apparent. It would be difficult not to acknowledge the artisanal excellence, painstaking care and time taken, and the emotional dimension of that process. Often creating original and unprecedented forms of contemporary craft, they are a celebration of female inventiveness and aesthetic sensibility.

KIHNU and MUHU TEXTILE TRADITIONS

Kihnu, an island which is a one hour ferry journey across the Baltic from the mainland of Estonia, has a long history of maintaining a strongly matriarchal society, where textile traditions have their own specific narrative within the culture. The income of the male population is mainly derived from seafaring occupations and building work, so that textile crafts are solely down to the endeavours of the womenfolk on the island, mainly for functional necessity, but also somewhat for their creative fulfilment.

Kihnu knitting and embroidery "meisters" are world-famous; their handicraft traditions, as well as their culture, are listed by UNESCO. Many knitting patterns for the socks, gloves and "troi" (gansey sweaters) worn by the fishermen, are extremely old, containing symbols which protect against illness or avert the evil eye. Comparably, rag rugs made by British fishermen's wives contained symbols serving a similar purpose. Creating a clothing collection for the dowry chest is vital women's work, and it is only through this that they prove their worthiness for marriage.

From three months old, babies are dressed in typical folk costume – a woven woollen skirt, bearing different band widths of bright colour. From then on, throughout life, the status and circumstances of a female are communicated, like verbal language, by the selection and arrangement of coloured stripes within the woven skirt length. The presence of black and dark colours denote mourning, both for the loss of a family member, and the leaving of the childhood home for marriage. By contrast, the predominance of bright reds, neon pink, yellows and whites worn throughout childhood, young womanhood, and motherhood, symbolise joy and stability.

Aprons worn over the skirts, obligatory for a married woman, are made from predominantly red cotton fabrics, which are now imported from the US, and are printed with a profusion of floral and paisley motifs, in a multitude of different designs. Patterns and colours multiply in the accessorising of the neatly fitting cotton blouse, the oft adopted headscarf or neckerchief, and occasionally socks or stockings bearing naturistic motifs. For more ceremonial wear, festive blouses, caps and hats display stunning examples of colourful embroidery, richly embellished with beads and sequins, bobbin lace and crochet. The juxtaposition of vibrant patterns and stripes in everyday costume is reflective of a strong feminocentric society, which is persistent in guarding and protecting its culture and heritage, and indeed its textile traditions.

"Our folk costumes are very much alive and everybody needs new ones, especially if you have girls in your family in cold and long wintertime, the result gives so much satisfaction! And of course, if you all the time busy with something, it's additionally good for everybody's mental health."
MARE MÄTAS

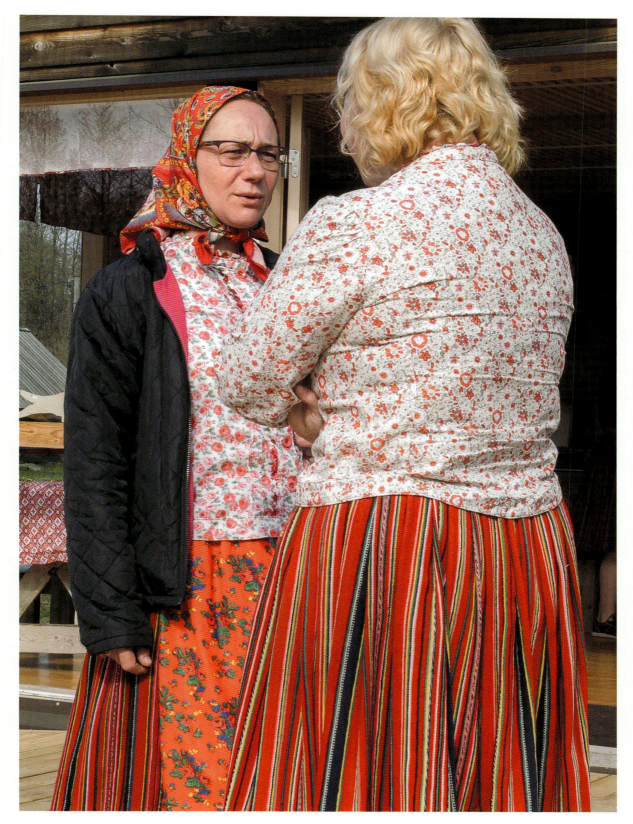

Above:
The woven striped skirts of daily Kihnu dress.
Photograph © Robbie Wolfson.

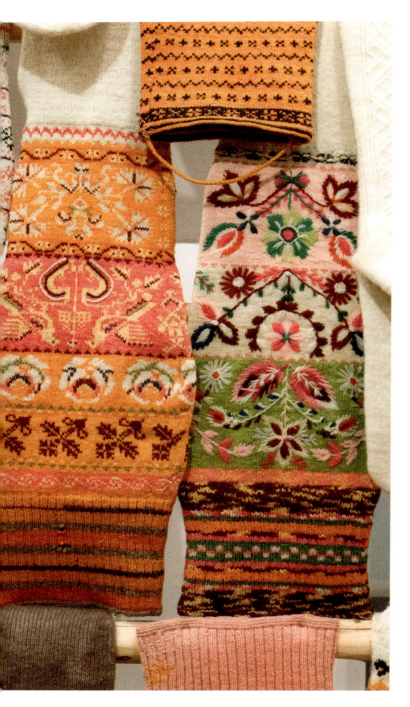

The Estonian island of Muhu bears many cultural similarities to Kihnu, in terms of its women being the chief members of society, due again to male absence for significant portions of the year. Aside from taking over many tasks which would have traditionally been regarded as men's work, through the end of the nineteenth and first half of the twentieth century, women used every free moment for knitting and needlework. Socks and stockings were sometimes knitted as the women walked, and embroidery done as they ploughed the fields during the horses' periods of rest! With no water to clean their hands whilst performing their tasks, they spat on their fingers to clean them. Because homes were dark, the women relied on the bright outdoor sunlight for doing their handiwork.

In the early 1900s the population was almost 8,000 people, and particularly for poorer inhabitants of the island, with little farmland to tend, handicraft was their sole means of income during the winter months. When the German troops occupied the Estonian islands in 1917, Muhu patterns were more sober, and mainly geometrical. Gradually, girls learnt and became influenced by the brightly coloured and exuberant floral embroidery and knitting patterns seen during their time spent on the western coast of the mainland. Reliant on aniline and chemical dyes for their bright palette, these styles now typify the island's handiwork.

Above:
Muhu traditional knitwear patterns.
Photograph © Robbie Wolfson courtesy of Muhu Museum.

SUZANIS

From the Persian word "suzan", meaning needle, the suzani is a hand-embroidered dowry textile, originating from the nomadic tribes of Central Asia. Until the early 1990s, the craft faced possible extinction, caused by industrial manufacturing; and then faced another crisis during Soviet rule, when their own symbols were imposed as a substitute for ancient traditional patterns.

Women are greatly respected within their community for superior embroidery work, and upon reaching a certain age, a girl would be taught the art of embroidery in preparation for the creation of her dowry. Traditionally, grandmothers passed on the family's embroidery designs before death, believing that their secrets would be shared in dreams, if death came suddenly. In the collaborative pre-marital creations of mother and daughter, suzanis recount feelings of motherly love, the wish to bestow blessings for a daughter's future and protection from the evil eye within the first 40 days of married life. A small fault or unfinished area, symbolising man's fallibility and the mother's wish for her daughter's continuation of the embroidery, is always a mark of the textile's authenticity. Dowry pieces are included in the wedding ceremony, as headdresses and awnings, before decorating the wedding chamber.

Ultimately, in their protective roles as talismans, suzanis are used for wrapping belongings, as prayer mats, and for personal and domestic adornment. Typically consisting of more than one panel, with each panel embroidered on narrow portable looms and sometimes stitched with friends or family members, before being assembled to form the suzani. Designs, both in colour and pattern, are dramatic and bold, displaying balance and harmony, and use four different stitches, worked in silk or cotton threads. Depicting an ideal universe, and believed to embody magical powers, transmitting health, joy, fertility, prosperity and hospitality, motifs include floral forms, pomegranates, fishes, birds, suns and moons.

Since Uzbekistan's independence in the 1990s, and significant market increase, young girls are welcoming new economic opportunities, and again learning to embroider suzanis. However, survival of the craft is threatened by soaring prices of silk and cotton, and inferior synthetic copies being made for the tourist market.

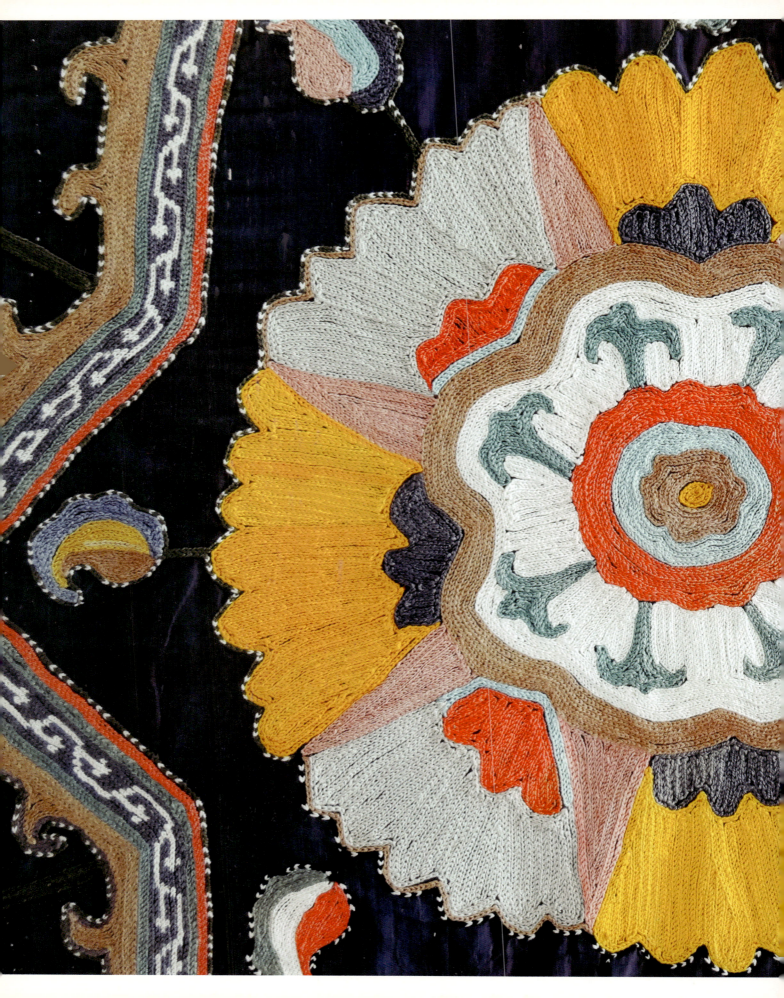

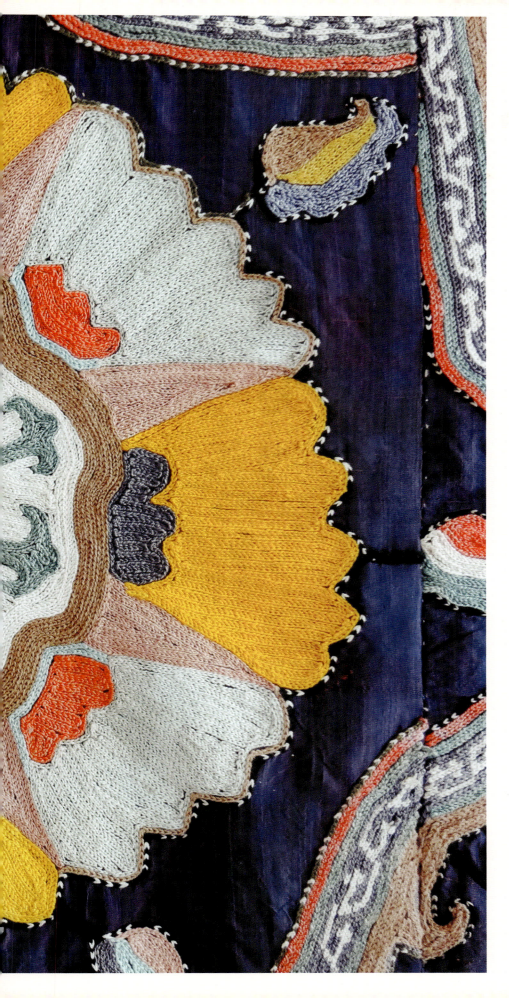

Left:
Shakhrisabz (detail).
Photograph © Peter Darjes.

BORO and SASHIKO

Both stitching methods grew out of necessity in Japan, and have been passed down the generations by rural Japanese women, lovingly and inventively finding ways to clothe and protect their families. During the Edo period (1603-1867), in order to preserve clear class distinction, rigid laws forbade the common people from wearing bright colours or luxurious fabrics, leaving them predominantly to wear garments of home-woven hemp or linen, dyed blue with the indigo plant. The availability and thus intensity of indigo was very dependent upon the region.

"Boro", meaning "ragged" or "tattered" was a technique developed during the nineteenth and early twentieth centuries. Based on the ecological concept of "mottainai" or "too good to waste", and not being able to afford to discard a single fabric scrap, common household textiles, such as pillows and futon covers, as well as "noragi" or farm clothing and workwear, were instinctively stitched, patched, and repaired with layer upon layer of recycled fabric remnants.

"Sashiko", meaning "little stabs", referring to its repetitive running stitch in simple, geometric or symbolic narrative patterns, was a method of strengthening clothing that had been pieced together. Determined by the region, the white stitching varied between five to ten stitches per inch, providing an attractive decorative contrast against the blue, and easier on the eyes of its stitchers during long, dark nights indoors. In northern farming communities, when the weather became too harsh to work outside, it became the winter work of wives and daughters. The stitched layers formed a quilted textile, which as well as being decorative, had durability and thermal properties, because of the air pockets, bulk, and body heat trapped between surfaces.

As well as traditional martial arts uniforms being given substantial padding with Sashiko, these methods were utilised by women to create the lower-rank firefighters' multi-layered garments during the eighteenth century. Before tackling a fire, their uniforms would be soaked with water, and because of the quilting, their clothing would radically increase in weight, offering considerably increased protection. Stitched surfaces that now inspire textile enthusiasts worldwide, have found a new contemporary vocabulary, and have become collectors' items, were for many once associated with shame, reminding rural Japanese people of their penniless past.

Right:
Sashiko stitching on child's martial arts jacket.
Photograph © Robbie Wolfson.

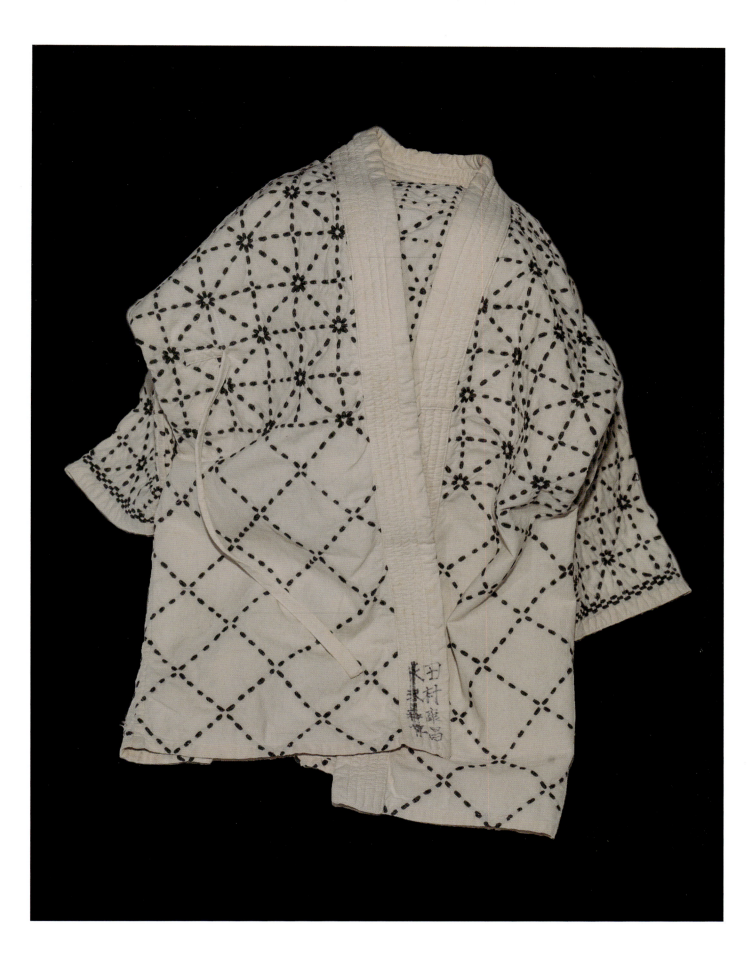

LINDA RAE COUGHLIN

Using largely upcycled, pre-worn and discarded clothing items and artefacts, which include ring-pulls, tin cans and metal buckets, Linda Rae Coughlin employs hooked, hand and machine embroidery, and hand dyeing processes, to create textile/mixed media pieces, which reference poignant and challenging women's issues, and question traditional female role stereotypes. Exquisitely and precisely executed and embellished with wire and metal, she frequently uses symbols, words and phrases to recount common and challenging feelings, stories and experiences, such as

the all-too-often silent crimes of verbal, physical and sexual abuse experienced by women.

Her work forms a vehicle of protest, and a cry for women's right to assert themselves, and tell their own stories. She is amongst 21 women artists featured in a video presented to the United Nations, entitled "Women Artists Consider our World", which include topics such as the female contribution to society, ageing, political freedoms, poverty, education, violence against women, and women's empowerment.

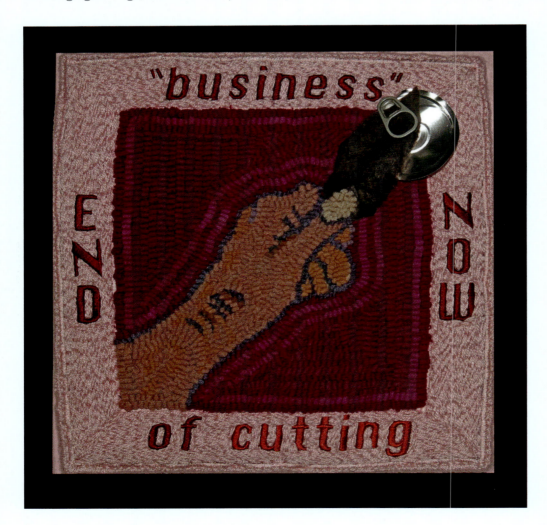

Left:
"End Now" (hand hooked and embellished textile). Photograph courtesy of the artist.

JOHANNA SCHWEIZER

Living in Breda, Holland, Schweizer, who initially trained in ceramics, studied at the AKI in Enschede during the 1980s, and then at the St. Joost Academie of Fine Arts in Breda.

Her crocheted characters, which she makes in her living room/studio, appear to be held upright by invisible forces, but they are neither stuffed nor have any internal support. Their shape and rigidity are retained by a special technique. With curved limbs, irregularities in the stitches' tensions, and colourful, resin-treated cotton and linen threads hung from them, they retain the playfulness and immediacy of a sketch.

Addressing themes of sexuality, power, dominance, life and death, Johanna's naturistic and anthropomorphic forms, and figures which openly reveal their sexuality, appear as characters from ancient myths and stories. The medium of crochet permits the visibility of both the inner and outer three-dimensional structure, and, like the constant retelling of old stories, their frayed, worn, and ragged forms can be patched, fixed, and darned.

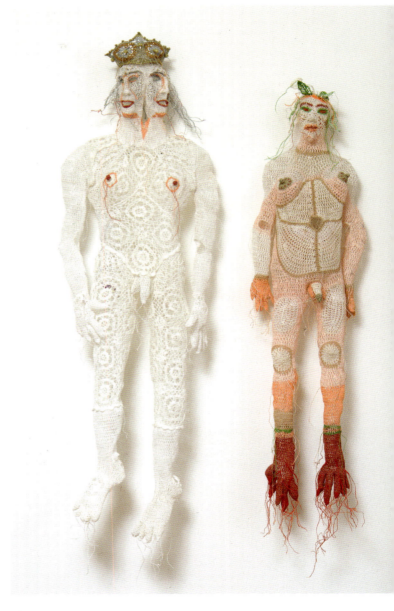

Above:
"Conjunctio" and "Androgyne"
courtesy of Johanna Schweizer.
Photograph © Peter Cox.

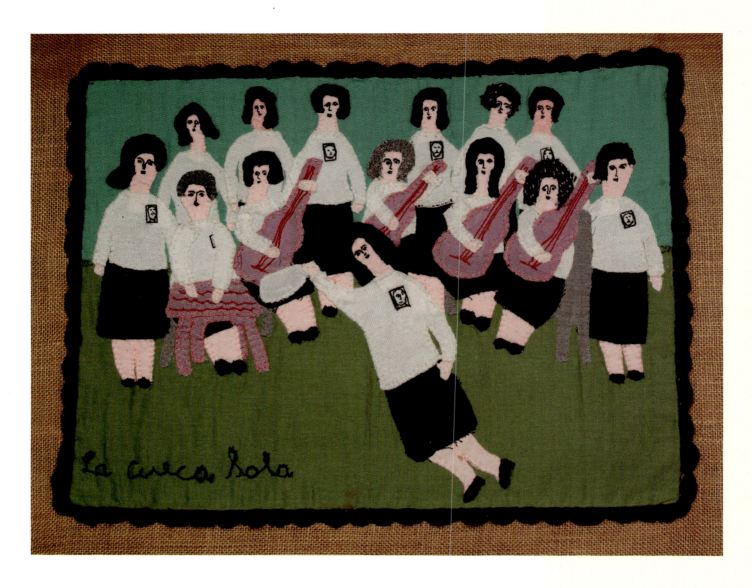

La cueca sola

ARPILLERAS OF CHILE

Arpilleras (pronounced "ar-pee-air-ahs" and meaning "hessian" or "burlap", the base cloth upon which the stitching is done), are three-dimensional appliquéd textiles, created collectively by women "arpilleristas", in the poorer shantytowns outside Santiago. Simple scraps of fabric were used to reflect and represent women's daily lives, often revealing their poverty and hardship. Resorting to these textile skills, frequently using material scraps and clothing remnants left behind from their missing or imprisoned loved ones, the medium also became a way for Chilean women to document their experiences, denouncing the human rights abuses and political violence of the Pinochet regime (1973–90).

Fortunately, such creations were often initially disregarded by the military, owing to their essentially

female and domestic appearance. In spite of the fact that these arpilleras graphically depicted all types of human rights contraventions, their naïve, child-like qualities, hand-crafted appearance, and inclusion of dolls was at first misleading, causing no perceived threat to the government, in terms of leaking sensitive information outside the country. During the early years of Pinochet's dictatorship, until the extent of their impact internationally was recognised by the regime, they were being used by solidarity groups to spread awareness and showcase the regime's atrocities.

The export of the arpilleras provided a degree of economic support, international pressure, and internal disagreements on and within the Junta. A common visual language communicating the scale of these injustices had developed, with the consistent appearance of symbols such as the Andes mountains conveying domination, and the sun, denoting equality. Once realising their true subversive function and purpose, exporting them became illegal, and if found, they would be stopped at Customs and destroyed, forcing solidarity groups and individuals to smuggle them out of the country.

"La Cueca Sola" / "Dancing Cueca Alone" was made by Gala Torres in 1989. Galvanised by the arrest and disappearance of her brother, Ruperto Torres Aravena, in 1973, she became an active member of the Association of Detained and Disappeared (AFDD), and director of the Folkloric Musical Ensemble of Relatives of the detained-disappeared, a folk group created by arpilleristas, who collectively composed and sang songs about their lives as women alone. Reflecting their communal mute protest, it shows women solo dancing Chile's national Cueca dance, which represents the different stages of courting and romance. In contrast to its former colourful norms, it is a sombre depiction of monochromatically attired women, wearing the image of the missing "loved one" over their hearts. However, the boldness of its image has influenced women worldwide, as well as inspiring Sting's song, "They Dance Alone", performed at six Amnesty International benefit concerts in 1986, and covered by many other singers, including Joan Baez. In 1988 General Pinochet signed the convention against torture, and was indicted by Spain on charges of human rights violations from 1973 to 1990.

Opposite:
"La Cueca Sola" ("Dancing Cueca Alone") Gala Torres
courtesy of Conflict Textiles Collection, CAIN, University
of Ulster, Northern Ireland.

ALICE KETTLE

"THREAD BEARING WITNESS" PROJECT

The engagement of collaborative art and making, in non-threatening, and possibly unintentionally therapeutic ways, has allowed Alice to make and maintain personal and meaningful connections with refugee women and children in camps, and those seeking asylum in the UK. Recycled fabrics, garments, and found objects were utilised to make textile pictures, bags and banners, using stitch to establish bonds and create resilience. The textiles are a means to tell rich and complex stories that are both personal and universal, since in their material

substance and process they operate as carriers of cultural heritage, of histories of people movement, of trade, of journeys, and of home-making.

In the "Thread Bearing Witness" project Alice's richly detailed, monumentally, and typically painterly stitched textiles involved the collaboration and participation of communities and individuals, refugees and asylum seekers, who contributed to the realisation of the artworks. Using thread and the notion of stitch

as a common and universal language, which carries cultural specifity, these works address the contemporary issues of migration and displacement, to make a richly layered textile narrative. Inspired by the strength, resilience, and lived experience of all the contributors, a voice has been given to their authentic experience by the way in which they chose to participate. Stitch became a way to express both individuality and fundamental ideas on human connectivity.

Above:
"Ground-Thread Bearing Witness" (cotton, rayon, and metallic thread, life jacket material on printed canvas) 8m x 3m, 2018.
Courtesy of the artist and Candida Stevens Gallery.
Photograph © Michael Pollard.

SHELANU

As part of their contemporary craft programme, Craftspace, a Birmingham craft development organisation, manages Shelanu: Women's Craft Collective. Shelanu, meaning "belonging to us" in Hebrew, supports migrant and refugee women in Birmingham, in the UK, improving their confidence and sense of well-being, teaching new skills, and combating negative perceptions and issues of isolation.

Using largely local materials, printing, and social enterprise production, the souvenir range collection consists of a shoulder bag, wash bag, tablet case, and coin purse. With support from the Barrow Cadbury Trust, The Silk Bureau, and Birmingham Museums Trust, it was launched at Birmingham Museum and Art Gallery shop in 2015. Shelanu were supported through the design process by textile artist Ekta Kaul, and by Emma Daker, Exhibitions and Project Development Manager at Craftspace.

Following their initial market research trips, Shelanu's members, many being newcomers to the city, were in a unique position to view Birmingham's urban environment and architectural heritage with fresh eyes. Birmingham's iconic buildings, industrial heritage, and reputation as the "city of 1,000 trades" formed a large part of the Collective members' experience of familiarisation with their new city, informing the development of a souvenir range of textile products, celebrating and inspired by the city's diversity.

Aiming to build upon methods of batch production and business skills, the objective has been for the Collective to become a sustainable craft social enterprise, with its product range able to provide a regular income, whilst supporting the challenging of negative perceptions and media coverage of migrants and refugees in the UK, and encouraging aspiration and confidence through their creative development. Celebrating the 50th anniversary of Birmingham and Frankfurt's twinning partnerships, the collections were purchased by Birmingham City Council, and given as civic gifts to the German Cultural Attaché and the Mayor of Frankfurt during their visit.

"...a place that I can feel connected and free to try new ideas and express my artistic side... It's a positive way to contribute and find your place in a new place."
SHELANU MEMBER

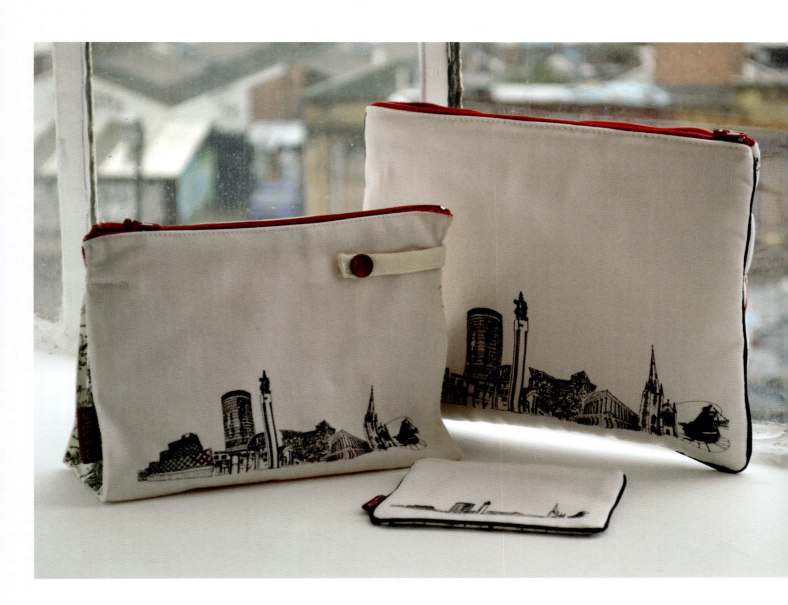

Above:
Birmingham Souvenir Range.
Photograph © Craftspace.

HLA DAY/LILY HANDICRAFT

In 2011 the military dictatorship ended in Myanmar. Traditional crafts which had long been lost have since been refined and economically redeveloped by local artisans, and also by Burmese makers and foreigners who have studied abroad. Hla Day, its name in Burmese meaning "beautiful", is a successful not-for-profit social enterprise which was founded in 2016 by their lead designer, German-born Ulla Kroeber.

and fair trade are paramount. Its emphasis is to be able to empower and transform the lives of the artisan community, by providing them with design knowledge and business support, enabling their beautifully crafted products to attract and access an appreciative international market.

Constantly aiming for both customer and artisan satisfaction, collaborative processes involve regular brainstorming sessions, local materials testing, prototype creation, quality control, and market research. To accommodate growing demand and satisfy regional tastes, the organisation is expanding its retail operations to different areas of Myanmar. Hla Day has recently extended its shop space to accommodate an exquisite range of finely crafted recycled goods, including those made from fabrics with traditional Myanmar weaving patterns. Its Gibbon Coffee Corner, serving coffee from the Magway region, is helping to preserve the environment of the endangered ape species, and to provide an alternative income for local communities. Hla Day also conducts craft classes, including beaded jewellery making, side-stitch bookbinding, and plastic fusion.

Lily Handicraft are a group of talented and spiritual women collaborating with Hla Day and supported by the "Myanmar Compassion Project", founded in 2000. Lily provides sewing and life-skills courses to young women and caregivers from orphanages and children's homes, some of whom are ultimately able to use their new expertise to support their livelihood. Any income generated is reinvested to support transportation costs, salary for the artisan women, and further education.

Working on an individual basis, with over 60 small independent local artisan groups, many consisting of women, in Myanmar's central downtown Yangon, Hla Day's shop has become the popular and iconic place for both locals and tourists, seeking out beautiful Myanmar-made clothing, accessories, interior objects and handicraft, where recycling, sustainability, social impact

KITEPRIDE

KitePride, a social enterprise based in Tel Aviv, was established to provide safe rehabilitation employment for those escaping from all forms of modern-day slavery. It was initially conceived at a conference in 2010, when its founder, Tabea Oppliger, was first exposed to the concerning prevalence and influence of human trafficking. After creating personal connections, she found that factors such as financial debt, trauma, lack of skills or education prevented each and every individual from from escaping such exploitation. Helping those affected to overcome victimisation, and to feel secure and connected, with their dignity and self-worth restored, is one of Tabea and her husband, Matthias, CEO of KitePride's prime objectives.

Converting trash into treasure, and creating products with a combination of quality and cool, more than ten women are currently employed. An attractive range of multi-purpose, lightweight and durable bags is created from upcycled, repurposed materials; and through every bag sold, essential employment opportunities are continually generated. KitePride bags are a symbol of a second wind for both the makers and the material, as the fabric is saved from landfill, being made from used surfing kites, sails, parachutes, canvas and wetsuits, donated from people around the world.

"My work before KitePride was hell. When I entered this place it felt like Paradise! Like the Garden of Eden. The love. The encouragement. The reassuring hugs using no words day in, day out. They made me strong. They made me feel lovable again."

Right:
A range of bags made from repurposed materials.
Photograph © kitepride TLV.

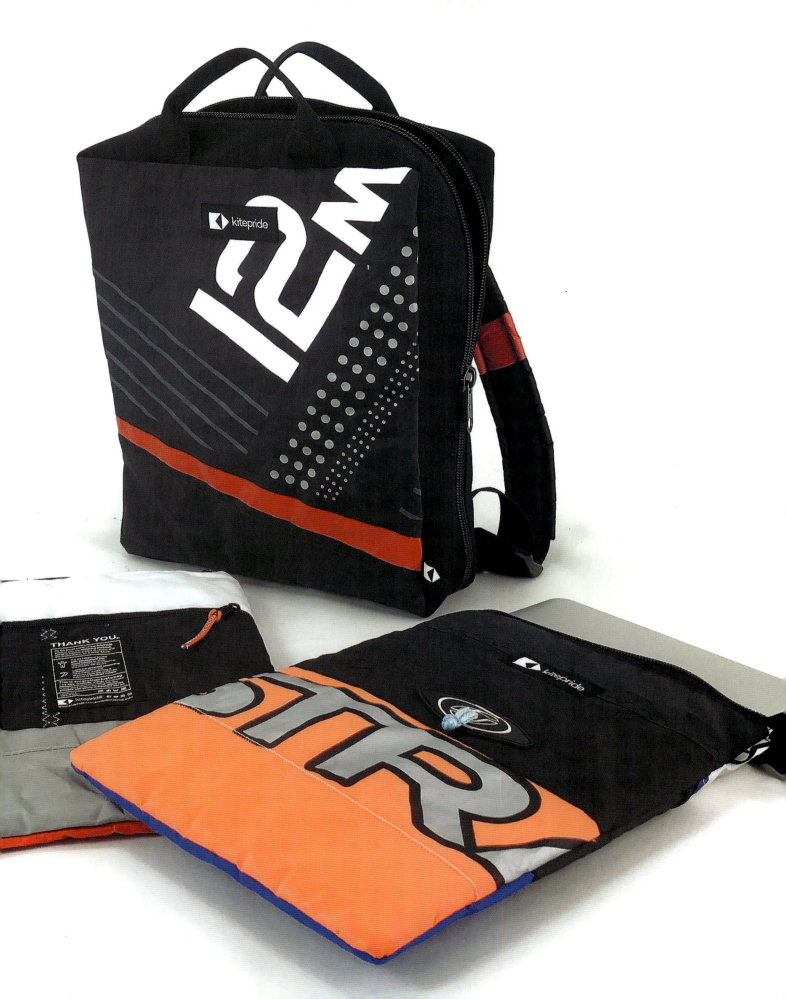

THE CROCHET CORAL REEF

Margaret Wertheim is an Australian-born artist, curator, and science writer on the cultural history of physics, based in Los Angeles. She and her twin sister, Christine Wertheim, founded and operate the Institute For Figuring. Christine is an experimental poet and an academic, with a PhD in philosophy and literature. An article by mathematician, Dr Daina Taimina in *New Scientist*, featuring her discovery of "hyperbolic crochet" techniques for making geometry models in 1997, first excited and influenced Margaret and Christine. Having been taught by their mother, both sisters grew up with a love of handicrafts, such as dress-making and embroidery.

Additionally, global warming, the decimation of coral reefs, Ernst Haeckel's scientific illustrations, and numerous television and cinematic fantasies watched together galvanised them to become the co-creators of the Crochet Coral Reef project in 2005. The world's largest evolving nature-culture community art project has involved the use of yarn, plastics, waste, and even videotape, to craft intricate emulations of living coral reefs. Uniquely fusing art, science, mathematics, handicraft, environmentalism, and community practice, the simple, repetitive, fractal-like pattern of crochet stitch can be varied by experimenting with its

many possible mutations to produce an infinite variety of mathematically diverse and totally unexpected forms. Although consistently emphasising the importance of playfulness and experimentation, the Institute has also published *A Field Guide to Hyperbolic Space*, which includes crochet techniques and instructions for making specific forms imitating corals, kelps, sponges and sea slugs.

In 2007, echoing the nature of the living reefs they reference, the sisters instigated the continuing spawn of hyperbolic crochet forms, known as Satellite Reefs, amongst largely female communities worldwide, involving various groups, crochet guilds and knitting circles, and now in excess of 10,000 people. Huge scale reefs have been created. Satellite Reefs, made by local communities, are usually shown in conjunction with the Wertheim's Reefs, wherever they are made. The sisters' Reefs, each with their own colours, fibre choices, formations, and algorithms, include the "Bleached Reef", the "Coral Forest" and the "Branched Anemone Garden". There is even a "Toxic Reef", largely made of plastic waste, to illustrate the escalation of plastic trash, destructively engulfing marine life.

" ...an amazing evolution of new creative ideas in art and science, and definitely in my own artistic practice. My crochet hook has always been my Magic Wand, and continues to have even greater significance at this point in time, especially in relation to climate change and its devastating effects."
ARLENE MINTZER

The Crochet Coral Reef project has been widely exhibited, including at the Andy Warhol Museum, the Chicago Cultural Center, The Hayward Gallery, London, Smithsonian's National Museum of Natural History, Washington D.C. and the 2019 Venice Biennale. In June 2012, co-ordinated by Lea Heim and Gabriella von Hollen-Heindorf, Föhr Satellite Reef was unveiled at the Museum Kunst der Westkust on the island of Föhr, off the coast of Germany and Denmark. Over 5,000 corals, including magnificent examples of local traditional tatting and bobbin lace, were contributed by more than 700 people from Germany, Denmark, Holland, Luxemburg, Switzerland and Austria. Weekly workshops were held at the Museum, attended by local island women. Bonding over tea, cake and crochet hooks, formalities swiftly diminishing, the project quickly became the embodiment of cohesive community creation.

Overleaf:
Margaret Wertheim in the Fohr Satellite Reef at the Museum Kunst der Westkuste, Germany, 2012. Photograph © Institute for Figuring.

"I'm honoured to have been part of the Crochet Coral Reef Project. The experience helped me to trust my own muse while being part of a greater whole. I entrusted my creations to Margaret and Christine and saw with gratitude the magic sensitive and talented curators can work."
NADEZHDA SEVERNS

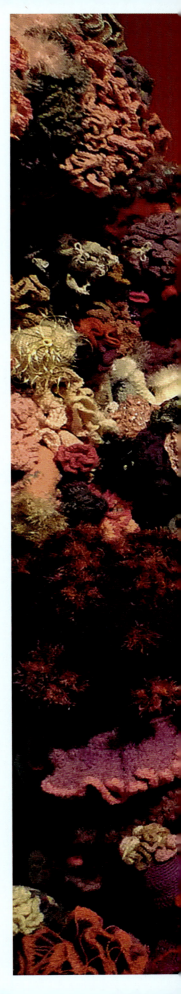

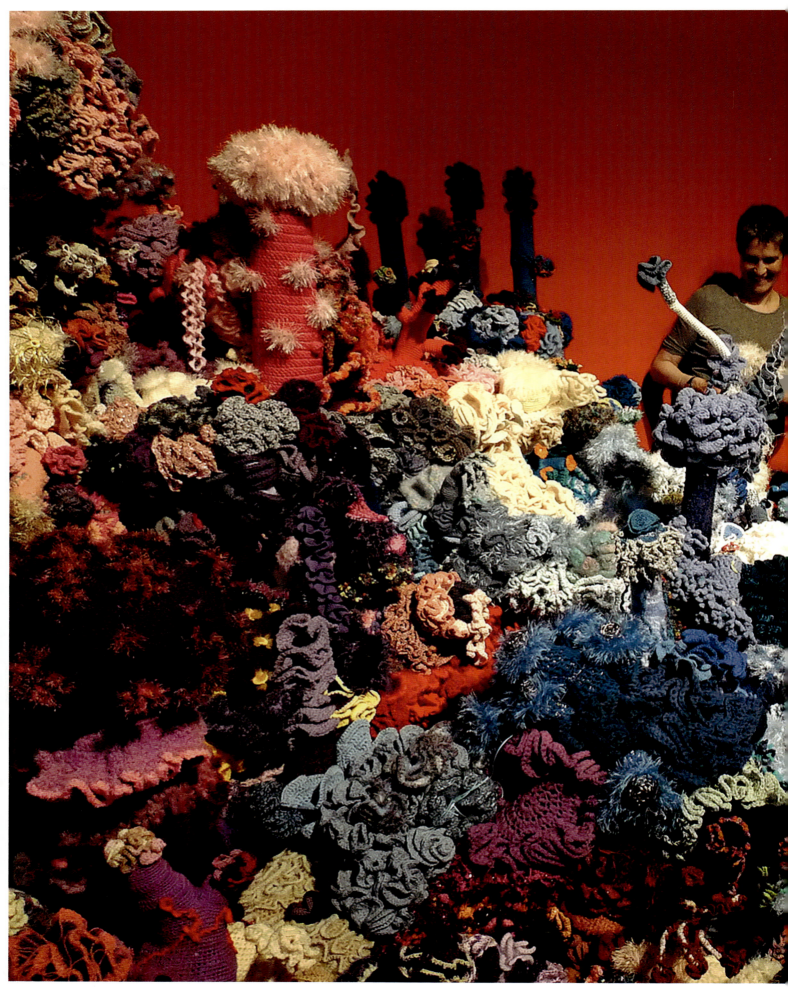

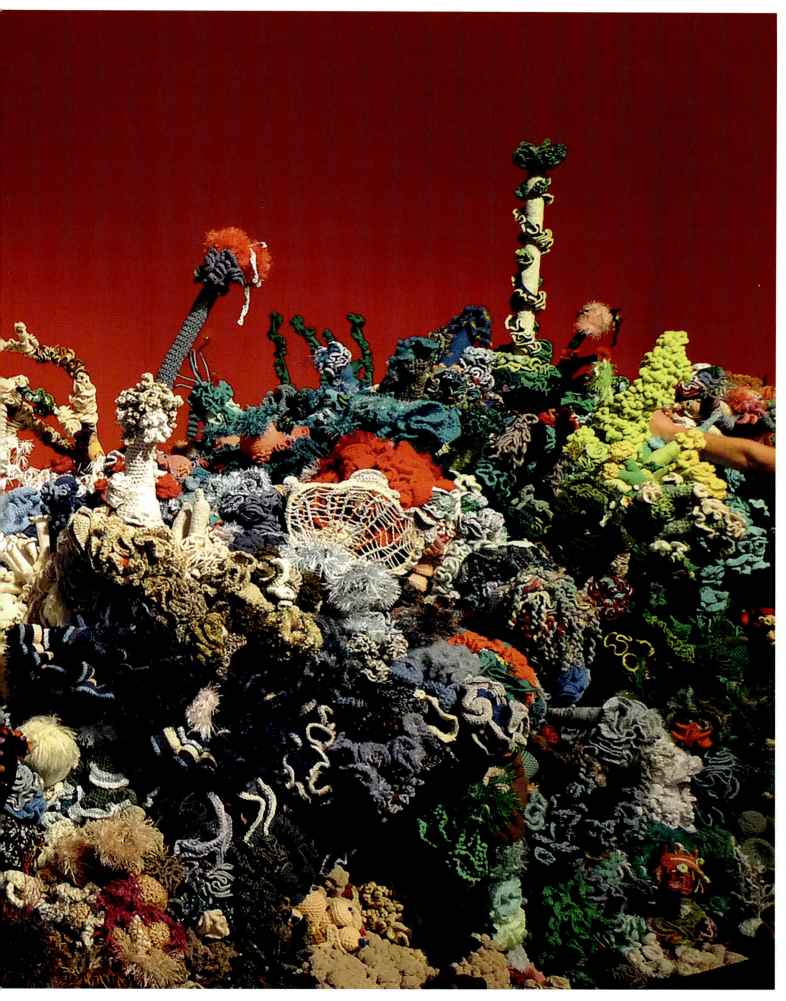

LAUREN O'FARRELL

Lauren O'Farrell, otherwise known as Deadly Knitshade, is an English artist and published author living and working in London. A storyteller at heart, she originally did a degree in creative writing and American studies. Coining the term "yarnstorming", and with her distinctly narrative and humorous style, she is largely responsible for the beginnings of UK graffiti knitting.

In 2005, at the age of 27, three months into her treatment programme for cancer of the lymph system (Hodgkin's Lymphoma), Lauren started Stitch London, a knitting club, with a friend, and learnt to knit at the first meeting. Following three difficult years of her illness, when all else in her life seemed bleak and terrifying, this became the activity that sustained and inspired her, renewing her zest for life, creativity and craft. Stitch London became the UK's largest craft community. Under the Whodunnknit label, Lauren also founded graffiti knitting and craft collective, Knit the City, in 2009.

Evolving from knitter to street artist, in addition to simply covering street furniture or natural structures within the environment with cosies, she combines stories, stitching, and history in her themed knitted and crocheted figures or "amigurumi". Created in her shared studio space at The Fleece Station, in Deptford's Old Police Station, they are later incorporated into her installations within the public domain. Her first woolly intervention, "Web of Woe", a 13-foot spider's web, crammed with struggling creatures, was created in 2009 underneath Waterloo Station.

Making clever use of social media, her photographic ability, and coverage by the BBC, a breakthrough occurred simultaneously with the police's acceptance of her Telephone Box Cosy in Parliament Square, reinforcing for Lauren the full scope of her storytelling medium. Exhibited at Tate Britain, the Natural History Museum, the V&A, and the Science Museum in London, and in Germany and New York, Lauren's other textile triumphs include a corset for a week-old piglet, a yarn-decorated cow for John Lewis's flagship store to celebrate their 150th anniversary, and "Plarchie", an eight-metre giant squid for London's Natural History Museum, made from 160 Sainsbury's plastic bags. Private commissions have included a storytelling forest for the interior of Emma Freud's shepherd's hut.

Right:
Whodunnknit
"Plarchie".
Photograph ©
Lauren O'Farrell
2009.

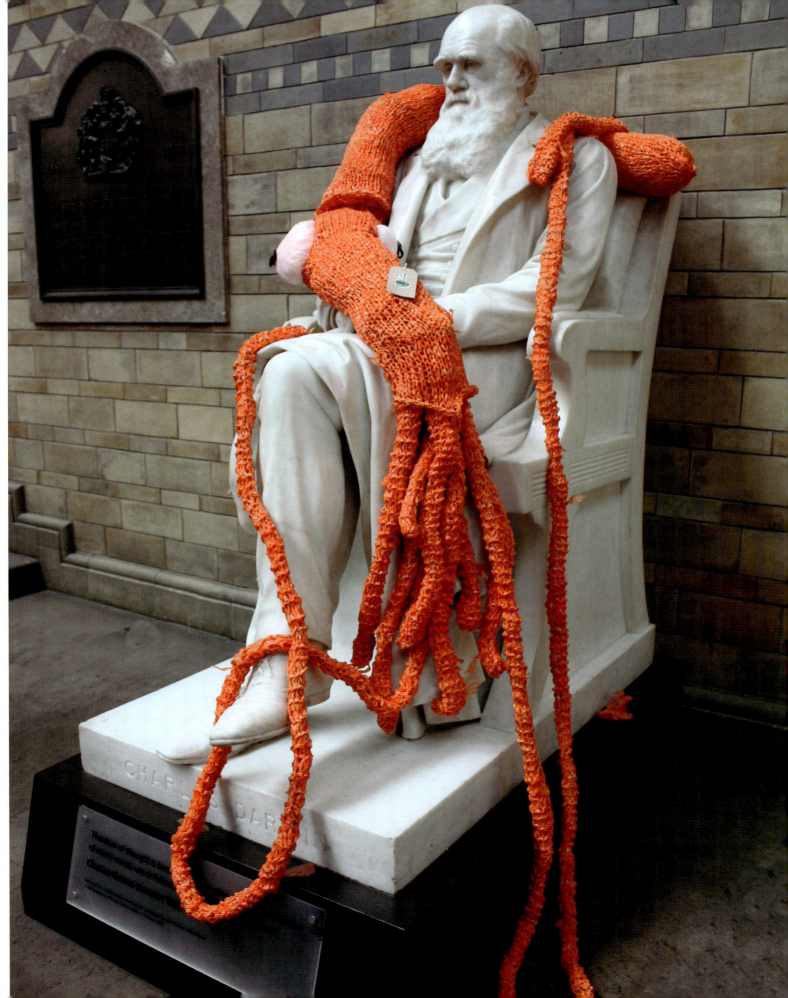

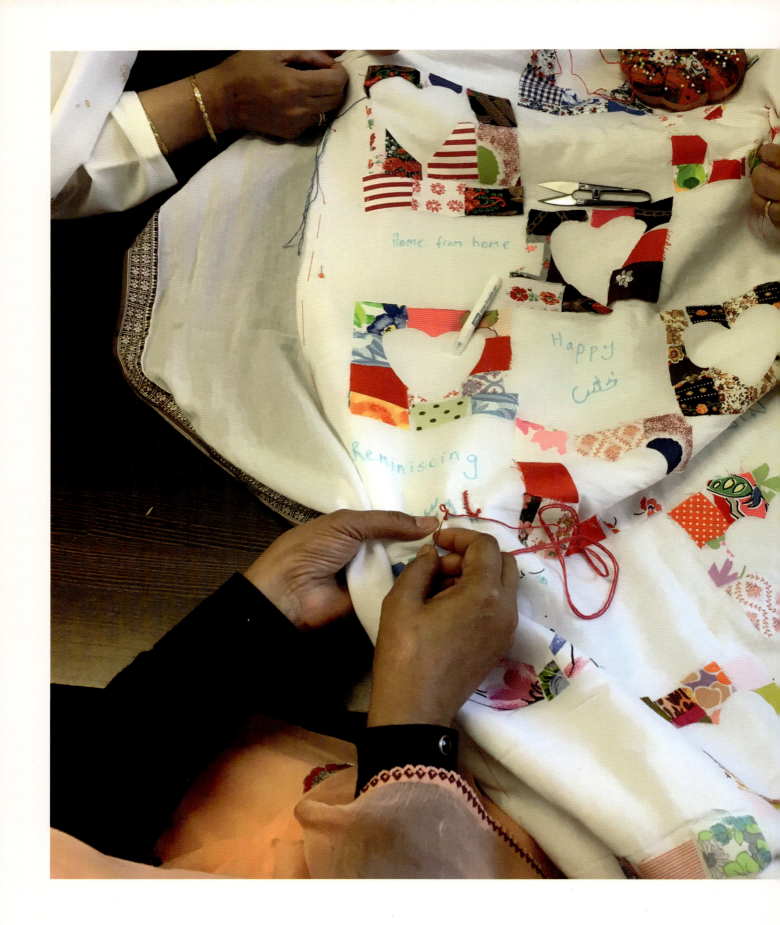

CLAIRE WELLESLEY-SMITH

Claire Wellesley-Smith's early memories include playing with offcuts from her Mum's dressmaking fabrics. With a deep interest in stories of place, she uses archival research as the starting point for her work, searching out suitable locations and community stories. Often engaging public participation, her projects frequently involve sourcing plant dye materials from both textile gardens and her own allotment to explore the rich dyeing heritage of her local environment around Bradford, West Yorkshire. Long-term socially engaged arts projects are a key part of her practice, allowing her to focus on the relationship between craft, health, memory, the natural environment and seasonal cycles. Encouraging the use of local resources, her workshops involve sustainable stitch, repurposed cloth, and traditional techniques.

Mindfulness, the Slow Movement and their relevance to textile processes, in terms of connection, balance, and rhythm are fundamental aspects of her craft. Believing strongly in the restorative power of choosing thread and beginning to stitch, several of her community projects have been conceived to have a positive impact upon the mental health and well-being of participants. In addressing cross-cultural techniques and traditions, Claire examines processes such as Kantha and Boro, piecing, patching and mending, to explore the means whereby cloth, dye, and stitch can become the agents for the natural and social history of place.

Left:
Roshni Ghar Project (2).
Photograph © Claire Wellesley-Smith.

TALYA TOMER-SCHLESINGER

Talya Tomer-Schlesinger initially trained as a ceramicist at Bezalel Academy of Art and Design in Jerusalem. The creation of seven embroidered benches was a response to an open call to artists as part of an annual street festival in Jerusalem, the first one being sited at the entrance of a home for the elderly.

Inspired by the pierced grid of the benches as a suitable "backing cloth", and by memories of her grandmother's needlepoint designs, Talya used recycled lycra swimwear and fabrics resistant to the harsh Jerusalem sunlight and heavy winter rain, to decorate the benches with patterned and floral motifs. Unexpectedly the stitching process created a great deal of interest from the local community, and very soon individuals were enthusiastically arriving with appropriate tools and helping to decorate the benches. Talya notes that since the time these were created, some five years ago, they have remained intact, with no attempts at vandalism, but rather, revealing the occasional neatly executed repair, proving them to be a truly valued community initiative.

Right:
Enthusiastic participation by people of all ages. Photograph © Talya Tomer-Schlesinger.

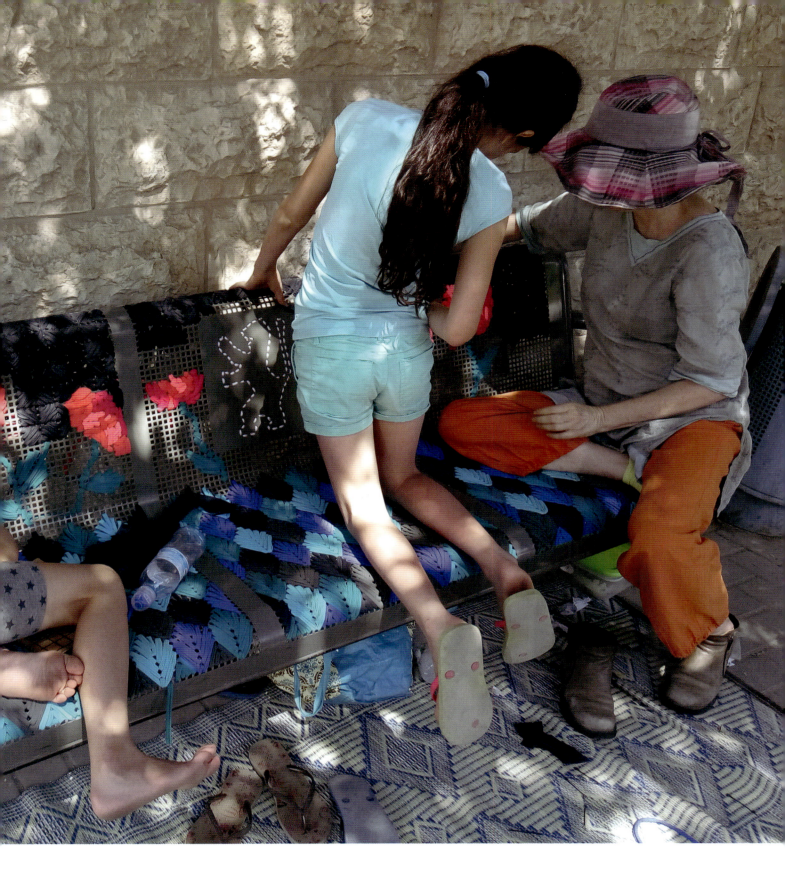

REFORM STUDIO

Waste is one of the major problematic issues in Egypt, where plastic bags are the second most wasted material. Every minute, globally, around nine million single-use plastic bags are distributed free of charge, and can take a thousand years to degrade into more harmful substances. In response to this Hend Riad and Mariam Hazem, female co-founders and designers of Reform, an award-winning design studio based in Cairo, developed "Plastex", a new eco-friendly material, made by weaving discarded plastic bags.

The Grammy's Collection consists of a range of one-of-a-kind 1960s retro-style chairs, which are upholstered with hand woven Plastex. Reviving the traditional craft of handloom weaving, and empowering local communities by hiring predominantly female artisans and housewives, plastic bags are collected, sterilised, and cut into thin strips for the fabric's weft. Officially tested at the National Centre for Research, Plastex was proven to be durable, water resistant, and tolerant to sand and dust.

Within its first year, Reform opened a workshop, reused more than 10,000 wasted plastic bags, designed three collections, and now sell their products at three different showrooms in Egypt, as well as exporting their designs globally. Aims for expansion include opening several more workshops throughout the country, co-operation with recycling NGOs and other countries towards the aim of achieving zero waste, the addition of other design fields and varied price structures in their product range, and the employment of a further 200 female artisans.

"I still had two years left in college and I had to search for a job to support my mother and sisters. With Reform's help and flexibility to work from home I was able to support my family and finish my studies to get my diploma."
AMIRA MOHAMED

Right:
Individual chairs
upholstered with Plastex.
Photograph © Reform Studio.

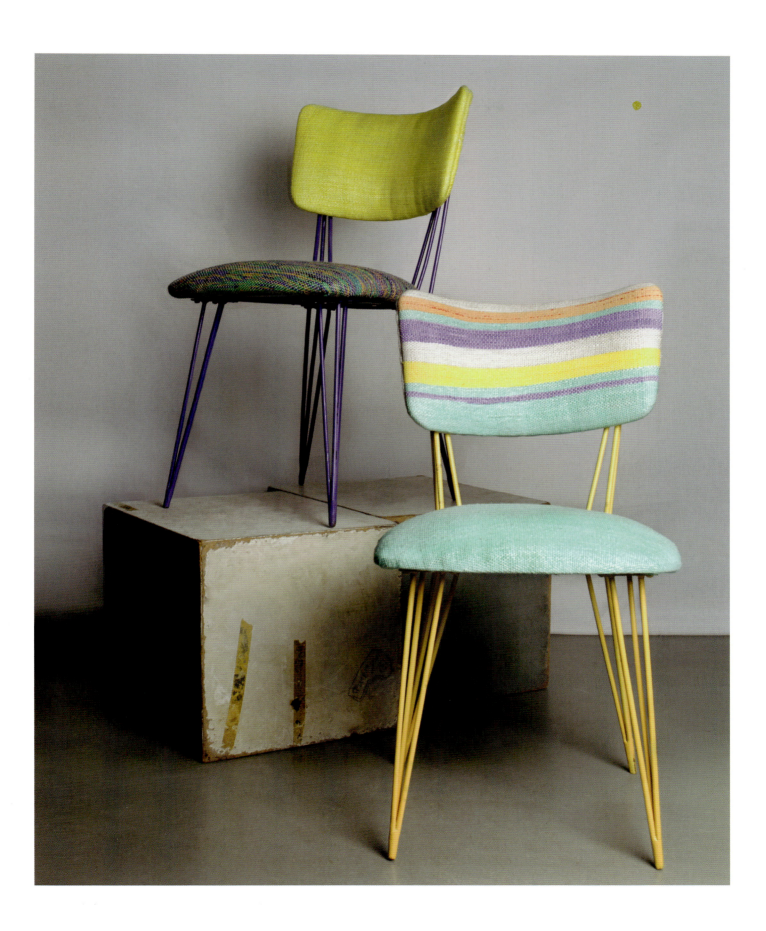

NADA DEBS and FBMI

In the early 1950s Afghanistan was a peaceful country with a learned population and a rich heritage. Since the late twentieth century political unrest, instability and warfare have monumentally taken their toll. In June 2010 Her Highness Sheikha Fatima Bint Mohammed Bin Zayed, wishing to create a positive and sustainable impact upon Afghanistan's women and children, joined forces with Tanweer Investments, to launch The Fatima Bint Mohammed Bin Zayed Initiative, FBMI. Empathically devised to provide a variety of reforms, including education, workshops, social development, medical care, and clean water, its success has largely been achieved by involving local communities in the production of hand-woven carpets, ensuring that the weavers are paid a fair market rate.

Carpet weaving in Afghanistan is a centuries-old exquisitely honed craft, passed down matrilineally for generations. 70% of FBMI's 3,000 employees are women. 35% of these women are widows and the sole bread winners in their families. Many are residents of refugee camps. The majority of the women are able to combine childcare with spinning and weaving, working in their own homes. Some have administrative jobs at the headquarters in Kabul or Jalalabad.

The success of the initiative, however, extends beyond FBMI's employees, creating substantial improvement in the lives of their children and the wider society. FBMI's education department works to prevent child labour, with obligatory full-time education until the age of 15.

Women receive training in health and hygiene, literacy, numeracy, and vocational subjects. FBMI artists are trained in Kabul University, and free healthcare is provided to all employees and their families, dispensing on-site essential supplies, including soaps, masks and simple medications.

Protecting nomadic lifestyles, the carpets' finely spun warp thread is sourced from Takhar, Herat, Badghis, and Helmand provinces in northern Afghanistan; its finest quality wool from the plains and mountains is sheared by local nomadic shepherds, and lovingly spun by hand. Avoiding environmental damage, natural organic vegan dyes are used, and are harvested by farmers to create a myriad of over 1,200 tantalising colours at FBMI's centre in Kabul, where the carpets' finishing processes are also undertaken, resulting in carpets that can be exported to world markets. Designs are both contemporary and historic, incorporating ancient motifs, with every aspect of the design being indicated to the weaver by a colour draft on graph paper.

Every year, FBMI collaborates with a contemporary designer, encouraging and empowering Afghan women to develop a modern approach to their traditional methodology through the introduction of new techniques. To launch its new contemporary collection during Dubai Design Week, Lebanese designer Nada Debs designed a series of rugs that bridge the gap between traditional and contemporary design, creating pieces that are imbued with emotion.

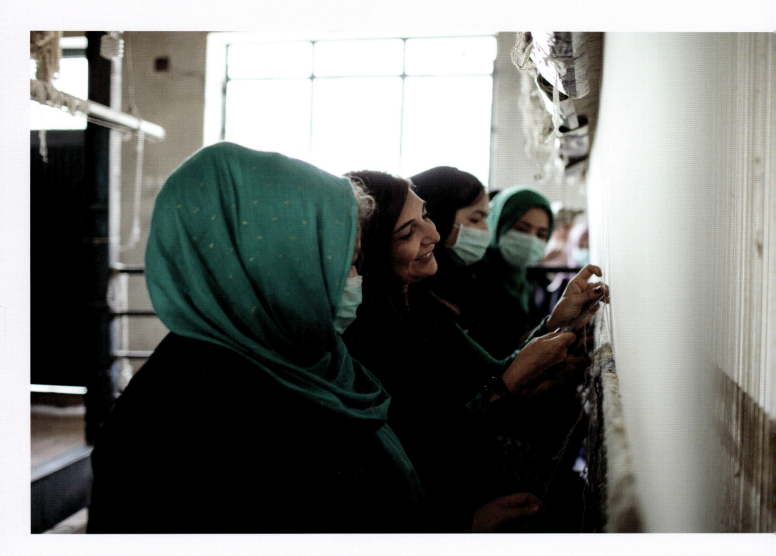

The "You & I" collection, commissioned by FBMI, was
created in collaboration with Afghan carpet weavers
in Kabul, Debs typically visiting the production site in
Afghanistan and working closely alongside the weavers
to create the desired technique and aesthetic. Exploring
the notion of duality, a constant in her work, the
collection is inspired by the love poems of Sufi poet Jalal
al-Din Rumi, creating a visual metaphor for the merging
personalities of two lovers. The collection includes six
colour palettes, and also allows for customisation.

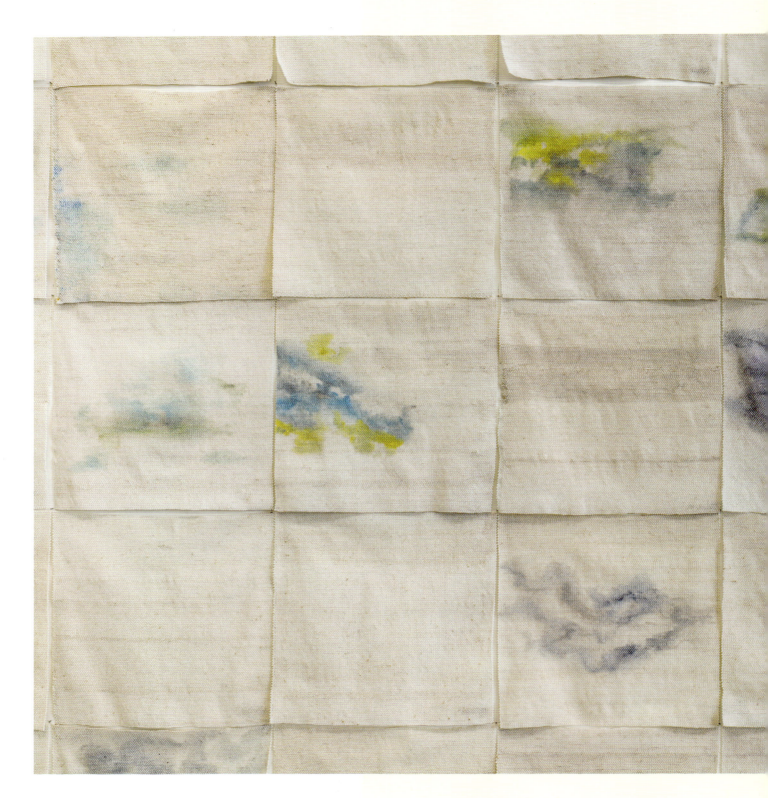

Above:
"The Clouds." Courtesy of the artist
and Lehmann Maupin, New York, Hong Kong, and Seoul.
Photograph © Matthew Herrmann.

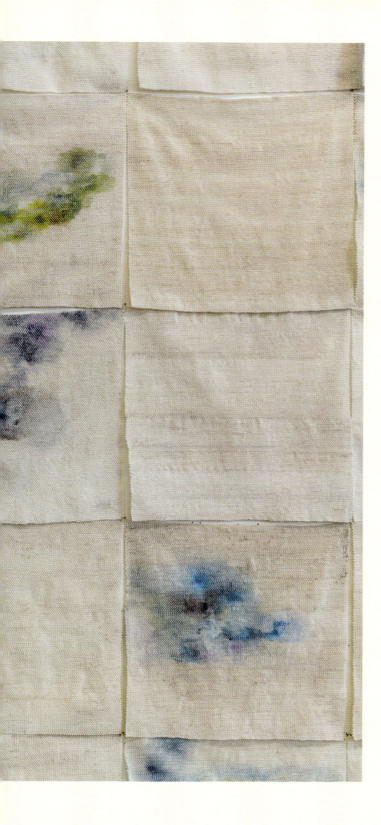

LIZA LOU

Liza Lou, b. 1969, New York, works between Los Angeles and South Africa. Lou's work first gained attention in 1996 when her room-sized installation "Kitchen" (1991-96) was shown at the New Museum in New York. Representing five years of intensive, individual labour, this ground-breaking installation challenged popular preconceptions of art by introducing glass beads as a fine art material. Through its slow, laborious process, "Kitchen" became a monument to the women whose work and cultural achievements have historically gone unrecognised. The installation blurred the rigid boundary between fine art and craft, establishing Lou's long-standing exploration of materiality, beauty, and the valorization of labour.

Working within a craft métier has led the artist to establish and continue her work in a variety of socially engaged settings, including ongoing projects with a collective of Zulu Artisans she founded when she moved to Durban, South Africa in 2005; several community groups in Los Angeles; a women's bead embroidery collective in Mumbai, India; and a sustainable employment project at a women's prison in Belém, Brazil.

Over the past 15 years, as a way of highlighting the poetic process of her work, Lou's approach to her medium has become increasingly minimalist and abstract. In recent years, she has taken inspiration from painting *en plein air* in Durban and Los Angeles, creating "The Clouds" (2015-18), where Lou painted directly onto 600 double-ply 14 x 14 inch beaded sheets to create an immersive, room-sized installation that blurs the boundaries between painting, sculpture and installation. In addition to the use of subtle variations in colour caused by the natural oils of the human hand as a form of tonal mark-making, the bead-woven cloths become the surface upon which the artist applies layers of paint, scraping and wiping it across the beaded surface, which she then partially smashes away with a hammer, to reveal the paint-stained network of thread beneath. The hundreds of sheets join together to form an immense yet delicate fabrication, evoking the monumentality yet groundlessness of passing clouds.

LAUREN SAGAR

"...I especially liked the idea that the exhibit created debate because of its medium: sanitary ware. We didn't make this obvious so people had to work hard to find out what it was about and it stirred many conversations when Lauren and I were installing...."

Styal Women's Prison is located close to Quarry Bank Mill, in the village of Styal, Cheshire, UK. The prison offers a variety of activities which focus on addressing offender behaviour and equipping women to deal with the challenges of life beyond prison. For the "A Woman's Work is Never Done" exhibition, artist Lauren Sagar was selected by Quarry Bank Mill to run workshops with several women prisoners, enabling a contemporary conversation to explore the theme of women's work in historical and contemporary terms, and in relation to their various roles as women, prisoners and artists. The artwork created would become part of Quarry Bank Mill's collection.

The group immediately discovered common attributes including resourcefulness, bravery, practicality, creativity, productivity, whilst being frequently undervalued and overlooked. Addressing the issue of limited resources, tampons and sanitary towels were selected as freely available materials to develop their work. Displaying the extent of their adaptability and innovative skills, their creative productions followed the compilation of a list stating some of their uses of these items: sheep for an artwork, insoles in boots and shoes, applying make-up and streak-free shines to mirrors, blocking out light and preventing windows and doors from banging, floor cleaners, filter tips for Rizlas and repairing lighters, dressing wounds, and snowy windows at Christmas. The variety of these functions are passed on from woman to woman as they enter and leave prison, encouraging continuity of the dialogue, and the potential for further creative contributions by other women at the prison.

Right:
"Tampons" Styal Women's Prison.
Photograph © Lauren Sagar.

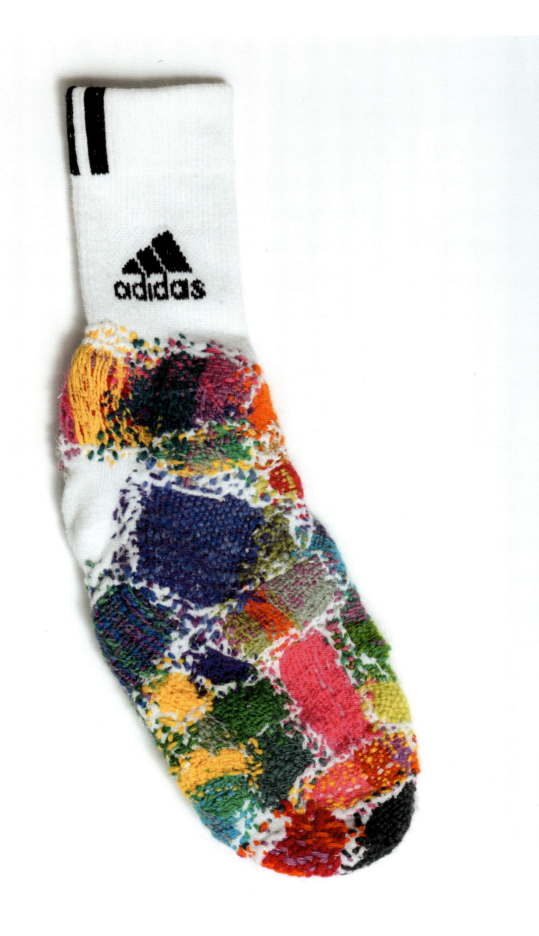

CELIA PYM

The practice of repair and darning stitches, and the humorous contrast of a logo-emblazoned sportswear item with a transformational painterly process, became the starting point for Celia's "socks" series. Trained as a sculptor, Celia's interest in repair was initially triggered by ownership of her great uncle's jumper, which had been lovingly and repeatedly mended by his sister. Possibly influenced also by previous generations of women in her family with a diversity of practical and textile-related skills, the act of mending is, for her, one of integrity, which is, on a profound level, connected with movement, use and habits; the wearer's inner and outer life.

Earlier careers in teaching and nursing have perhaps helped her to regard the mending process of worn clothing as one which transcends the simple act of repair. It bears a direct relationship to both the physical being and the intimacy of the wearer's domestic environment. In her work, exposure of both the damaged area and its repair are of equal importance. In the presence of the garment's owner, in her "surgery for mending", the process can provide a nurturing adjunct, when dealing with grief and trauma, giving parallel meaning to absences in the damaged fabric, and ultimately providing substance for that void. It can facilitate dialogue about the item's and the wearer's history and preservation. The acts of mending and repair are essentially meditative, requiring patience, practicality, discipline, and constant practise.

Left:
"The First One's The Best" 2015
© Celia Pym.
Photograph © Michele Panzeri.

"Sometimes someone will approach me with a damaged item, asking about it getting mended. After we talk about it a bit, examine the garment and damage, turns out maybe they don't actually want it mended. Talking about the item and their associations with it, that satisfies a need they had. Sometimes darning isn't the answer."

JUDITH SCOTT

Judith Scott, b.1943, Cincinnati, Ohio, was an internationally renowned American fibre sculptor. Unlike her fraternal twin sister, Joyce, Judith was born with Down Syndrome. During her infancy, although unrecognised until later on in her life, Judith lost her hearing due to suffering from scarlet fever. At the age of seven she was labelled "ineducable", separated from Joyce and placed in an institution for the mentally disabled, which profoundly affected both twins. Judith became severely withdrawn, displaying considerable behavioural problems. After 35 years of separation and heartache, Joyce became Judith's legal guardian, bringing her to live with her in California.

She was soon enrolled at the Creative Growth Art Center in Oakland, California, which supports people with developmental disabilities, allowing them total artistic freedom. Judith experienced her first fibre art class, and discovered her passion and talent for the medium.

Her creativity and application were immediately recognised. Encouraged to select her own materials, everything from a bicycle wheel to a shopping trolley were soon immersed, swaddled and encapsulated in string, rope, rubber tubing, colourful fabric, and thread. Each project became an experiment in creative spontaneity, instinctive use of colour, and construction of tactile, sculptural forms.

In abstract terms, her work reflects her life and its events, her identity, and the loss of it for so many years, as Joyce's twin. Not only uncovering prodigious talent, Judith's early pieces were her first "words", giving her the facility for self-discovery. Creating work frenetically until her death in 2005, and producing over 200 pieces, now held in international museum and private collections, her wrapped and woven sculptures are her own distinctive legacy of language.

Right:
Wrapped and layered threads and fibres create a dynamic sculptural form with a surface of crayon-like marks.
Courtesy of Creative Growth Art Center, Oakland, California.
Photograph © Benjamin Blackwell.

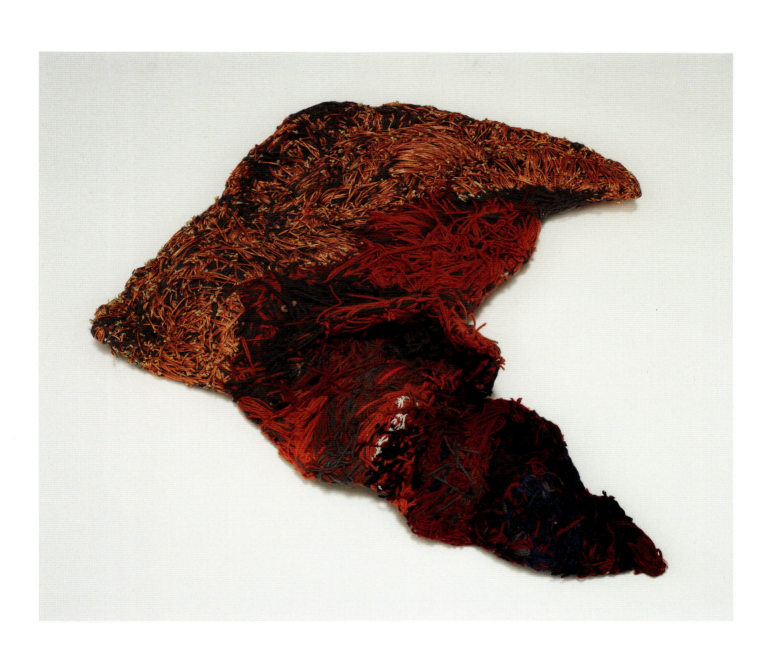

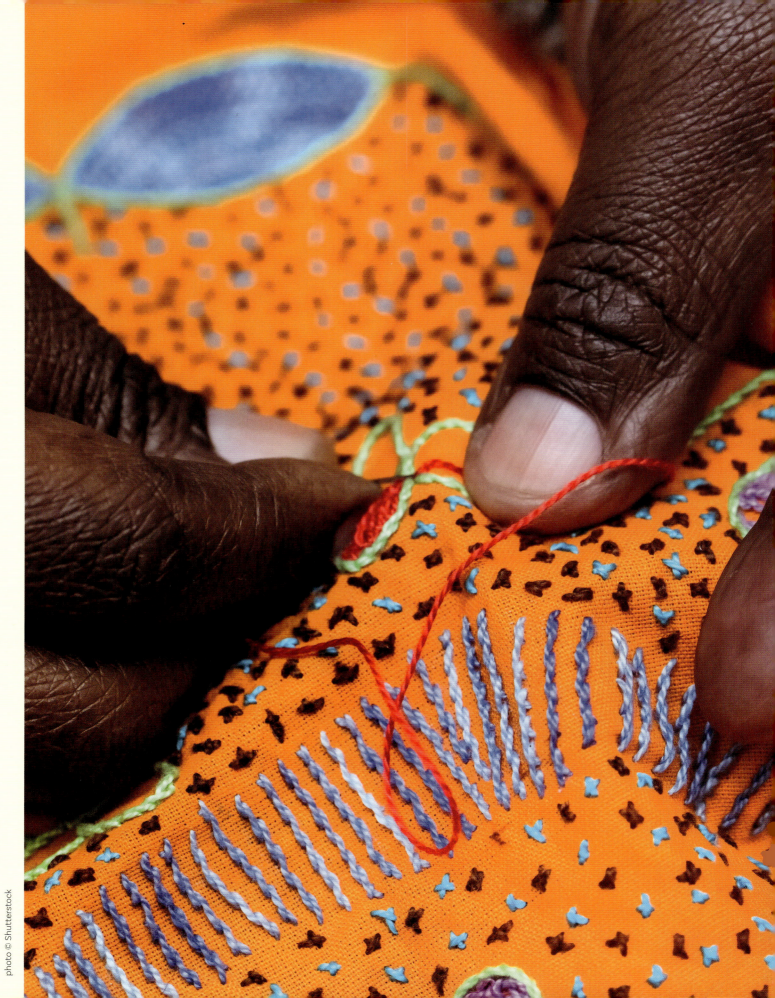

CHAPTER TWO

Initiatives
and
Enterprises

For many of the female
enterprises featured,
handicraft represents their
very means of survival.

INTRODUCTION

With their roots often grounded in ancient methods and techniques, using familiar, accessible, and occasionally self-crafted and repurposed tools and materials, these are the trans-global stories of female craft practices which commonly have visible origins in an inherently folk aesthetic. Whilst further adopting and developing a personalised language and energy, they are frequently imbued with symbolic and spiritual meaning, and even a modern, contemporary and witty twist, giving them a twenty-first century freshness and relevance. It is true that the book features predominantly textile-related crafts; but in so many parts of the world, in their tactility, and as a means of communication and expression, textile crafts represent the skills and traditions which, particularly in matrilineal societies, have been passed from generation to generation, and woven into their culture.

For many of the female enterprises featured, handicraft represents their very means of survival. Within this context, the term "empowerment" may take on different connotations and definitions, dependent upon the culture, cosmology, history, topography, political, and social circumstances surrounding any particular group of women. It is too easy to have both an idealised romantic notion of the issues, and also to view situations with Western value systems. For some groups of women it represents support, companionship, information sharing, perhaps even addressing issues of homelessness or displacement, or the means to escape, at least for a portion of the day, from an oppressive male-dominated environment. In the recounting and stitching of their stories, for some it offers the flexibility of being able to combine their traditional craft skills with domestic duties and childcare, whilst being able, for the first time in their lives, to open a bank account, and supplement the family income. For others it offers their first opportunity of gaining continued employment, and the freedom from long-held stigma, as is the case in certain Ethiopian communities, where mothers of twins can be tragically outcast from society.

Numerous studies and statistics illustrate that by creating economic empowerment, particularly in rural communities, whereby women are able to generate a regular and sustainable source of income, the poverty cycle can effectively be inhibited, ultimately creating a degree of social change. In their ability to be both practical and adaptable, women have consistently proven that they are more able to make family-focused decisions. They create secure households, purchase livestock and grow fruit and vegetables, providing

adequate nutrition, hygiene, healthcare, access to clean water, and educational provision, for their daughters as well as their sons. All of this, in turn, has a positive impact upon their communities.

Indigenous crafts are hugely dependent upon the continued availability of local materials, and the cultivation of certain plant materials; such as sisal in Kenya for basket-making, bamboo in Japan, indigo and other plants and vegetables for extracting dyestuff, as well as reclaimed sari and dhoti fabrics, plastic waste, and recycled paper for papier maché. Regrettably, even with successful cultivation and the ability to display considerable skill and artistic expertise, due to certain unethical practices, cultural appropriation, mass-production, and geographical distances between maker and market, traditional crafts in many parts of the world are and have been somewhat threatened. However, successful, altruistic interventions from external, government, or NGOs are sometimes made within craft groups, which may also include areas where women have been educationally deprived.

By fully addressing impact and sustainability issues, and by forging relationships and collaborations between indigenous artisans and designers, which combine local knowledge with global trends, and respect and preserve their culture and practices, potential for increasing the effectiveness of the production and marketability of their craft is often found. In some situations, by providing and motivating individual artisans with promotion where due, entrepreneurial mentoring, assistance with technology, finance and marketing, and by strengthening maker-consumer relationships, their craft production has the capacity to be taken into new directions.

In order to further address the requirements and demands of contemporary society, and to successfully market their hand-crafted products, there is an increasing tendency for otherwise disadvantaged female artisans to attempt to free themselves from the involvement of middlemen, who often take a large proportion of their profit. New business models are adopted, engaging with and establishing long-term non-profit fair-trade relationships, including the development of collectives, co-operatives, and social enterprises. Although achieving maximised profits is by no means the prime purpose of social enterprise, occasional help from grant funding can sometimes aid its ability to optimise its productivity and generate revenue through its sale of goods. In maintaining its ethical values and its central social objectives, it is able to reinvest its profits for the benefit of society and the environment.

By addressing a range of social needs, such as job creation, fair wages, training and education, healthcare, and the provision of local services, its artisans are helped to live dignified, purposeful lives, and share the beauty of their craft.

Are shackles actually being shed? And if so, to what degree? Quite apart from my sheer admiration of the contents of their creative output, I have continuously asked myself these questions whilst engaging with, and seeking answers from the many hugely helpful contributors in this book. Amongst several cultures and societies, in addition to their various domestic tasks, the actual workload for women increases considerably, when adding the commercial practice of their craft into the mix. However, at grassroots level, perhaps it is social cohesion, the sense of security derived from the ability to independently earn an income, and not least of all, the preservation, protection, and sometimes development of ancient, indigenous techniques which remain key factors.

During one of my conversations with Alvaro Catalán de Ocón, of PET Lamp Project, he said, "The attitude towards basket weaving and their different processes is really something very particular which opened my mind towards understanding it from an anthropological point of view rather than simply a way of manufacturing objects. After going round it, the simile I have closest found is the way in which we understand cooking in our society (especially in Latin countries like Spain, France or Italy). It's something mothers do, and on many occasions they become real experts, but they are not professionals. They just do it by teaching and learning from generation to generation. Every Italian mother is a great cook, which is a way of keeping the family together, of showing their love towards them and passing family knowledge from generation to generation. Something similar I have found in Colombia, Chile or Australia but around weaving." I can compare this with my own methods of preparing certain traditional Jewish recipes, perhaps gefilte fish, or charoseth for the seder plate at Passover, which rather than having been taught, I experienced, witnessed, smelt, and tasted at an early age, amongst the matriarchal figures in my family. The experience somehow has an ancestral quality, as though embodied deeply in my DNA. And so it often is for the basket weavers, the beaders, the embroiderers and the stitchers featured in this book. Not only the skills and the techniques, but the very sensual experience is passed on from generation to generation.

BOSNA QUILT WERKSTATT

In 1993, shortly after the outbreak of the Bosnian War, Lucia Lienhard-Giesinger, an Austrian painter living in Bregenz, Vorarlberg, visited a refugee hostel in Galina, meeting women who, because of the conflict, had been traumatised and forced to flee their homes, and were facing permanent displacement and alienation from their loved ones.

During this period, a regional initiative was launched, inviting artists' responses and ideas for projects involving women of the refugee community. A quilted blanket from India, that Lucia had stumbled upon in a development aid boutique, helped to plant the seeds of the possibility of some form of collaborative

textile making with the women. She aimed to inject some colour, gentleness and humanity back into their lives, by showing them her sketches and designs, and encouraging them to engage with textile tools and materials as a vehicle of expression: the idea was instantly met with an enthusiastic response.

Although predominantly using mixed media, wax crayons, tempera and watercolour within her own artistic practice, to tackle her fondness for maritime and naturistic themes, and having no previous experience in quilting, Lucia discovered an affinity with textiles. Initially, feeling unsure of how or where to begin using a less familiar medium, Lucia found that she was able

to focus upon the colour relationships, patterns, and proportions, which are such a common feature of her paintings.

Anticipating at first that this would only be a short-term project, Lucia founded the Bosna Quilt Werkstatt. Quite quickly, more than 30 women participated, resulting in the quilt-making collaboration becoming an ongoing project, which provided a necessary diversion and distraction for the women, and a regular means of income, providing payment as soon as a quilt was completed, regardless of whether the work was sold or not.

Against the devastating circumstances of their recent history, the power of creative engagement for the refugee women could not be overestimated. The productive environment, and indeed the physical act of employing needle and thread, provided the refugees with an element of protection and stability, and a means of processing traumatic experience. The calming, soothing, repetitive motion of stitching would prove to be effective in helping to equilibrate disturbing images and nightmares, and to gradually generate increased feelings of empowerment, giving language and form to the previously inexpressible.

Provided by Caritas, a Catholic relief organisation commissioned to run the hostel, a nearby garage was transformed to create the temporary studio space. Only large enough to accommodate a long table, benches,

an ironing table, and a storage rack, there were two sewing machines, but not realising that such equipment existed, no quilting frames or stencils. A radio, ashtrays, and a kettle for making Bosnian coffee all helped to provide a conducive atmosphere for the wide range of social classes amongst the women. Cooks, bookkeepers, draftswomen and radiologists were part of the group, as well as those who were barely able to write.

Neither the refugee women or Lucia herself had any particular previous knowledge or expertise in quilting as a medium, relying somewhat upon trial and error, and allowing for a rather democratic approach to the work, where they could learn from each other. For a short period, there were two textile specialists who were able to offer some basic instruction, and also help to determine realistic selling prices for the quilts. The group met regularly for two sessions per week, becoming increasingly motivated and self-reliant.

In devising a project with the refugee women, which she hoped might inject a level of joy and optimism into their lives, Lucia was keen to derive pleasure also from her own participation. Although the lack of a common spoken language might certainly have presented a stumbling block, this was soon overshadowed by the group's creative connection. Safira Hoso, who is now the Werkstatt's co-ordinator in Gorazde, rapidly learnt German, and was able to articulate her feelings about being part of the quilt group, telling Lucia, "Once we go

Left:
Arbeitsbesprechung
(quilters' project meeting) 2019.
Photograph © Daniel Lienhard.

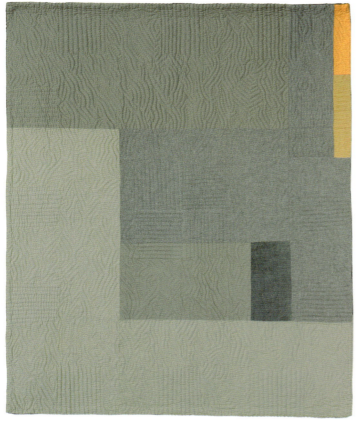

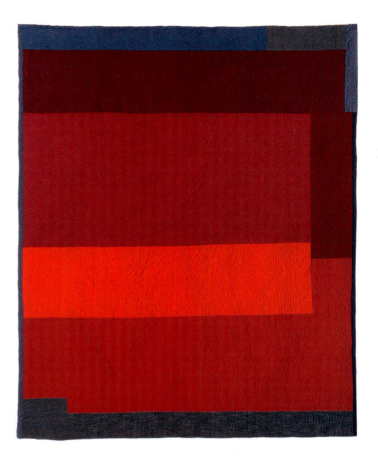

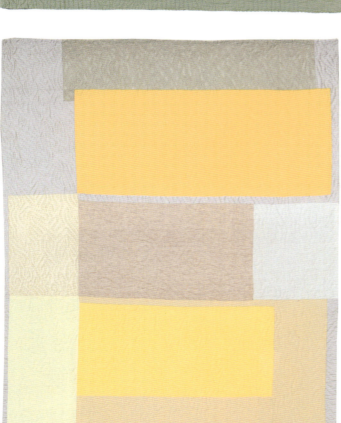

back to Bosnia, you have to continue this work with us" and exclaiming, "It is my love and my life!"

As well as creating work of social and political significance, the aim was certainly for the quilts to appeal aesthetically to the public, and possibly also to potential buyers, rather than merely engaging their interest out of pity. It is Lucia, with her beautiful collection of fabrics, who has initial creative control. She designs both the colours and the abstract rectangular patterns of each work, which give the quilts their instantly identifiable signature. The ordered linear rhythms of the Bauhaus aesthetic, the paintings and palette of Josef Albers, and the horizontal, linear simplicity of Mark Rothko are instantly brought to mind.

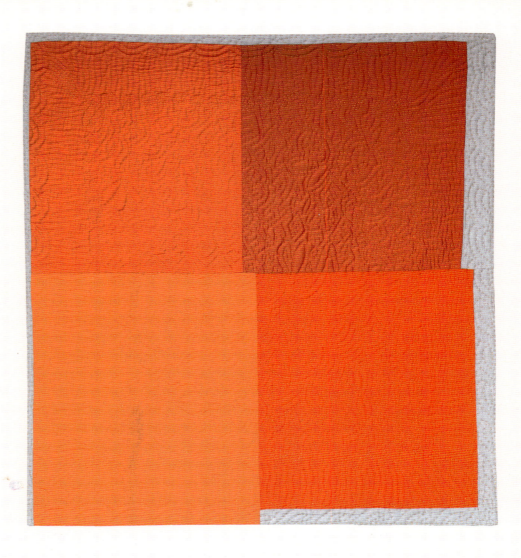

Opposite top left:
Curvilinear, leaf-like shapes, and straight vertical and horizontal lines form the stitching, 2015.
Photograph © Matthias Weissengruber.

Opposite top right:
Red and blue quilt.
Photograph © Laurenz Feinig.

Opposite bottom:
Yellow and grey quilt.
Photograph © Laurenz Feinig.

Right:
The vibrancy of mandarin orange tones is enhanced by the thin scallop-stitched grey border, 2018.
Photograph © Matthias Weissengruber.

Displaying a varied and contemporary palette, subtle neutral shades are often juxtaposed with warm, sunny yellows, and softer salmon tones are set alongside vibrant flame and mandarin orange hues. By contrast, a quilt with thin, tenuous outer areas of royal and midnight blues forming the framework, give definition to the heavier rectangles of maroon, scarlet, and plum within.

The initial preparation of the quilts involves literally laying out the fabrics to actual scale, on the studio floor. Once this has been done, small sketches with details of colour, and the design's precise measurements are given to the makers, Safira, Vesna, Camila, Hedija, Sevala, Sabina, Mirza Kozo, Mirza Masic, Munira, Sada, and Emina. They are given full responsibility for the seams and the stitching, with the implicit invitation that each quilt may be further developed as their distinctive hand and individual creativity dictates. Wishing to take responsibility for the particular piece they are making, the women generally prefer to work on one quilt individually, although occasionally it might be done in pairs. One quilt can take up to five or six weeks to complete.

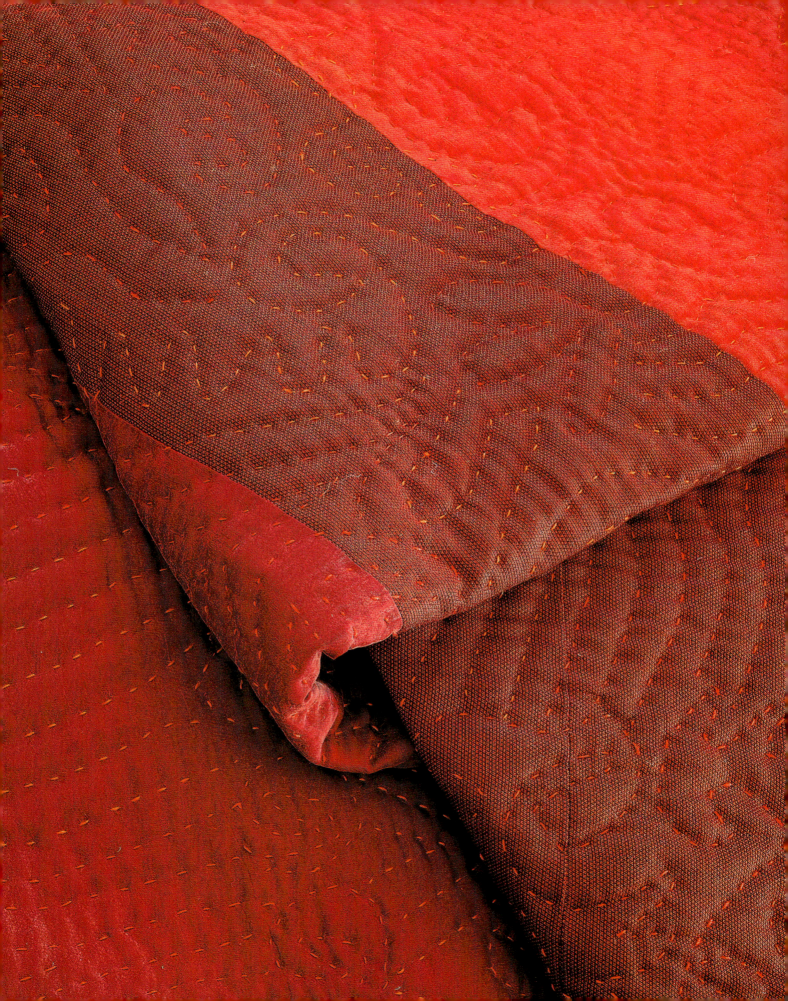

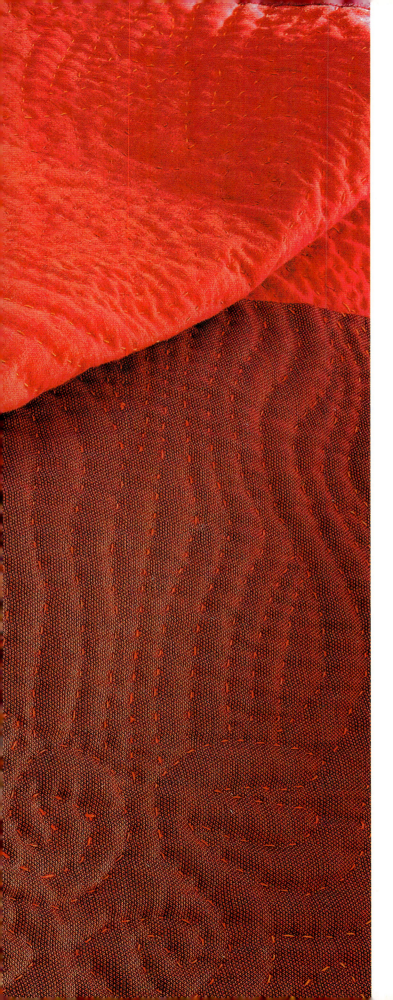

Maintaining a clear division of labour in the various stages of the quilt-making process has consistently proven to be a satisfactory system for all concerned, and produces aesthetically pleasing results. Sometimes linear, and otherwise curvy, concentric stitching overlays the basic quilt constructions. The directions and closeness of the stitched rows sometimes renders subtle tonal shifts and undulations within the base fabric, with increased pattern towards the centre of the work. Other quilts display vague spiral, paisley and fan-shaped forms, with scalloped stitching along the outer edges. Some of Munira Karo and Emina Hoso's stitched overlapping petal and leaf-like shapes perhaps reflect their other passion for vegetable growing.

The sharp geometric patterns and arrangements of rectangular coloured fabric blocks and strips contrast with the intricate complexity of the stitches, providing a subtly textured surface of raised patterned ripples. They seem to have their own narrative, representing the shifts and transformations of the makers' circumstances, and unveiling an enduring relevance.

In its early stages, the project received funding support from the Federal Government's "multi-cultural pot", together with contributions from certain other organisations. Because growth and development in the project has been deliberately gradual, they were quickly able to continue independently. It has been additionally

Left:
Red quilt detail 2017.
Photograph © Laurenz Feinig.

sustained by both Lucia and her husband Daniel's ongoing voluntary involvement in all organisational aspects of the Bosna Quilt Werkstatt, including invitations, advertising and all necessary information for its current six exhibitions per year.

After the war, the refugees were able to return to their home town of Gorazde, with its 20,000 inhabitants, on the banks of the Drina River. Anxious to continue her work, and regularly maintaining close communication with Lucia, Safira Hoso taught and co-ordinated every aspect of the project to a new group of 11 women, who had remained in the besieged area throughout the war. Since this time, and just as before, the quilts' colour scheme and construction are done in Vorarlberg, and the quilts made in Gorazde.

Although the last 21 years has brought about improved conditions and opportunities, for some considerable time the after-effects of the armed conflict persisted, revealing war-torn building facades, disrupted farming, high unemployment, interrupted studies, and fractured families. Although some of the women found employment in factories or farming, for many, quilting became their sole means of regular income.

Until 2012, there were 12 changing exhibitions each year. Never actively marketing or seeking out exhibition opportunities, these have always occurred through invitation, and have received considerable acclaim. Even from their very first exhibition, the superior quality of the work and its individuality, each one bearing a label with the artist's signature and year of making, has meant

instant sales. Every Bosna Quilt sold anywhere in the world is also a reminder of the inhumanity and lack of empathy displayed towards those who have suffered the injustices of war. Now, in order for more people to be able to view the quilts, and also gain further insight into the actual making process, an impressive design studio, showroom, and exhibition space has been created in Bregenz.

In celebration of their twentieth anniversary, Lucia, Daniel, and Lucia's son, Laurenz Feinig, collaborated in the publication of four heavily illustrated booklets in German. Concerning all aspects of the Bosna Quilt Werkstatt, it justifiably highlights its talented makers, the vast body of work created, and the places, public and private, in many parts of the world, which now proudly hang the quilts upon their walls, or display them in their homes.

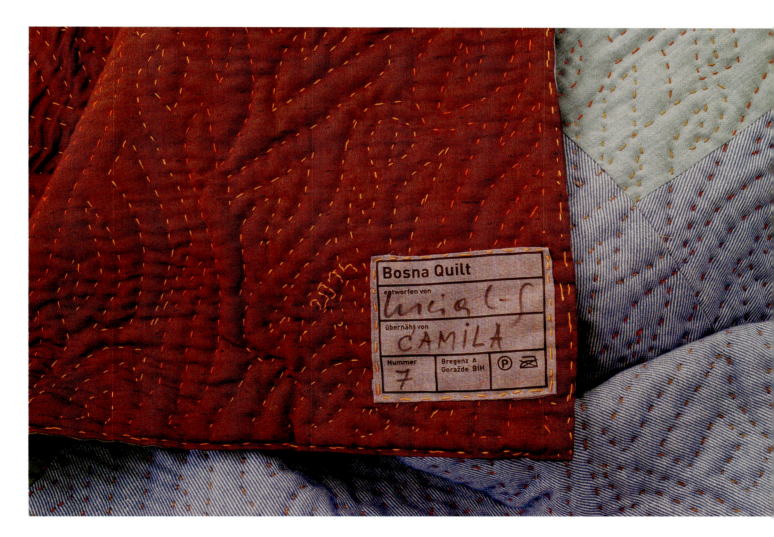

Opposite:
Gorazde, Bosnia.
Photograph © Daniel Lienhard.

Above:
Each quilt bears a label revealing the name of its maker.
Photograph © Laurenz Feinig, 2018.

BOUCHEROUITE RUGS

The history of the Berbers or Amazighs dates back to prehistoric times. They are an ethnic group, indigenous mostly to North Africa and some northern parts of Western Africa, and were the original inhabitants of Morocco. The word "Berber", meaning barbarians, was believed to have been given to those people by the Romans; and the word "Amazigh" is said to mean "free people" or "proud raiders". They are, in fact, collective terms given to disparate ethnic groups sharing social, cultural and economic existences. Currently constituting over 40% of the population, over the centuries they have been influenced by Arab and Bedouin invasion, later by the Andalusian population, and more recently by the French.

Although one of the main occupations has been agriculture in the region's mountains and valleys, the population's relative upper classes have actively been merchants and traders, being the first to establish trade routes between North African towns and the Sahara Desert. In time, however, the commercial viability of these routes dwindled, and power amongst the classes shifted, as farmers became wealthier.

"Tamazight", the Berber language, is predominantly oral, consisting of numerous different languages and dialects, but the Berbers have also had their own alphabet for over 2,000 years, which, together with Arabic, is the one most commonly used. In the seventh century, having largely belonged to the Christian faith, they converted to Islam, adhering to all aspects of the faith other than fasting during Ramadan, because of their nomadic lifestyle. Believing in the power and existence of several spirits, they wear and carry amulets and talismans, to protect them from evil, danger and disease.

Regarding the Berber's autonomy as a threat, the Moroccan government has striven to encourage the assimilation of Berber culture into the wider Moroccan way of life. Fortunately, this has begun to change, together with changing attitudes towards the preservation of the language and culture. A homogenised form of the Tamazight language is now taught in many schools, and the advent of satellite radio and television broadcasting, as well as a small film industry in the Berber language, has occurred over recent years. Only a short distance apart, from one small village community to another, spoken language and dialect can differ considerably; and although for the elderly, cell phone ownership and usage is now commonplace, the language used is certainly unintelligible to anyone outside the Berber population.

Today the Berbers live in many parts of Morocco, including the Draa Valley, and the Mid and High Atlas Mountains. As well as farming, they also sometimes own or run small shops and enterprises in towns and cities like Fez and Marrakesh. Many examples of fine Berber craftsmanship include work with wood, silver, leather, and embroidered and woven textiles, including the

Right:
Repetitive square and rectangular shapes broken only by the central vertical arrow.
Photograph © Gebhart Blazek, http/berber-arts.com.

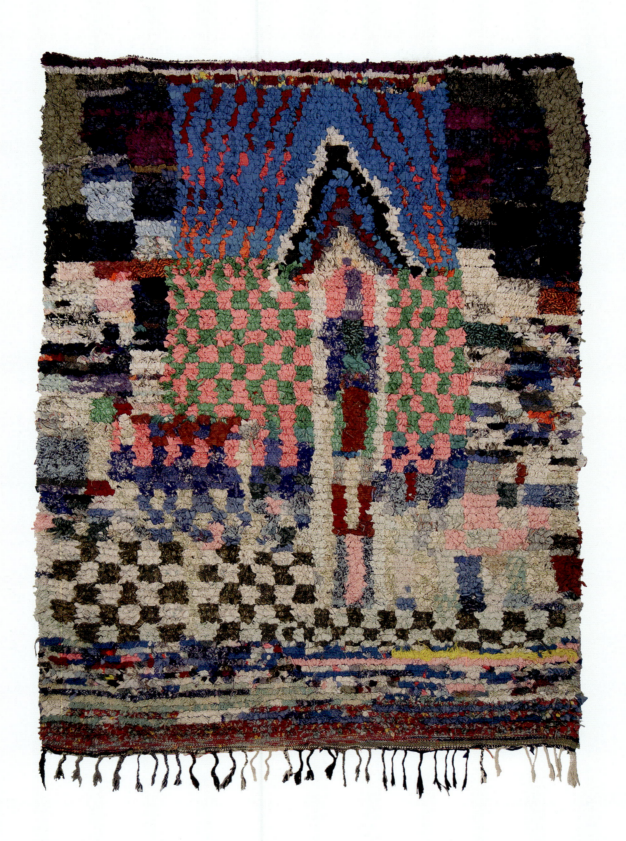

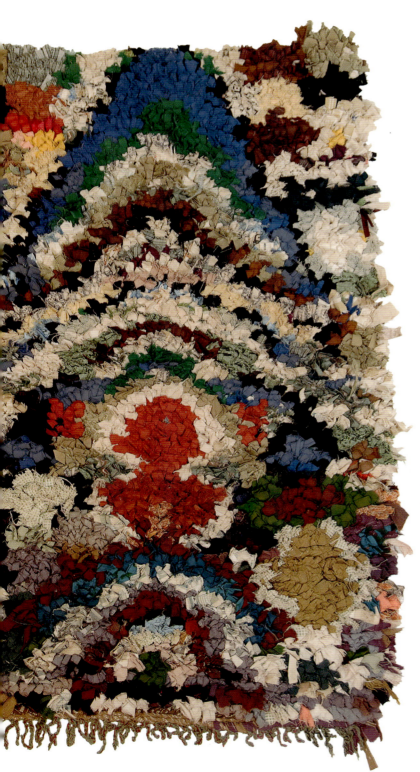

Berber carpets of different styles and regions, which have, particularly since the 1990s, become so popular and on trend.

French infiltration in Morocco in the early twentieth century led to restrictions on the Berbers' lifestyle, and their having less freedom of movement. Since the late 1950s, Morocco started to build large dams for irrigation, which in turn allowed former nomads to grow crops and introduce different breeds of sheep, substituting them for the former resistant long-haired nomadic breeds. Since this time, nomadism has been less apparent, and consequently sheepherding along with wool production has considerably reduced.

The Berbers started to build houses instead of living in tents, but concrete floors are particularly cold during the winter months, making warm floor coverings a necessity. Given that the traditional raw materials used for weaving floor rugs had become a rarer commodity throughout Morocco, they have

Left:
A warm floor covering is provided by the shaggy looped pile surface. Photograph © Gebhart Blazek.

had to seek out additional and alternative weft materials for their rugs. From the 1960s onwards, together with the first dam and irrigation projects having been established in the region around Boujad and Beni Mellal and the growth of the country's textile and clothing industry, the people of this particular area were the first to resourcefully include recycled synthetic materials. Lurex, polyester, nylon off-cuts, plastic strips from grain transport bags, as well as cotton scraps, and occasionally wool and goat hair, is now used in their weaving.

These hand-knotted rag rugs, known as Boucherouite, (pronounced Boo-shay-reet) an Arabic word meaning "fabric strip" or "torn piece of clothing", have been made entirely by Berber women since the 1970s and early 80s. Although from this period, they are now considered within the global market as "vintage". The rugs were originally chiefly made for domestic use, to keep their homes warm and provide additional comfort as saddle covers when travelling by horse or mule. They were used for seating and bed covers, blankets, and as coverings for more extravagant wool rugs underneath them. Additionally, they were frequently made as wedding presents or gifts to celebrate the birth of a newborn child.

All Moroccan rugs, whether the Boucherouite, or those belonging to other periods and styles, such as Azilal, Boujad or Beni Ouarain, are in fact Berber rugs, as they are all made by Berber tribes in different rural parts all over the country. Because of factors such as the local resources, the area's climate, and previously, in the early twentieth century, native plants used for dyes, the styles have distinct differences.

Not underplaying their symbolic and narrative content, as well as their apotropaic power, they are certainly charged with mystery, magic and superstition. Their feverish labyrinthine asymmetrical patterns, made up of widening and narrowing dizzying forms, chevrons, zigzags, diamonds and squares, all changing colour and merging into each other, resemble twentieth century abstract paintings and Outsider art. Every Boucherouite rug is the direct and deeply personal expression of the woman who made it.

Although the actual meaning of many symbols has been lost due to relative tribal isolation and independence, unlike other ethnicities, the Berbers have maintained and preserved many of the original and essential forms and motifs in their carpets. Beyond any verbal translation, the mark making within many of the different rug styles is not dissimilar to those seen in prehistoric cave drawings and paintings, and the marks made on bone, horn and stone. Similarly, they recreate the rhythms and shapes of the Amazigh villages and landscapes, as well as tattoos, jewellery and pottery motifs, and evoke the power of the culture's legends and songs.

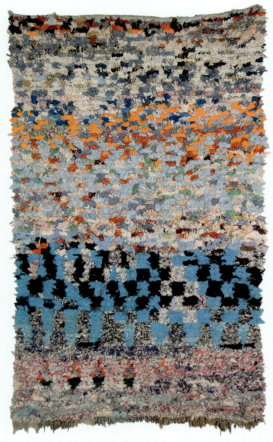

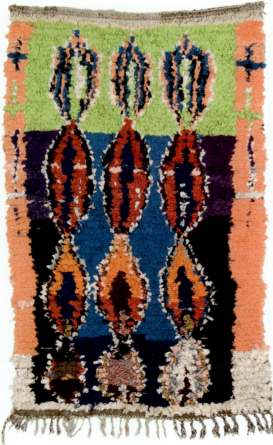

Since rug-making occurs within families and close-knit communities, and Berber women remain the gender preserving the core of their cultural identity, the methods and traditions are still being passed on through the generations, from woman to woman. The designs, with their distinctly female derivations, commonly relate to protection and survival, sexuality, fertility and procreation.

Although farming is the main occupation for many families, in addition to their household and child-rearing responsibilities, it is the women who do much of the heavy agricultural work, apart from ploughing. Traditionally, working on the rugs is done during "free" time, unless for some women their production has become professionalised, and they are then able to earn a wage from their craft, substantially contributing to the family income. Most families in every Berber village would have at least one female weaver in the house, and as well as being an essentially functional occupation, both in the domestic setting of their homes, and within professional workshops, the social exchange for women weavers is an intrinsic aspect of their culture. Executed with integrity, creativity, spontaneity and intuition, the making of the Boucherouite rug is, however, devoid of ego, exemplified further by the lack of ever displaying any evidence of its maker. In spite of this, the act and productions of weaving are still regarded as the measure of a woman's value, skill and proficiency.

Above left:
Close tones and shapes resembling Pointillist paintings.
Photograph © Gebhart Blazek, http/berber-arts.com.

Let:
Vivid colours and strong shapes displaying the freedom and originality of the weaver.
Photograph © Gebhart Blazek, http/berber-arts.com.

The rugs are woven on vertical looms, which have a comparatively narrower working width than those set up to create other styles of Moroccan rugs, which are, by contrast, often woven by several women simultaneously; whereas the Boucherouite rug might be woven by one, or sometimes two women together. Generally, the proportions of the rug tend to be long and thin, to fit the narrow rooms of Berber homes. The looms are set up in the private "female" part of the home, regarded as a woman's particular domain, and normally quite separate from the more public "male" part of the house. Although the recycled fabrics originally largely come from used clothes, with increased production and professionalisation, pre-cut fabrics are now widely available to buy in the souk.

It is commonly the case that even when rugs are just being made for domestic use, with no particular intention to sell them, families are visited by travelling dealers, who seek out some of the best makers and works in each village. Both rugs and any other household artefacts are the man's domain, and in these circumstances, it is he who determines both the sale and the price. Different types of semi-professional dealerships exist, and they are occasionally intermediaries between the weavers and the more established dealers in the cities. In such cases, regular orders are often made, offering fixed prices, which have been established in advance, but require final agreement from the women before production starts.

Right:
Vessel shapes echo traditional Berber pots.
Photograph © Gebhart Blazek, http/berber-arts.com.

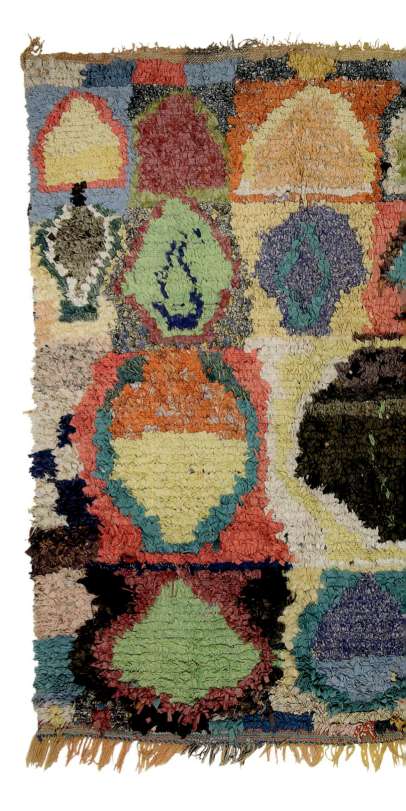

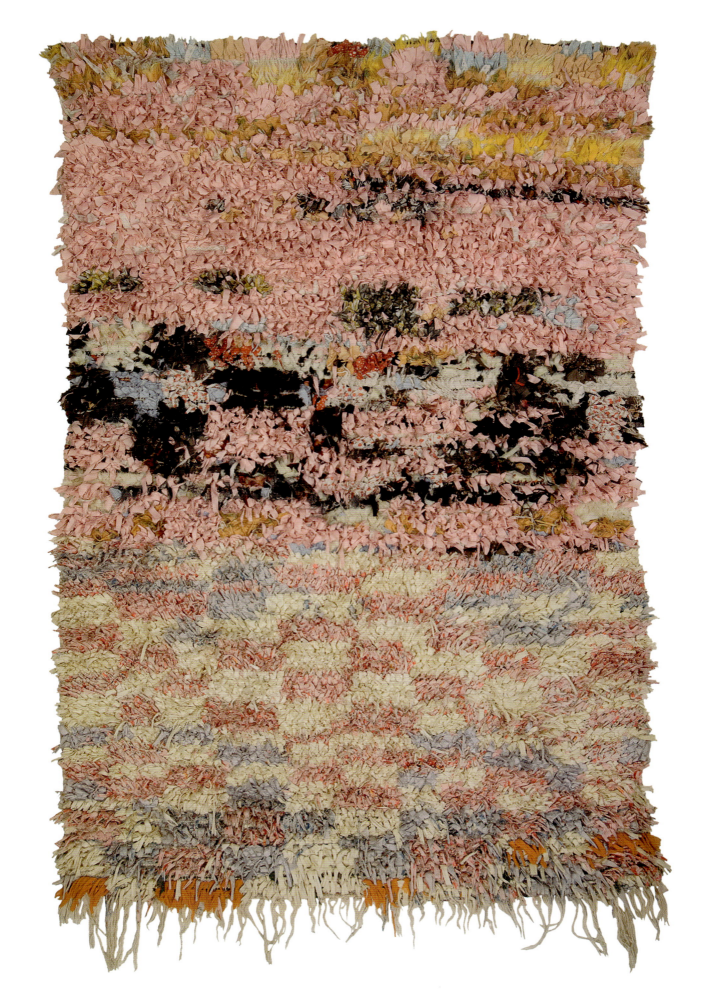

In other forms of production, male workshop owners also purchase all the looms and equipment, and wash the materials. The women do their weaving there, rather than in their own homes, and are paid in accordance with the amount of work they produce. Rather than the hours spent, production is costed out by the square metre or the number of knots.

Increased popularity and professionalisation has the potential to attract more women to the craft as a viable occupation, strengthening the tradition of passing on their skills to younger generations. Occasionally there are also women's co-operatives, where responsibility is taken for their own marketing and price-setting. Often selling directly to the souks, they are able to increase their own share of the profits.

Perhaps being made by people of geographically remote societies has given the weavers, and consequently the rugs, a creative freedom and individuality, which sets them apart from the rugs made by any other culture. This in turn has led to a rise in a very particular folk artistic practice. Interest in Moroccan tribal rugs, and indeed many aspects of the country's style and culture, began to grow in the mid 1990s, increasingly being written about and photographed for the pages of interior magazines such as *Elle Decoration*, *Wallpaper* and *Architectural Digest*.

Left:
Some rugs are executed using a more restricted palette.
Photograph © Gebhart Blazek, http/berber-arts.com.

Right:
Rugs are often long and narrow to fit the proportions of Berber homes.
Photograph © Gebhart Blazek, http/berber-arts.com.

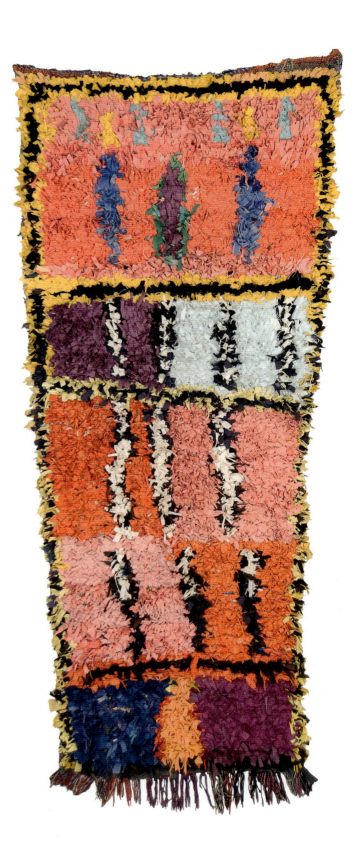

Capturing the attention of scholars of textile culture and the wider art world, as well as the imagination of architects, interior designers, homeowners and lovers of boho chic worldwide, they began to be collected and studied, and admired inside the "hippest" homes. Since this time, and helped by the fashion for stone, slate and wooden floors, the demand for genuine Berber rugs has soared, creating a substantial market, and consequently the need for a prolific output of work.

Having been actively involved in this field, and a significant contributor in publications and at conferences since 1996, Gebhart Blazek, a leading authority, independent researcher, and dealer in Moroccan textiles collaborated on an exhibition of Boucherouite rugs, together with Cavin-Morris Gallery in New York. The substantial attention and rave reviews that followed from the *New York Times* and the US press certainly further contributed to the rise in popularity of the rugs, particularly in the USA. Additionally, digital media and its dissemination of images and details has undoubtedly raised public awareness, and increased their marketability.

Unlike other carpet-producing countries, it is likely that the production of these hand-woven recycled rugs will continue out of necessity for their own domestic use, because the raw materials are easily available and relatively inexpensive, and not least of all because they provide a constant means of self-expression. Rather than diminishing women's roles, they serve to illustrate their superiority and capacity for documenting their culture. Because of their unique, eccentric, painterly qualities, no two rugs ever having the same appearance, it is likely that the appeal for them will persist within the global market. Perhaps women will increasingly regard them as a valuable and viable way of earning extra income.

WOOL POTS

Traditionally used as containers for bread or sugar, these decorative pots, often seen in the souks of Marrakesh, are made completely by hand by women in many parts of Morocco. Using traditional Berber methods, the straw or reeds as the foundation core are coiled to create their shape, before being wrapped and woven in industrial wool yarns, to create the one-off designs.

In the early part of the twentieth century, natural dyes would probably have been used for the yarns. The pots dating from the 1960s and 70s also included plastic strips from transport bags, becoming increasingly graphic, bold and bright. Totally unique, aesthetically they are the perfect pairing for the Boucherouite rug, and for stylishly storing objects within the home, and consequently have great current appeal, particularly for the tourist market.

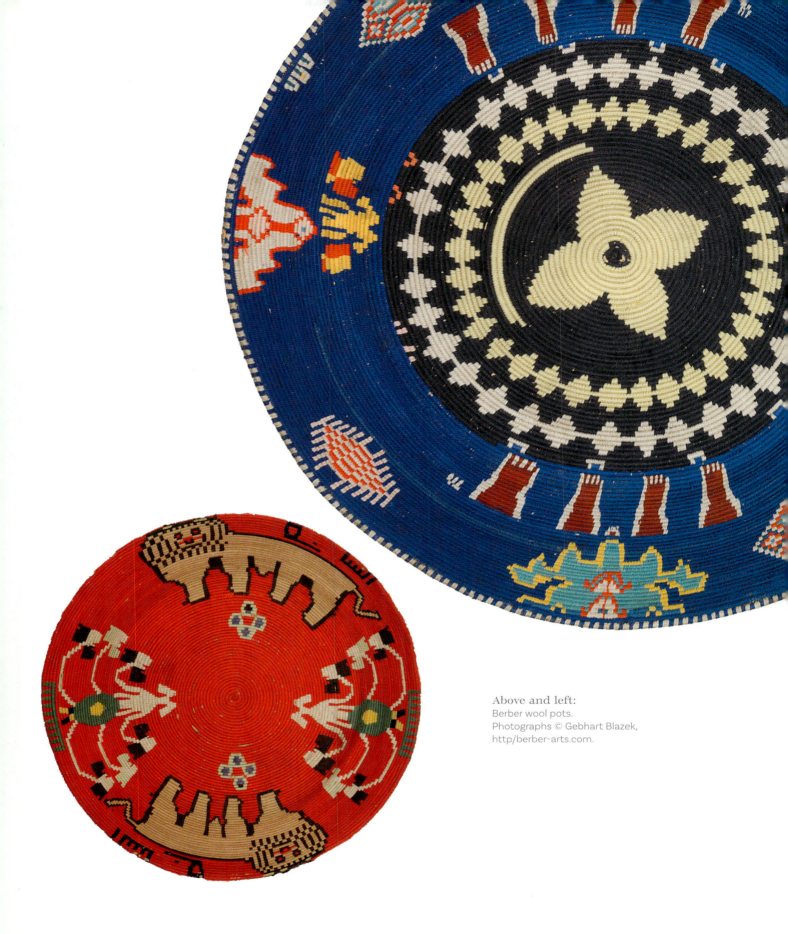

Above and left:
Berber wool pots.
Photographs © Gebhart Blazek,
http/berber-arts.com.

KAROSS

After initially spending the first few years experimenting with different media, and exploring their creative and commercial feasibility, Kaross was founded in 1989 by Irma van Rooyen, an artist with a BA Degree in Fine Art from the University of Pretoria. She and her husband relocated from Johannesburg to become citrus farmers, close to Letsitele, in the Mopani District of the Limpopo Province, in northeastern South Africa. Having increasing concern about the seasonal nature of farm work, and the incredible poverty and limitations of alternative sources of employment for the local population, she decided to start a business. This began in recognition of the need to uplift and empower women in mainly rural parts of South Africa, and help them to recognise, through their heritage and traditions, their own potential for sustaining themselves and earning a living, by means of their capacity for self-expression and creativity. Today, 30 years later, Kaross constitutes one of South Africa's major export industries to many other parts of the world.

The name Kaross originates from the Khoisan word for "blanket", a metaphor for a happy gathering of those enjoying together the traditional craft of embroidering and handiwork. The initial signature designs were created by Irma herself, and the business began with five Shangaan ladies coming to stitch them at Irma's home. In 1998 a new studio was built as the business grew and the number of workers increased; and in 2001 they moved to a tobacco shed on the neighbouring farm acquired by the van Rooyens. The quality of the embroidery, and the unique and colourful appearance of the designs has meant rapid business growth, and in 2003 a retail outlet was opened. Today Kaross employs 26 permanent studio staff, three artists, all of whom are men, and 1,300 mainly female embroiderers. The work mainly takes place in the embroiderers' homes in Letsitele, Risaba, and MaMitwa.

Embroiderers are given enough work to keep them busy for around six weeks, dependent upon each individual's home commitments and circumstances. Many work on a part-time basis, particularly if they also have seasonal work on the farm or elsewhere, or supplement any income by selling fruit and vegetables, or through their roles as healers or herbalists within the community. Embroidering full-time on such detailed work is extremely taxing on the eyes and hands. It is feasible to complete a cushion cover square in two days, but very unlikely that any of the embroiderers would manage to sustain this pace for very long. If the embroidery is of an excellent standard, the maker is usually then given the larger designed cloths to work on.

When work is completed, it is normally brought into the studio on a Monday or Wednesday for inspection and subsequent payment. Transport is expensive, and distances can be considerable, and the embroiderers' journey to and from Kaross is sometimes made by bus, taxi, or if available, in someone's "bakkie", the local term

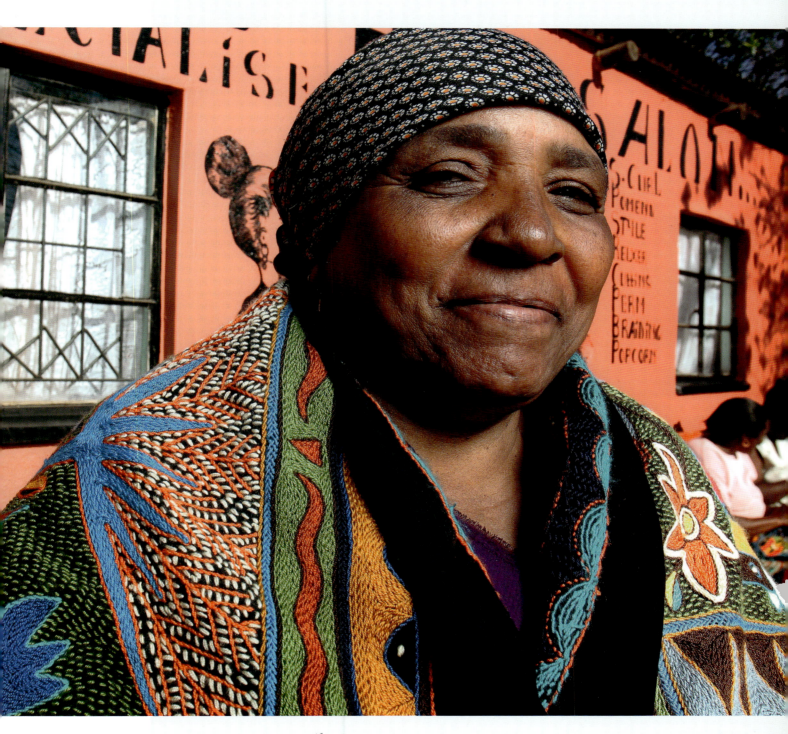

Above:
Kaross embroiderer wearing one of her own creations.
Photograph © karosswerkers (pty) Ltd

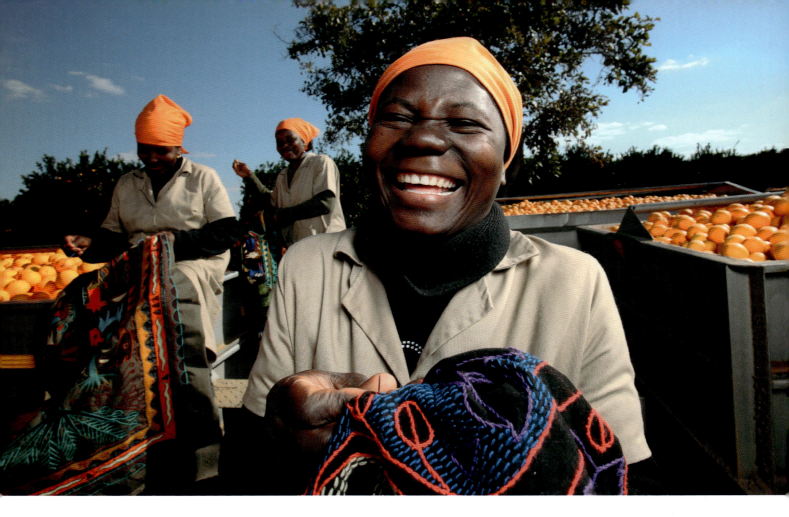

for a pick-up truck. Arriving with colourful embroideries overflowing from their bags, the individual pieces are then often hung to be viewed on a long washing line, suspended by tall trees outside the studio. Payment is made by square unit of embroidery, and there is a real incentive for quality perfection and punctual delivery of the work. The products are sold from the Kaross Studio to retail outlets around the world, and also online. Although the women cannot earn a great deal from the work, it certainly does keep poverty at bay, and is very often able to help with the cost of such family staples as creche facilities, school clothes and books.

Designs continue to be developed by Irma in Kaross's Studio, and are then applied to standard-sized cloths, which are collected together with the appropriate yarns by the embroiderers. Influenced and inspired by the surrounding environment, and a modern expression of the VaTsonga culture, the designs embody stories that are retold in the hands of women, in every stitch and in every pattern. The three male artists draw the designs and patterns onto the cotton fabric with pencil, frequently claiming this to be both a joyful and spiritual act. The embroiderers collect the cloths, and determine the designs' individual interpretations and their own choice of colours. Many Shangaan women love to work with their hands, and derive great pleasure from both seeing and showing the results. In many cases, family members and close neighbours get together informally at certain homes which seem to have become the "get together" places to create. They offer help and advice to each other on their work, chattering whilst they sit, perpetuating the meaning and spirit of Kaross. The finished pieces are washed, dried, and then ironed, and finally sewn to achieve their final form as cushion covers, wall hangings, tablecloths and runners, placemats and bags.

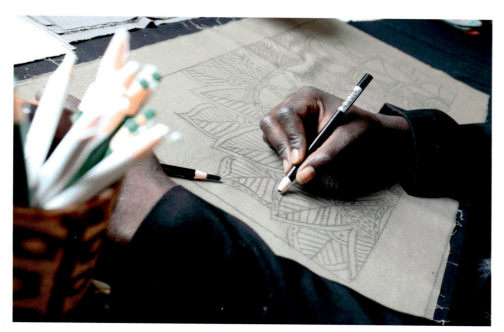

Opposite:
Kaross workers stitching at Irma's citrus farm.
Photograph © karosswerkers (pty) Ltd.

Left:
Drawing the design onto fabric.
Photograph © karosswerkers (pty) Ltd.

Below:
Work in progress.
Photograph © karosswerkers (pty) Ltd.

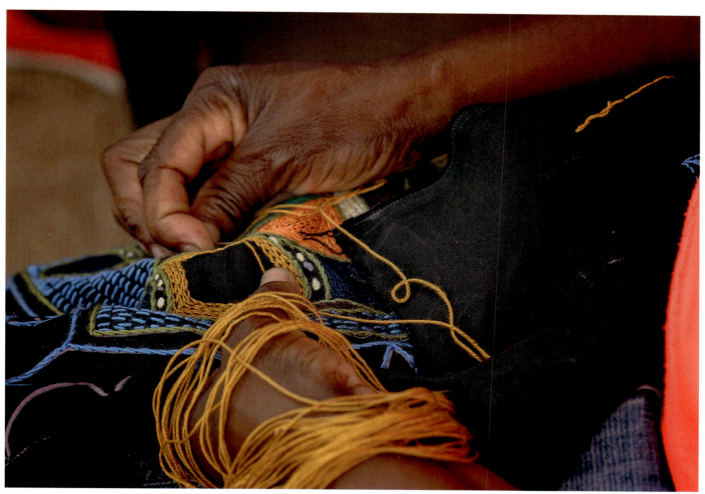

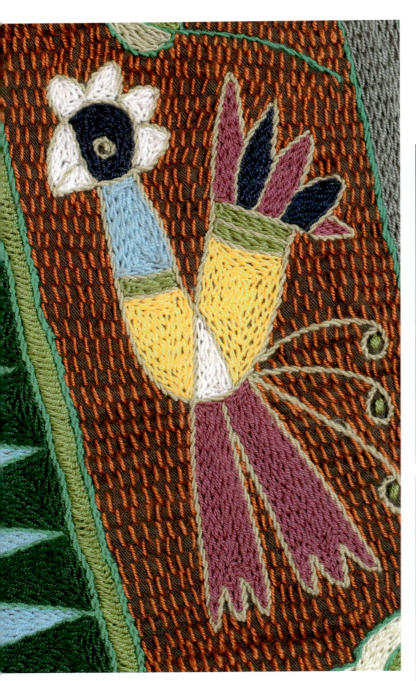

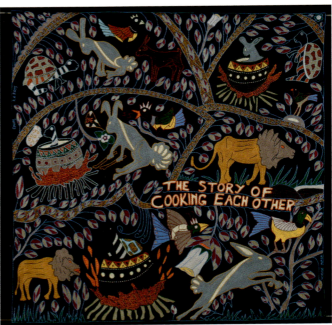

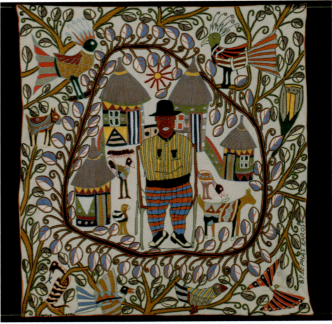

The Kaross designs, which have been developed over the 30 years of being in business, initially rely upon their beautifully stylised drawings of indigenous animal and plant forms, which are rearranged and reconfigured to create new cloths. The contrasting textures provided by hand-embroidered hem stitch, and chain stitch, resembling tambour work, and the clever colour combinations, help to create a unique collection. The range of embroideries is increasing to include one-of-a-kind artworks, which will only be sold through exhibitions. Design inspiration also draws heavily upon the immediate environs; the villages, people, fashion and fabrics, as well as themes connected with the natural and supernatural world, mythology, folklore, fables and legends. The abundant naturistic and animal images are very often illustrative of commonly used Shangaan proverbs, rich with metaphor for the human condition, such as, "a lion roars in the bush" and "an elephant does not die of one broken rib". The tree image is central to Kaross's work, and indeed its artisans' lives, providing fuel, shelter, a material for shaping simple furniture, bowls, spoons, and other utensils, as well as its roots being used to concoct healing medicines. It serves as a symbol for life, prosperity and community.

The designs have a very orderly appearance, with geometric borders and patterns, which are part of the Kaross signature, and scalloped shapes reflecting the painted decoration to be seen occasionally on the exterior walls of their homes. In some designs, the chain-stitched outlines leave the colour of the neighbouring area of background cloth exposed as part of the design, always balancing one bold shape against another, whereas other shapes are densely filled with stitches. In some of the larger, more sophisticated narrative works, the designs display a greater variety and complexity of stitches, providing increased textural contrast. Yarn shades are reflective of both the surrounding nature, and the colours of the Shangaan women's clothing, offering both vibrant intensity, and more subtle earthy tones within Kaross's large palette range. The colour combinations chosen for the embroideries are also very much determined by market trends.

The Tsonga people originally lived in Central Africa hundreds of years ago, before migrating south towards the coastal plains of Mozambique. Political and economic events in the 1800s caused substantial migration to the area between Drakensberg and Kruger National Park. The Tsonga now inhabit the areas of Mpumalanga, Kwa-Zulu Natal, and Gauteng provinces. Embroidery is a traditional skill amongst Tsonga and Sotho people. It has long been part of their culture to embroider motifs upon their traditional garments for their own personal wear and pleasure, although many of these traditional skills have been hidden for many many years. Families, friends and neighbours introduce each other to Kaross. As self-taught embroiderers, and people who have very often not completed their school education, Kaross seems to play a significant

maternal role in their lives, providing a vehicle for self-expression, reinforcing life skills, and inspiring the degree of patience, perseverance and skill necessary to achieve the standard required.

The women take pride in the many different roles that they are able to fulfil. Particularly for those who have unfortunately become widowed or divorced, or whose husbands are ill or have no work, by passing on the embroidery techniques to sisters, daughters, aunts and mothers, they feel that they are leading by example, teaching self-reliance, and an alternative to unemployment. However, undoubtedly opportunities for earning a significant income through embroidery are negligible, and in recognition of this, the Kaross Foundation is focusing on both the development of education in the area, and that of its employees. With financial help and general involvement in the area's schools and their education system, more young people are matriculating, and tertiary education is encouraged. HIV/AIDS is a significant health issue within the population, and it is a common occurrence for those affected to be in denial, resulting in the obvious impacts on family life. Early recognition and diagnosis is key, in order for sufferers to receive retroviral medicine and good nutrition.

The Sotho-speaking people involved in Kaross are based in the northeastern side of the country in North Sotho, and historically are pastoralists, involved in farming cattle. In some cases, subsistence, cattle and small-scale farming is still practised. Sometimes, in addition to embroidery, a woman's obligations on the farm are considerable, and can often involve the slaughtering of cows and the processing of meat. It is not uncommon for a woman to be only one of a man's several wives, whilst bearing him in excess of six children. A common issue within the region can be an insufficient or non-existent water supply, which creates obvious problems for health and hygiene, but can also make cooking, including the common practice of using the indigenous local marula fruit to brew beer, more fraught with difficulties. Dwelling places usually have verandahs, which provide good communal sitting areas for small groups to stitch together. Shangaan women take pride in their appearance and are also house-proud. When they rise in the mornings, their homes are thoroughly cleaned, before embarking on their Kaross embroidery work for the following five hours, until it is time for lunch. After a break in the early afternoon, they resume their work, which will usually occupy them for a further several hours.

Women often carry out all their tasks with a baby strapped to their back, by means of a sling of brightly coloured material, competing in vibrancy with the brightly coloured patterns within their embroidery. Image is important, from the time and effort put into the traditional hair treatments of braiding and relaxing, to the patterned headscarves, multi-layered rows of

Right:
With her baby attached to her by a sling, the mother is able to continue her embroidery work.
Photograph © karosswerkers (pty) Ltd.

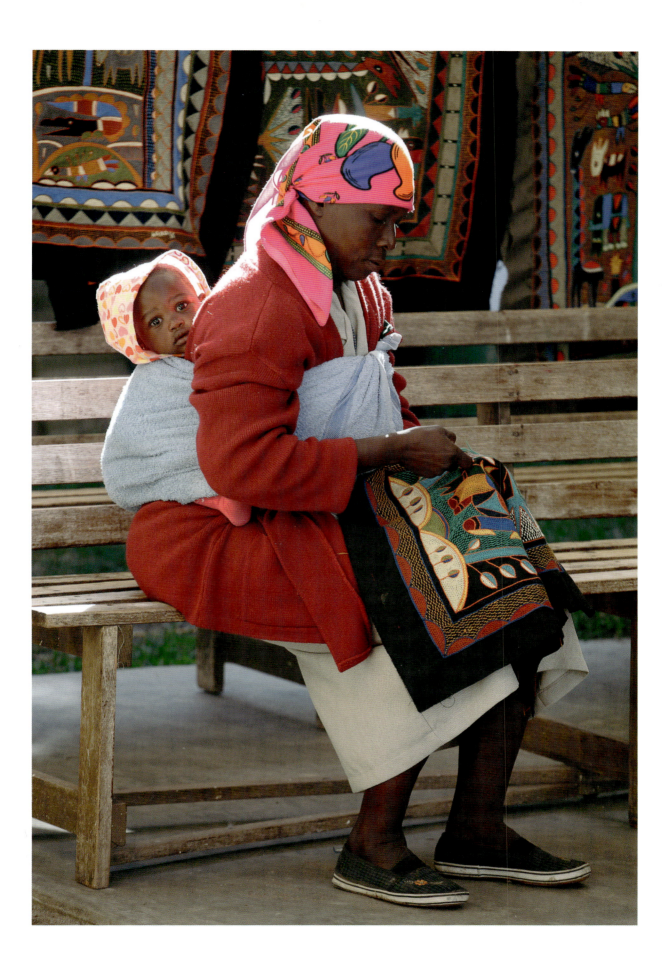

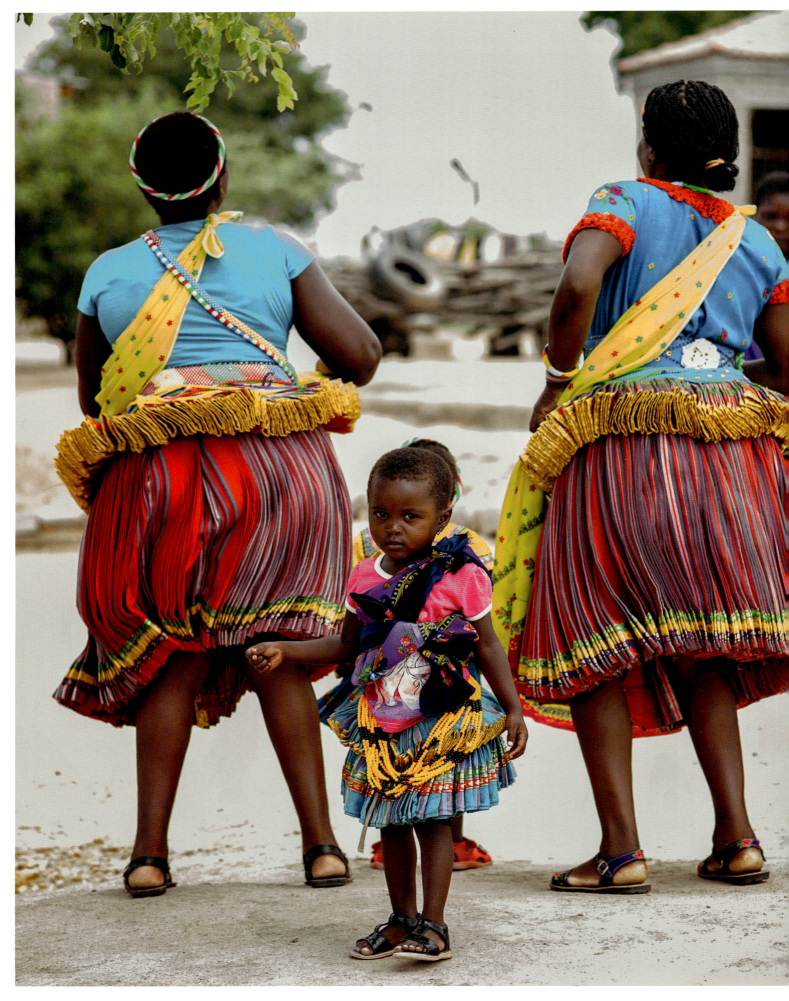

beaded bracelets and necklaces, and other items of clothing worn in their daily dress. Dance and music are an intrinsic part of their culture, and the women's skirts are constructed to emphasise the movement of their hips whilst dancing. A skirt consists of 18 metres of fabric which is stitched into pleats, and has an additional voluminous peplum just below the waist. The word for the skirt, "Xibelani", is identical to the word for dance. Bodices or "minceka" are knotted at each shoulder.

Kaross has participated in numerous shows and initiatives, which in 1990 included the Paper Prayers project, an AIDS awareness campaign, and in 2009 in the Quilts for Obama exhibition. Continually endorsed and recognised by the Craft Council of South Africa, its work has regularly been included in exhibitions which have been curated by them. In 1999 they received the Proudly South African Craft Award. They have actively engaged in including their embroideries as a collective voice, in socially and politically themed shows such as World Court of Women Against War for Peace.

Kaross's retail and online success, and its popularity both locally in South Africa, as well as in parts of the US and Europe, has resulted in commissions to create bespoke embroidered artworks. In 2003 work was completed for the Arabella Sheraton Grand Hotel in Cape Town, and in 2006, for the Oprah Winfrey Leadership Academy. In celebration of the Centenary of the University of Pretoria in 2008, a large and complex embroidery was commissioned involving 16 people in its creation. The work of Maria Mhlongo, one of Kaross's most talented embroiderers, was represented at the Sanlam Portrait Awards in 2017; and the following year, Kaross was the recipient of the prestigious South African National Craft Award.

Kaross's journey has been one of immense creativity and collaboration. In the women's words, in their local language of "Xitsonga", being part of Kaross's success story is "Ubuntu", a word which expresses the idea of oneness and community, and the essential virtues of humanity and compassion.

"It means great things in my life, the food, soap, everything I use is from Kaross."
AGNES TIRHELA MABUNDA

Left:
The voluminous pleated skirts emphasise the movement of their hips whilst dancing.
Photograph © karosswerkers (pty) Ltd.

KENYAN SISAL BASKET WEAVING

Basket weaving is an art form that is as old as mankind. In parts of Kenya, whilst maintaining its history, methods, materials, and traditions, these skills are able to facilitate modern flexibility of employment. It is a durable and easily transportable craft, that can be done whilst riding on a bus, or walking to neighbours, and can be taken almost anywhere. Although the techniques, as much as the patterns and forms, differ across regions, the commonalities owe much to cultural absorption of the making processes and aesthetics, rather than formal teaching and spoken language.

Particular types of sisal basket construction are native to Kenya, and were traditionally made by mothers as wedding gifts for their daughters, and for storing staple foods. Their essentially circular form, an important shape in African culture, is symbolic of wholeness and continuity. They are hand-woven by women's groups and co-operatives of the Bantu ethnic heritage, one of the largest tribes in Kenya, which includes the Taita and Kamba groups in Tsavo, the villages and rural farmlands of Meru, and the small rural villages of Machakos county, 70 km from Nairobi. The language and culture of all ethnic groups within the Bantu people are closely related.

The knowledge of basket making has been passed down from grandmothers to granddaughters from generation to generation, and is ingrained with the comprehensive teachings and philosophies of the culture. The craft is an expression and reflection of interconnectedness, reciprocity, and co-existence. The baskets are traditionally crafted with great dedication, using the thinnest and finest quality of sisal, and employing labour-intensive processes. They are woven by joining several strands of sisal and thread, and beginning the construction of the vessel from its core or base outwards. This very process, in its fundamental, back-to-basics approach, echoes a significant element of the culture. Hand-twisting the fibres, the most compact weaving techniques employing interdependent threads, and natural plant dyeing, all create a soft and pliable structure, with great resistance to colour fading.

Most of the artisan women in rural Kenya work the land which is given to them when they marry. They predominantly earn their livings as subsistence farmers, and carry the responsibility for supplying the family's food. Although baskets are woven throughout the year, the dry season is the optimum time for doing so, as widespread drought can be hugely detrimental to crops, and basket weaving has the potential to provide a valuable and creative alternative income. During the rainy season the women are able to grow cabbages, collards, bananas, mangoes, oranges, and other tropical fruit. In the villages of Machakos, they often work 12 hours per day at their market stalls, selling their produce and weaving baskets whilst waiting for customers. Dependent upon their individual expertise, one basket can take up to two weeks to make. Although the artisans mainly weave within their individual domestic

Right:
Labour intensive processes,
such as plant dyeing, are employed.
Photograph courtesy of Lore Defrancq.

Below:
Several strands of sisal and thread are joined.
Photograph courtesy of Lore Defrancq.

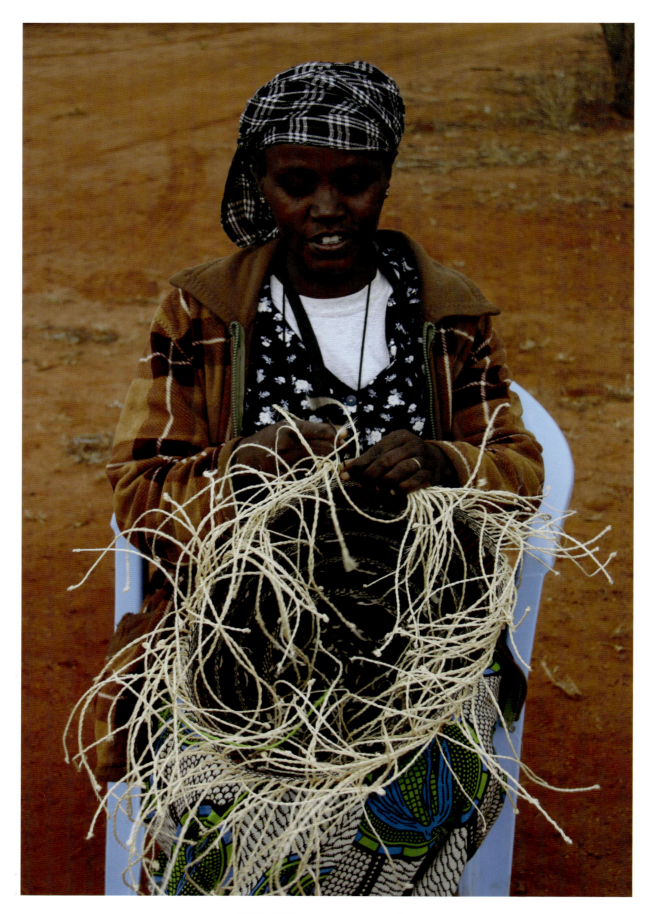

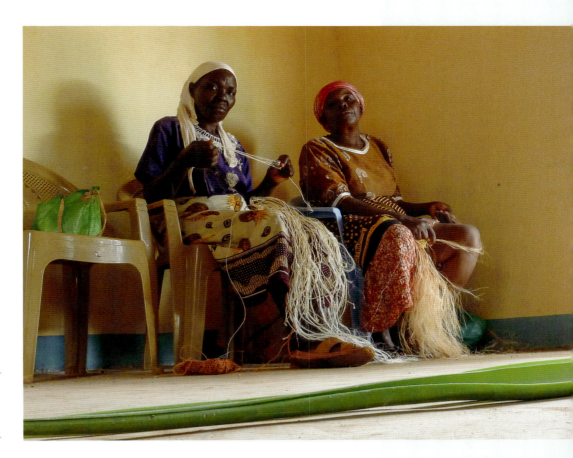

Opposite:
A skill passed down from grandmothers to granddaughters. Photograph courtesy of Lore Defrancq.

Right:
Artisans frequently work together in communal meeting places. Photograph courtesy of Lore Defrancq.

environments, they also frequently work together in communal meeting places, enjoying the opportunities for socialising, mentoring, and discussion. When the weather is very hot and dry, they move their tools outdoors, seeking shade under the largest trees.

Farmers throughout Kenya grow and harvest the sisal, and supplies of the fibre can be easily sourced at every market; although it obviously keeps the cost down to be able to grow one's own. South East Kenya's climate is particularly arid, with its frequent droughts continually presenting challenging conditions. However sisal, from the agave plant, although slow-growing, fares well in hostile conditions such as these, provided that it

survives being eaten by elephants before harvesting! As well as strong hands, the mouth and upper leg are also involved in decorticating and converting the fibre into a thread for weaving. Once the weaving begins a knife and scissors are needed, as well as a knitting needle for additional wool or thread wefts. Dependent upon local availability and sustainability, and the particular product being made, locally harvested sisal is sometimes combined with other materials like banana leaf fibre, doum palm, palm leaf, wool thread, and more recently recycled plastic and unravelled yarns from second-hand sweaters. Natural dyes come from pounded roots, tree bark, soil, and vegetables of the region, whilst all synthetic dyes are locally purchased.

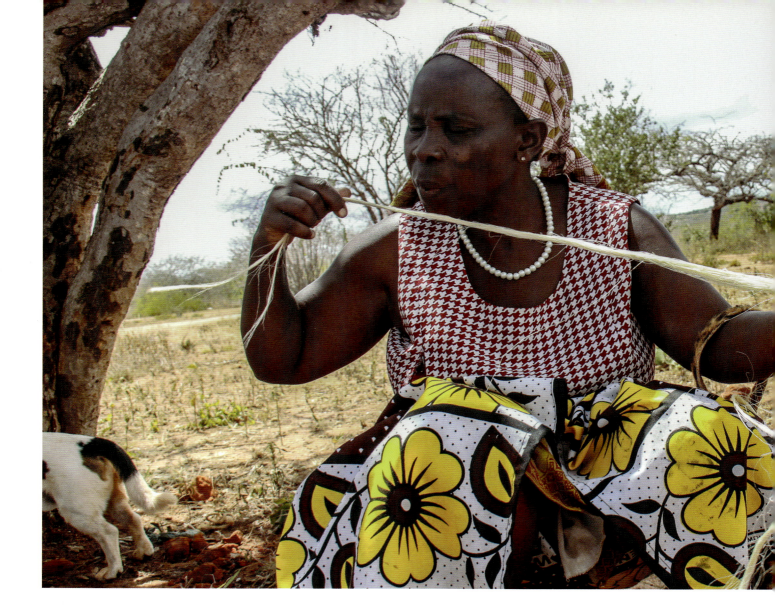

Many of the women involved in basket weaving are widows, in polygamous marriages, or those who discover that their husbands are lazy or continually unsuccessful in speculative pastimes like gemstone mining, particularly ruby and tsavorite. Most people of the region adhere to the Christian faith, and God plays an important role in their everyday lives. Even on their cell phones, multiple blessings are generously and frequently exchanged! One of the staple foods is ugali, or cornmeal, which is both cheap and filling, and is commonly added to goat, chicken, beef or bushmeat, to thicken stews and casseroles. It is also fed to babies, having been mixed with boiling water to form a grainy paste. Food is well seasoned with garlic, cumin, coriander, ginger, and masala spices. Potatoes and rice are the usual source of carbohydrate, though Indian-influenced samosas, chapatis, grilled maize, and "mandazi", or sweet fried doughnuts, are all street foods that can be easily bought along the roadsides. Chai tea is served with goat's milk, and sweetened with plenty of sugar.

Left:
The thinnest and finest quality of sisal is used.
Photograph courtesy of Lore Defrancq.

Above:
The mouth and upper leg are involved in decorticating the fibre.
Photograph courtesy of Lore Defrancq.

Hadithi Crafts is a social enterprise working with over 1,000 female weavers in South East Kenya, in the area between Tsavo East and Tsavo West National Parks. The weavers are organised into formal "self-help" groups, each consisting of between 15 to 50 members. Every woman makes her own product from start to finish, except for leather straps, labels, tags or trims, all of which are goatskin, and sourced as a by-product of the food industry. These are added by local leather craftsmen.

Each group of weavers is visited every two months, and the baskets are purchased from them, then and there. Hadithi provides ongoing support by offering business and training skills, product improvement mentoring, and by organising joint sales and marketing initiatives, so that the craft may evolve and flourish alongside modern market developments. So that the weavers are able to work at any time they choose, equipment such as sisal and dyes is consistently made available to them. The baskets are sold in four continents, including Europe,

which represents its biggest market, North America, South America, Africa and Australia, and 12 different countries across the world, with a view to even further expansion. All of the profits, as well as any donations made to Hadithi's umbrella group, are used for supporting these women's groups. This provides families who live in a vulnerable ecosystem with an alternative income that is regular, ecologically sustainable, legal, and safe, in a region where many may otherwise turn to poaching, petty crime or acts potentially damaging to their environment, in order to make ends meet. It affords them better nutrition, healthcare, education, and aspirations for the future for their families.

Dadaduka was founded by Chloe Bartron, and works with weaving groups in Machakos and Meru. There are currently 50 ladies weaving in these two places, and each has a head weaver; Juliet in Machakos, and Lydia in Meru. Chloe collaborates with and is supplied by Lore of Hadithi Crafts, who, with her successful basket-weaving enterprise, even after her husband's death, has been determined to keep supporting the environment and community.

Preparing for each subsequent collection, it is Chloe's role in Dadaduka to oversee the design element, patterns and colourways of the wool thread baskets, which are made mainly by the older ladies within the groups. Traditional designs and patterns have evolved, having become somewhat looser and less intricate than those initially bearing symbolic tribal marks, in the form of flowers, houses, words, and walking sticks. Dog baskets

"My husband died in 2004, by which time we had six children together. Their education took a hit when their father passed away, and some started dropping out of school as early as 2005, to get married. Three of my daughters were married, but all later divorced and returned home with their children. I was able to take responsibility for taking care of them, whilst their mothers went out to search for casual work every morning."
ELIPINA KINYALA, BUNGULE

Right:
Each basket bears its maker's name.
Photograph © Chloe Bartron.

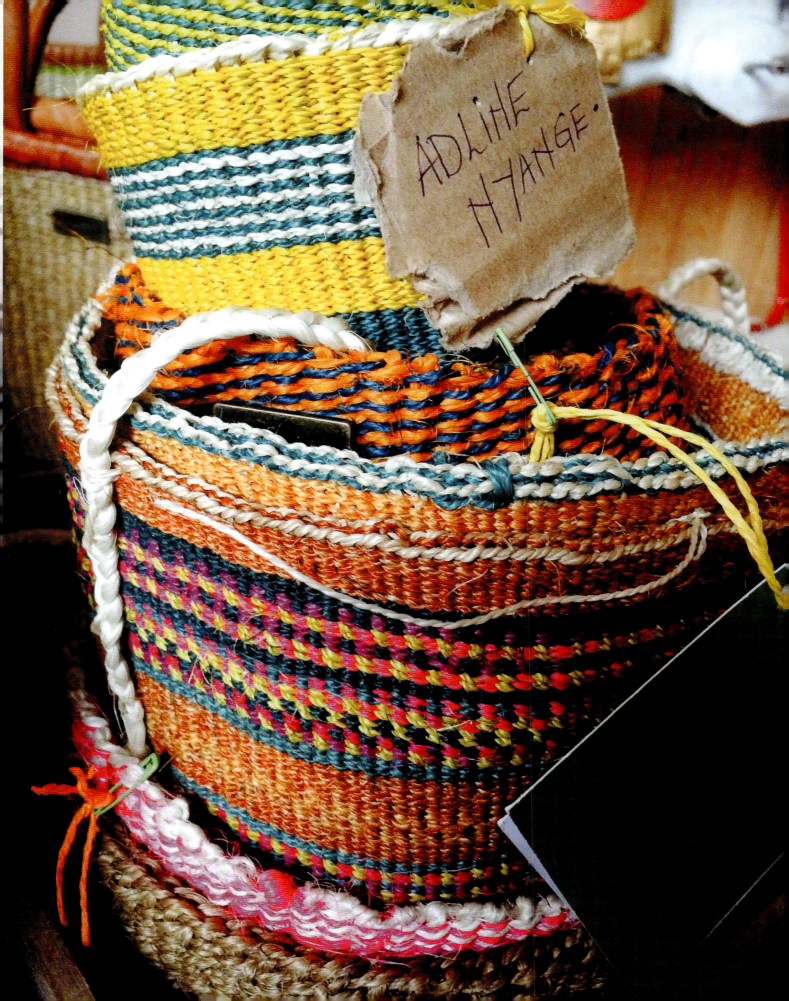

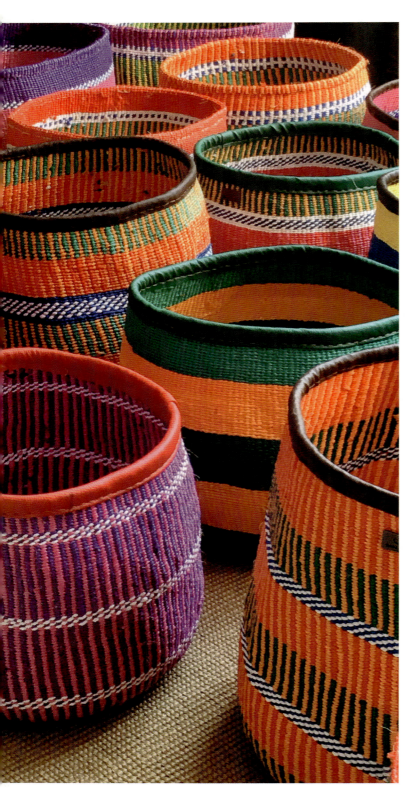

have also been introduced into the collection, and as well as sisal and wool, other fibres such as raffia, cotton, doum palm, and banana fibre are included in the making.

Although some of Dadaduka's weavers do grow their own sisal plants in their "shamba", or vegetable garden, not all have enough land, or even a garden to enable them to do so, in which case it is readily sourced from the market or from local sisal estates. Every part of the basket-making process involving cloth and fibres is done by the weavers, from achieving exactly the desired dye colours with traditional natural or synthetic pigments, to binding the rims of certain collection pieces with pretty, stitched, patterned cloth.

The use of cell phones and WhatsApp communications, and the ability to follow social media channels are all vitally important in running a social enterprise and generating trade. Payment is made to the head weavers via their cell phone wallets, known as "Mpesa", a Swahili term fusing the "M" in "mobile" with "pesa", the word for money. This is distributed amongst the other women in cash form, or transferred from cell phone to cell phone. Group saving and table banking, or mutual forms of money lending, are commonplace. There are shops and corrugated tin huts all over Kenya where the payment transaction can be made.

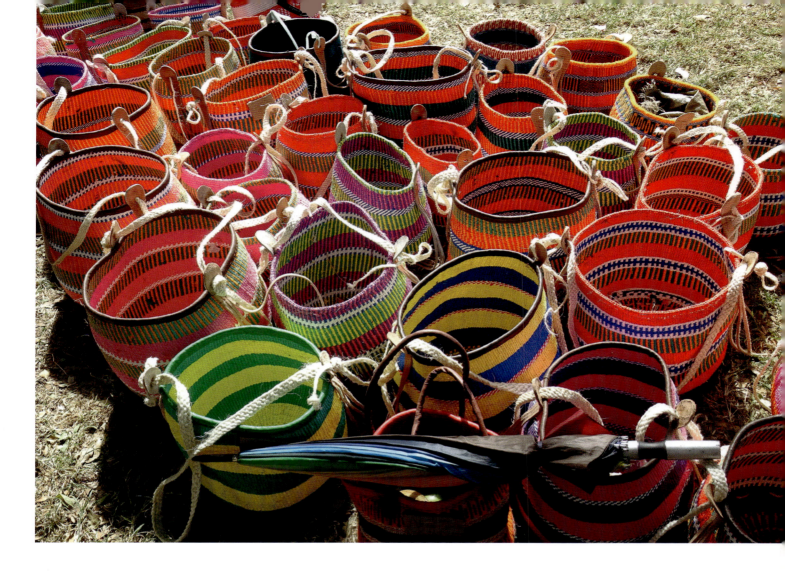

There is a wide age range amongst Dadaduka's weavers, and in Machakos Juliet reflects the thoughts of several others in claiming often that they feel themselves to be far more than a weaving group. They regard their group as people of the same gender with a creative passion, and the chance to share ideas, solve problems, and inter-generationally help each other to overcome life's challenges. From their point of view, basket-weaving and co-operative employment is giving them independence from their husbands, and offering a more gender-equal future for their children. It enables them to buy goats for milk, have bore holes drilled, acquire water tanks, and budget for family ceremonies. Whilst still passing on the traditional skills of the craft as well as their work ethic

and aspirations to their daughters and granddaughters, they are hoping to ensure that they too will ultimately be able to benefit from fair wages, and safe, dignified working conditions.

With environmental activism and sustainability becoming increasingly pressing issues, it is hardly surprising that both aesthetically and ecologically the organic nature and tactility of plant fibres, combined with simple patterns and satisfying hand-crafted shapes, find an easy place within our current lifestyles and interior spaces. They serve our needs well, for storage and decoration, and are a welcome replacement for the plastic carrier bag.

MADHUBANI PAPIER MACHÉ

Geographically, Bihar is the twelfth largest state in Northern India, and has the third largest population, of around 83,000, almost half being female and under the age of 25. In 2000, the southern part of Bihar was subdivided, becoming the state of Jharkhand. The Himalayas to the north of Bihar influence both its climate and culture, creating a huge difference between summer and winter temperatures. The River Ganges flows through the middle of the fertile Bihar plain, providing ample water resources and a diversity of agriculture. Edible cereal crops such as wheat, maize and gram are cultivated in addition to rice, sugar cane, and a range of vegetables, including potatoes, onions, cauliflower, and eggplant.

Carved and sculpted wood and stone work, textiles, sikki grass craft, and terracotta pottery are all highly practised traditional art and craft forms in the different regions of Bihar, as well as Madhubani painting, practised in both the Mithila region of Bihar and Nepal, and papier maché in Salempur village, in the Madhubani district of Bihar. Evolved from the mud creations fashioned for marriage ceremonies, papier maché is a particularly low cost, eco-friendly craft, requiring minimal tools and equipment and relatively straightforward methods.

The term "papier maché" is French, meaning "chewed paper", although in fact it dates back to the Han Dynasty in China (202BC-220AD), where paper itself was first invented. The technique, which through the centuries has been adopted and adapted throughout many parts of the world, involves using shredded and pulped paper mixed with a glue or adhesive to shape and mould a variety of both decorative and utilitarian items.

Unlike the smooth and highly varnished Kashmir papier maché often used to make boxes, bangles, trays, and letter racks, and embellished with neat and precisely painted narrative miniatures, Madhubani papier maché has its own unique and recognisable style, with its "kachni", or black ink lines outlining the "bhani", or bright and boldly painted shapes within. Its distinctive larger scale forms are inspired by Madhubani painting, a folk art practised by the women of this region since the 1800s, with its methods and motifs meticulously passed down from mother to child. Their roughly textured exterior surfaces are typically decorated with complex geometrical patterns, prominent facial features, and large eyes. Wall hangings, masks, vases, pots, trays, and bowls, created for a variety of uses and purposes, frequently depict local village characters and activities, ritual ceremonies, and religious festivals, in human, animal, floral, and mythological form, which include the fish, parrot, sun, moon, elephant, turtle, lotus, and bamboo tree, as common subject matter.

The making process involves a relatively lengthy sequence of soaking, mashing, mixing, shaping the form, drying, levelling, drying again, layering, and a final drying before the object is ready to be painted and finally coated with a matte varnish. Newspaper is soaked in a bucket of water for a minimum of 24 hours, and sometimes as long as one week. The following

Right:
The lengthy sequence of shredding and pulping the paper.
Photograph © Robbie Wolfson.

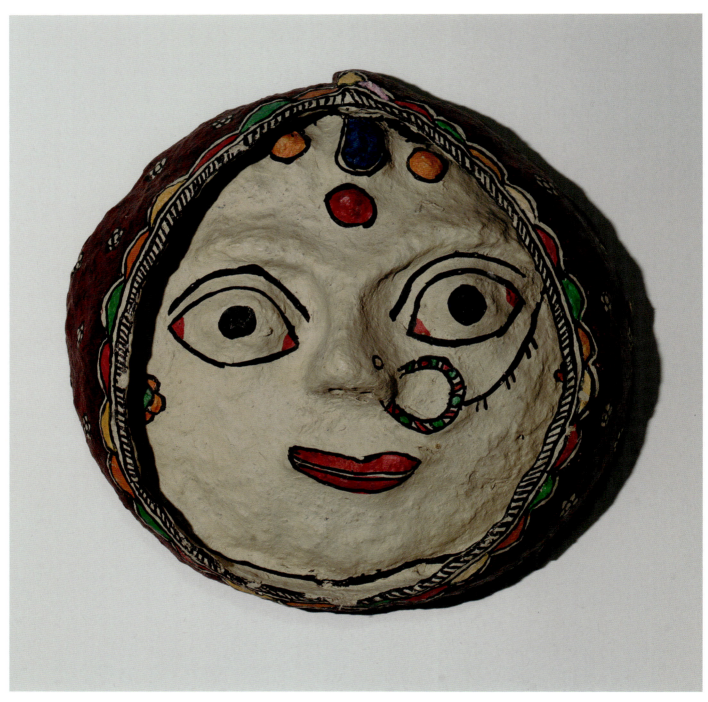

Above:
The charm of its distinctly hand-crafted appearance.
Photograph © Robbie Wolfson.

day the soaked paper is shredded by hand into small strips, beaten and mashed on a stone slab with a wooden mallet for at least five minutes, and mixed with equal quantities of "multani mitti" or Fuller's earth powder, which acts as a binding agent. A synthetic resin adhesive, the powdered ground bark of "methi", or fenugreek seed, is added to the mixture, for its fragrance, and as a deterrent to insects. The pulped mixture is laid onto a plastic sheet, and is ready to be used as a modelling medium. Eventually, the moulded object is placed in the sun for between two hours and four days, dependent upon the season and the temperature.

The object's form and structural qualities are of prime importance, and during the drying process any warping and shape distortion is checked at regular intervals. The form is then coated with a further layer of pulp to create a more even surface, and dried for a few days. Its surface is smoothed with sandpaper before painting begins using a very fine brush. Formerly, the artisans used bamboo paintbrushes and paints and pigments derived from nature; but these have since been replaced by more readily available brushes from the local market, and poster or fabric paints, which have more colour vibrancy. No two creations are completely alike, and no mould is employed in the process: each one is entirely designed and made by one artisan, giving it a uniquely hand-crafted appearance.

Salempur village's predominantly Hindu population originates from numerous communities, and the main occupation for women, in addition to papier maché, is agriculture, either farming one's own land, or in employment as labourers. Traditionally, young girls would observe their grandmothers making the customary decorative wedding items, created and displayed at the wedding ceremony to invoke fertility and marital prosperity. Similarly, mothers in this area have been teaching their daughters the special patterns and dye recipes which contribute to the ritualistic practice of the painted adornment of the walls and floors of their mud homes.

Towards the end of the twentieth century the government of Bihar, in conjunction with Upendra Maharathi Shilpa Anusandhan Kendra, a well-established institute for the region's arts and crafts, established in 1956, began to recognise the viability of a revival in the craft of papier maché. Its flexible employment potential for women, and their ability to pursue the craft within their own homes during pregnancy and combined with childcare were noted as obvious advantages. They decided to organise six monthly training programmes for local women.

"I earn money from stitching clothes on a sewing machine. If there are times when I don't get orders for stitching, getting training in papier maché and having a different skill will help me earn money for my family."
NIRMALA DEVI

The Institute meanwhile developed a process of using Plaster of Paris and domestically available stainless steel for the construction and use of moulds for the papier maché's shapes, resulting in a certain uniformity in the quality of each piece. Although to an extent losing the typical handcrafted quality, these methods would obviously facilitate an increase in production. Reliant upon exposure to the heat of the sun, once the papier maché is dry, it can easily be removed from the mould. Combined with hand-moulding, some of its personal and unique qualities can be preserved, and increasingly finessed forms and intricate decoration are possible.

NGO historic involvement has been problematic and counter-productive, and in addition to this, female artisans often receive minimal support from the male members of the family, both in terms of the craft's production, and in permitting their attendance at shows and craft fairs. The immediate domestic market had been somewhat limited, partly due to a tendency in inadequately trained and unskilled local people having an over-optimistic view of their ability to replicate the craft and to embark prematurely upon independent production, before being able to fully satisfy consumer expectations. However, with assistance in sales and

Right:
A very fine brush is used for painting the "kachni" or black ink lines.
Photograph © Robbie Wolfson.

Opposite:
The "bhani" or bold shapes are painted with poster or fabric paints for colour vibrancy.
Photograph © Robbie Wolfson.

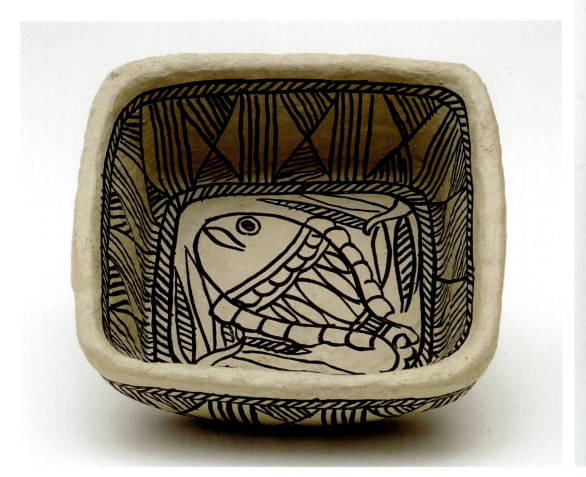

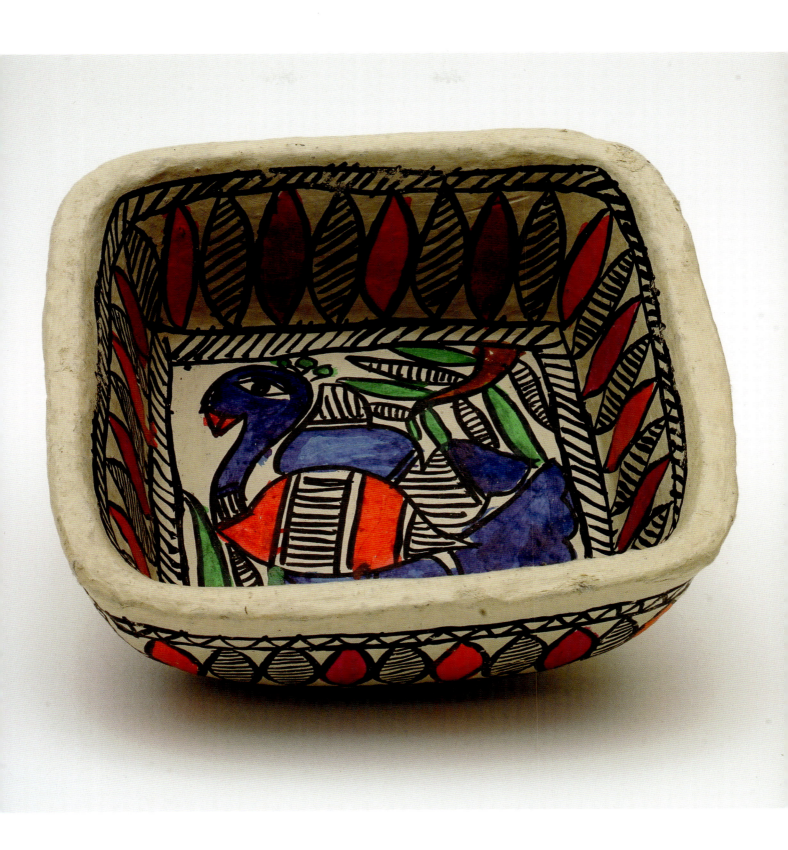

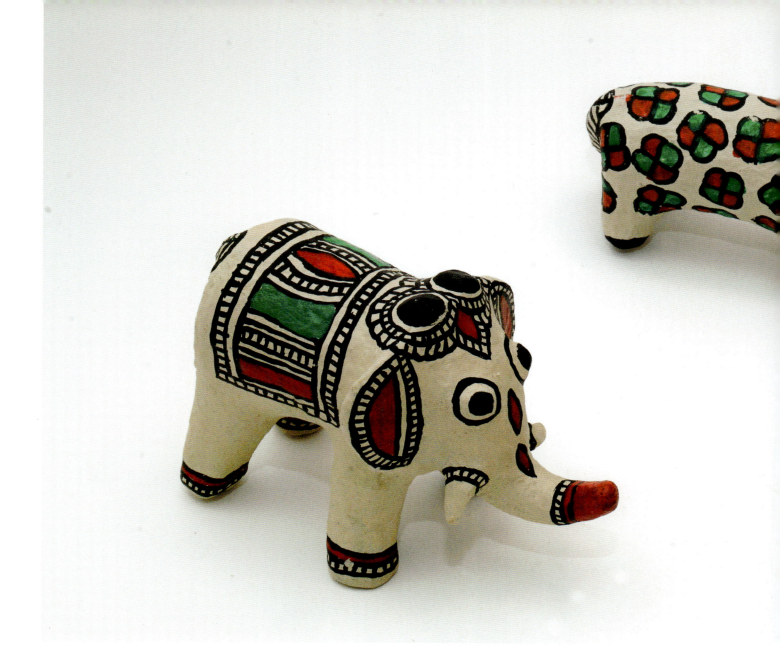

marketing from government agencies like DASTKAR and CCIC, Madhubani papier maché has achieved both national and international status, with design stores, museum shops, exporters and wholesalers becoming significant elements of the customer chain. Many institutions, including the National Institute of Design in Ahmedabad, together with Upendra Maharathi Shilpa Anusandhan Kendra, are continuing to provide practical training, as well as photographic documentation and assistance in marketing and exhibiting the craft.

The National Institute of Design's museum, which houses an impressive collection of the region's artefacts, regularly invites artisans specialised in Madhubani painting, bamboo work, pottery, and papier maché, to display their work, and also encourages them

for the women of Salempur, involving workshops and mentoring programmes taught by herself and Smt. Lalita Devi, another highly skilled artisan. In collaboration with the Commission and Upendra Shilpa Anusandhan Kendra Surabhi Khanna, design consultant, architect and teacher, was responsible for the implementation of the design intervention workshops and the formation of the Papier Maché Cluster in Salempur in 2013, which proved to be a valuable resource in facilitating a complete review of the future of Madhubani papier maché.

It was acknowledged that although the Madhubani style of papier maché was undoubtedly a rich heritage craft, it was visibly in decline, with relatively few skilled artisans still working in the craft. Fresh ideas, with a departure from the more traditional ceremonial and mythological themes, would be necessary in order to create an increased appeal for the contemporary market. With a continued emphasis upon individual creative expression, accessible methods of mass production were suggested, using both hand moulding techniques and the use of household objects such as metal bowls and plates for moulds. Another idea was the inclusion and amalgamation of other eco-friendly materials in the making of the artefacts. A specially devised institutional plan to attract and motivate the interest of the younger generation in the craft's development as a viable means of livelihood, and schemes for encouraging craftswomen to pass the skills onto their children were regarded as paramount issues for the craft's survival.

to exhibit on a national scale. Smt. Subharada Devi, a resident of Salempur, who had gained recognition as a highly skilled craftswoman, was encouraged by the Handicraft Development Commission to exploit the medium of papier maché in preference to clay, because of its durability, decorative qualities, and use of recycled materials. Receiving state and national awards, she was invited to run a training programme

With an unexpected degree of positive response, participant feedback within the Papier Maché Cluster included the desire in many to learn the craft, in order to generate an independent or additional family income, particularly for some during the non-farming season. Several women were keen to pass on their skills to daughters and other female members of the family, and for some already skilled in the art of Madhubani painting to be able to transfer their skills to another medium. Some women, clearly having been inspired, expressed the wish to emulate and follow the example of Subharada Devi. There was unilateral recognition of the benefits of women working as a group. The numbers attending, the level of motivation, and the quantity and quality of items produced during the workshops exceeded all expectations.

Solutions to ergonomic and logistical problems were also tackled during these sessions, such as the need to wear protective plastic gloves on hands so long immersed in water, and the importance of covering soaking containers when not in use, in order to prevent insect infestation. Feasible dimensions and proportions of new designs of papier maché articles were also discussed. As well as organising regular collaborative concept design workshops, the necessity of forming a local association of papier maché artisans, and creating a common facility for craftswomen to meet and work together, was acknowledged. Brand development, standardised methods of billing and payment, internet knowledge, social networking, and maximised use of selling portals such as iTokri, Lokatma, and YouTube, for the marketing of new products and possible showcases to invite potential new artisans, were regarded as being vitally important.

As changes in design evolve, artisans are concentrating heavily on meeting consumer tastes, and an increasing demand for utilitarian and gift articles, lightweight furniture, jewellery, children's products, and educational toys. In practical terms, papier maché products are completely recyclable, and, conveniently, its artisans are easily able to store completed work safely, without risk of damage, in a dry place inside their homes. Maintaining an essentially eco-friendly quality in every aspect of its production and marketing, packaging of the craft is also important. Plastic bags and bubble wrap are replaced with paper and cloth wrappings, and since many of the artisans are able needlewomen, there is scope for attractive packaging to be further developed. Locally, Bihar emporiums are proving to be useful platforms for the sale of the work, since it is an area visited by tourists from all over the world. Local rickshaws, buses and "tempo" trucks are the usual modes of transport when delivering the work further afield.

Right:
Utilitarian items and gifts such as pencil pots are made. Photograph © Robbie Wolfson.

MONKEYBIZ

During the nineteenth and twentieth centuries, huge quantities of glass beads were imported into Africa from Europe by Arab and Portuguese traders. Beadwork has, since this time, been a traditional craft practised by indigenous South African women. The skills have been passed on from mother to child, and serve decorative, ritualistic, ceremonial and functional purposes, as well as being imbued with spiritual powers. Initially, beads were prohibitively expensive, but following gradual European settlement around the Cape area, they became more widely available, resulting in the craft's rapid development.

Monkeybiz South Africa was founded in 2000 by Shirley Fintz and Barbara Jackson, both ceramicists and art collectors, together with Mathapelo Ngaka, whose mother Makatiso, a skilled bead artist, was by request responsible for creating the first beaded prototype, in the form of a doll, in 1999. A seed was sown, and the idea of Monkeybiz was born.

Monkeybiz is a non-profit, income-generating project, with its prime mission being to develop and assist women living in underprivileged and under-resourced rural communities in South Africa. Focusing on their economic empowerment, its aim is to inspire them with the power to take control of their own lives. All of the profits from the sales of artworks are reinvested back into community services, constituting a positive step in improving the lives of some who are on the very lowest rungs of the ladder, both socially and economically.

The beading community is centred within the Cape Town townships Khayelitsha, Delft, Phillipi, Ianga and Gugulethu, as well as a few around the Eastern Cape. The enterprise is run by Kate Carlyle, previously the founder of Cape Town ceramic studio Mustardseed and Moonshine. Kate works very closely with the beaders, and a thriving community of more than 380 mainly female bead artists has been established, many of whom are now the sole breadwinners in their family. Through this enterprise they are able to put food on the table. The work also enables them to have the flexibility of being able to work from home, care for their children, and carry out domestic duties, whilst dispensing with transport costs to and from a place of work.

From its early beginnings, the structure of the business and its methods of remuneration have evolved to devise more satisfactory solutions. In Monkeybiz's earlier years, work would be brought to a large container in Macassar, which eventually proved to be somewhat problematic due to dust, wind, and fluctuations in the weather. Now, twice per month, there is a Market Day in Cape Town, and there are two groups of "active" beaders, with ten group leaders, who can be counted on for regular delivery of their work, with a usual of output of making a few articles per beader per week. A number of other beaders have a somewhat more spasmodic output.

The women occasionally come together within their homes in the townships to create their work, often sharing communal food amidst a backdrop of children,

toddlers, domestic animals, and the soundscape of energising melodies and rhythmic beats. Immediate payment is made for each article into their individual bank accounts, each work being graded for its quality, artistry, and size, and the fee being made accordingly. Normally the quality of the work is superb, but if, in some cases, it falls short, a beader is required to attend a workshop in the township in order to rectify this. Having done so, they will then also receive direct payment. The leaders return again to the townships with messages about the work, as well as the materials for making new pieces: a free supply of high-quality beads, recycled material for the stuffing, cotton, and occasionally wire for animal parts, such as the legs.

Conditions in the townships have scarcely improved since the end of segregation in 1990. Significant health issues are rife within communities, including HIV/AIDS, which amongst the region's black population represents one of the world's most severe epidemics. Lack of accurate information, education, and the prevalence of superstition and false beliefs all help to spread the disease, as well as rape and mother-to-child infection through pregnancy. In 2003, the Norwegian government provided HIV-related funding, and in 2004, Monkeybiz/Monkeypress published their own coffee-table book, the first of two of their own publications, entitled "Positively

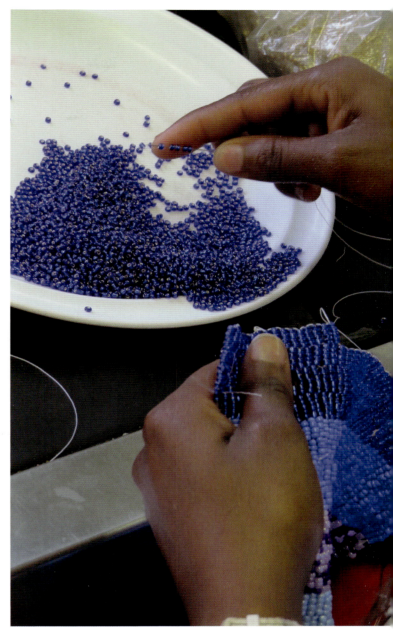

Above:
A free supply of high-quality beads is used by the beader.
Photograph © Monkeybiz.

"Being part of Monkeybiz feels good, because before I was suffering and today I have many things. We bead full-time as a family."
NOSANDISE MVINJANA AGE 44

HIV". The chief aim was to allay certain myths and fears about the disease, and together with a five-track music CD called "Statements", convey a level of realistic optimism. Burial ritual and traditions have a long-held vital importance within the culture, and because all connected procedures are extremely costly, a Burial Fund, which receives match funding by Monkeybiz, is also established for every registered beader.

Whereas food parcels used to be given out, these have now been replaced by food shopping vouchers, recognising the difficulty of appealing to everyone's specific culinary preferences. In some families, beaders can afford computers for their use at home, and more frequently children are able to go to school and receive an adequate education. Occasionally, they can also go on to university. Within the enterprise, there is generally a high value placed upon education in its widest sense. Recognising the importance of the provision of regular beading workshops, occasionally led by visiting artists, both for beginners and refreshers, the standard of the work can continually be raised. In addition to receiving a wage, education and training is provided in money management, business and entrepreneurial skills. This helps the artisans to manage their own finances, and gain understanding and expertise in important aspects of the business. Monkeybiz has provided a benchmark for non-profit organisations.

Opposite:
The flexibility of being able to work from home.
Photograph © Monkeybiz.

Right:
In addition to the vast quantity of beads, recycled material, cotton, and wire are used.
Photograph © Monkeybiz.

Whilst its brand focuses on the tradtional craft of beading, and has helped the women to retrieve a lost part of their culture, there is a very high emphasis upon encouraging individualistic expression by the beaders, many of whom have not previously had the experience to tap into their own creativity. Historical traditions of beadwork were more usually created two-dimensionally, in the context of costume and adornment. In Monkeybiz's revival of the artform, the beadwork does not carry its earlier symbolism and narrative. The basic tools of needle, thread, and bead, and the mathematical

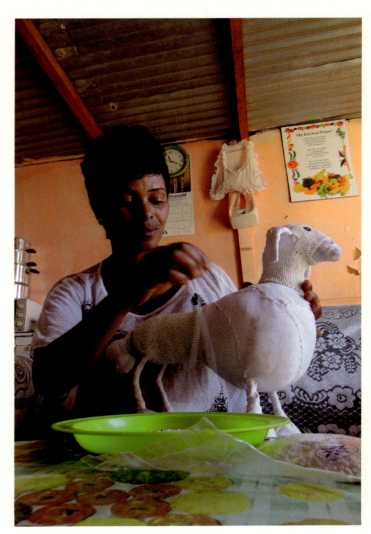

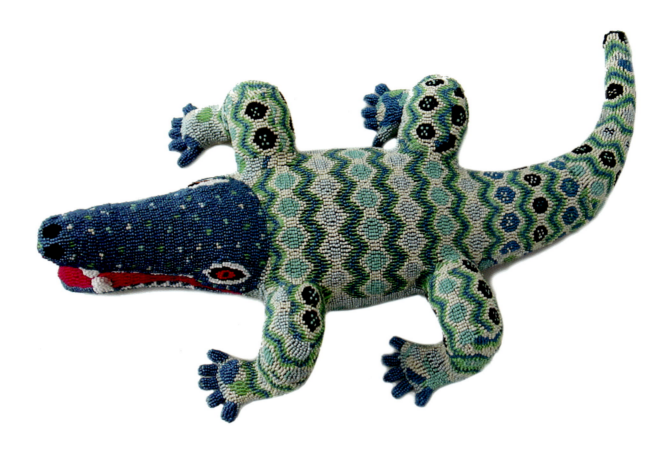

linear and horizontal beading directions remain, but with the idea of creating three dimensional creatures, and being given free, uninhibited artistic reign. As is clearly illustrated in "Bead by Bead", Monkeybiz's 2007 publication, the craft, which lies firmly within the folk art tradition, and a typically South African aesthetic, has been contemporised. Within the vibrant, coloured funky patterns are zigzag, chevron, striped and lozenge shapes, upon tactile, mosaic-like surfaces. Different from the more formulaic and mass-produced beaded items created for the tourist market, each and every unique

work of art is signed on an attached tag by the artist who has made it, helping to assure their recognition and possible success in gaining further commissions.

Although certain methods and techniques within the craft may have disappeared, some of these motifs and patterns are still somewhat reflective and reminiscent of the culture's history, now invested with new meaning. Within the townships, animals other than dogs or chickens are rarely seen, and so the beaders' designs and creations are very much reliant upon their own

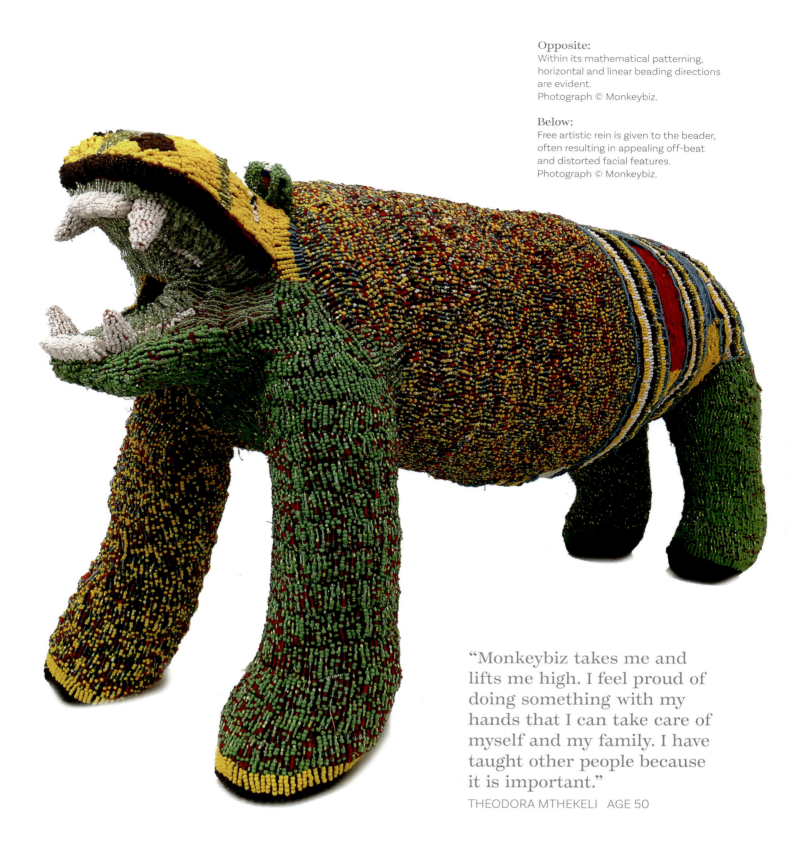

"Monkeybiz takes me and lifts me high. I feel proud of doing something with my hands that I can take care of myself and my family. I have taught other people because it is important."
THEODORA MTHEKELI AGE 50

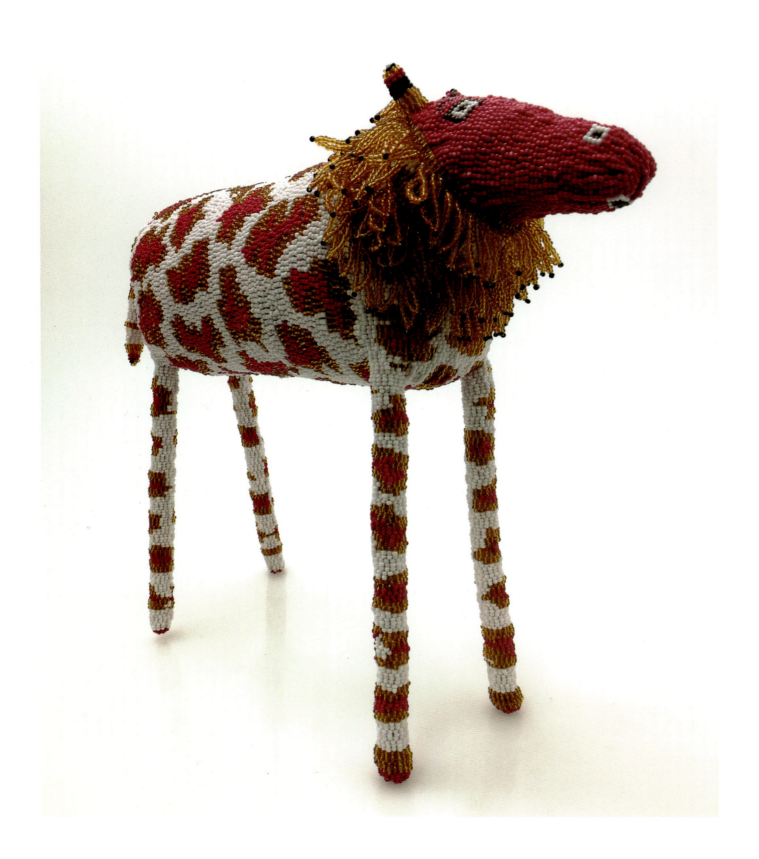

imagination. The creatures' forms, off-beat and distorted facial features, and their jazzy, decorative patterns display a distinctive, joyful, spontaneous, and child-like aesthetic. It has been evident that the facial expressions of the creatures have a great influence on their general appeal. Paying close attention to certain trends and themes, such as monochrome dogs and endangered species, as well as the willingness to create bespoke work and certain characters for a specific market, have all been equally commercially beneficial factors.

From its inception, it took Monkeybiz a while before things started to actually take off. In 2002, however, their exhibition with Sotheby's Contemporary Decorative Arts was a sell-out. This suddenly afforded the work an iconic cult status within South African art, and created significant opportunities with galleries in many parts of the US Monkeybiz exhibits at the New York Gift Show twice per year, and at Design Indaba Expo, where its appeal to the designer/decorator market has become rapidly apparent. A number of the most talented beaders, such as Zisiwe Lumkwane and Joyce Sithole, have become known for their style and the perfection of their pieces. Joyce's zany people and wobbly camels and Zisiwe's African kangaroos have become extremely collectable, fetching some of the highest prices. The enterprise generally attracts volunteers from all over the world, giving their time, and in many cases undertaking internships of considerable length, in order to experience many aspects of the business, from the packing and dispatching of orders, sales and shop management, to digital marketing.

In 2014, an exciting, collaborative culture-blending project began, between the Haas Brothers, Los Angeles-based art and design duo, and Monkeybiz. The drawn designs of Nikki, combined with the mathematical and complex bead algorithms devised by brother Simon, gave birth to a collection of the most extraordinary shapes and creatures, aptly named "Afreaks". The weird and wonderful range of characters, dunes, chairs, and eight-foot-high mushrooms sometimes included

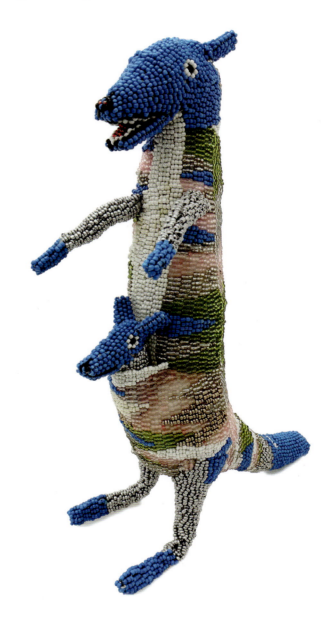

Left:
Free artistic rein is given to the beader.
Photograph © Monkeybiz.

Right:
The recognisable style of talented beader Zisiwe Lumkwana.
Photograph © Monkeybiz.

combinations of felt, bronze, wood, and fibreglass as part of their construction, and in so doing involved additional collaborators in the process. The project allowed 16 beaders to gain full-time permanent employment for a period of four years. In 2016, the collection was exhibited as part of the Cooper Hewitt, Smithsonian Design Museum's exhibition, "Beauty-Cooper Hewitt Design Triennial". Showcasing 63 designers, and featuring more than 250 works from all over the world, the message of craft's sensuality and its ability to engage each and every part of the mind, body and spirit was paramount.

Four of the beaders involved in the project travelled to New York with Kate Carlyle for the opening of the show. The work was also shown at Design Miami/Basel. Occurring in December in Miami, and again in Basel in June, this represents the most important global forum for design culture. It attracts many of the most influential gallery owners, architects, designers, curators, and critics, from all over the world, continually generating a culture of astute contemporary collectors of craftsmanship, and frequently ground-breaking critically acclaimed collaborations.

More recently, the Sally Little Foundation, a sustainable social development and upliftment programme, based in Cape Town, with its Garden Village Initiative, has formed a collaboration with Monkeybiz. Its aim has been to provide and increase beadwork training to small numbers of its residents, and ultimately also to the children at a neighbourhood school. It has been ready to acknowledge the importance of beading as a significant medium, with the capacity to nurture female empowerment and generate a source of income for artisans and entrepreneurs, not least because the skills are continually transferrable to new beaders.

In less than two decades from its humble beginnings, the work is now sold in trendsetting stores across

major world cities like London, Paris, Reykjavik, New York, and Tokyo. With humour, but also great pride in her voice, Kate Carlyle confesses that one of the pinnacles of Monkeybiz's vast number of achievements has been the creation of a beaded Dalai Lama, which was subsequently presented to His Holiness.

"I now feel that the work has taken me away from poverty, and as a single mother I am able to raise my children and send them to school."

MANTSHEPISENG MAPHAKA AGE 55

OTOMI TENANGO EMBROIDERY

This very flamboyant and figurative embroidery style has traditionally been the work of women, having been absorbed and learned ancestrally. It originated in the Tenango de Doria municipality of the Mexican state of Hidalgo, to the east of Mexico City, where the practice continues to thrive, both locally in the San Nicolas and San Pablito municipalities, and to a lesser degree within the neighbouring municipality of San Bartolo Tutotepec. This part of the Sierra Madre region's topography consists of dramatic canyons sandwiched between mountainous terrain, somewhat isolating its population and thus helping to preserve their traditions.

The region's climate is relatively wet, with consequently lusher vegetation than in most Otomi locations. This has considerably influenced the consistency of the embroidery patterns and motifs, providing somewhat of a compendium of the rural life of its people.

The Otomi people are the fifth largest indigenous ethnic group in Mexico, also being known as Nuhu or Hnahnu, dependent upon local dialect. Otomi communication consists of four main languages. Although many speak Spanish, a significant proportion of the Otomi people only speak their own language and dialect, and maintain very similar cultural practices to one another. Since the Otomi tribe are now dispersed throughout Central Mexico, Otomi work can be seen in many parts of the country as well as in Tenangos, where over 1,200 artisans practise the craft. However, because of its origins, this particular type of embroidery is still often known as Tenangos.

The life of native Mexican women is traditional, and most female artisan embroiderers either tend to have a slightly more urban lifestyle, living in the town, or alternatively a more time-honoured rural lifestyle, living high up in the mountains. Modestly sized vegetable plots growing maize, beans, squash, and tomatoes are dotted around the small houses within their communities, where chickens roam freely, all creating a quiet and peaceful atmosphere.

Left:
The local dwelling places in Tenango de Doria.
Photograph © Rebecca Devaney
MFA, Textile Researcher, Practitioner and Educator.
Rebecca Devaney research project,- "Bordados: Embroidered Textiles from Mexico."

Above:
The closed herringbone stitch used to fill each shape.
Photograph © Rebecca Devaney MFA.

It is typically regarded as the woman's role to tend to household chores, cultivate the vegetable plot, gather firewood, and bear and care for their children. Money is short, however, and women are additionally expected to contribute financially to the wellbeing of their families. After domestic work is finished, women allow time for their sewing within the quiet of their own home, only occasionally meeting and stitching with other neighbouring women. When the work is completed, they will often spend hours walking to the town in order to sell their work at the market.

Textile crafts such as sewing, weaving and embroidery are still passed down to younger generations, but far less so than in the past. Formerly, because costumes bore tribal significance, these crafts were an essential and natural part of women's lives. Because school uniforms are now routinely worn by pupils, and cheap western-style clothes are commonly available, the skills have greatly diminished. However, now that Otomi embroidery is less associated with the creation of personal clothing, and more as a means of potentially earning money, it has increased in popularity, and young people have started to recognise it as a useful skill, having fashionable currency.

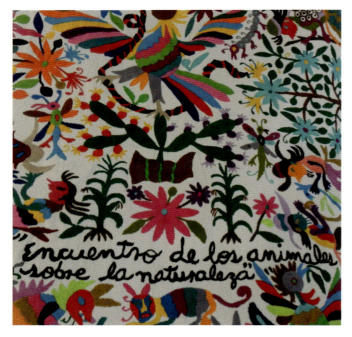

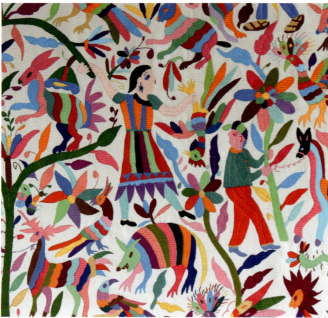

Otomi embroidery dates as far back as pre Aztec Meso-America, and the designs seem to originate from prehistoric wall paintings of the Hidalgo region. The embroidery commonly seen today only began a few hundred years ago, when Otomi women began to embroider in a more European style, having been subjected to Spanish colonisation. During the 1960s, a severe drought in the Tenango Valley had a major impact upon subsistence farming, and consequently was responsible for an economic crisis in the region. For the Otomi people, the urgent necessity of seeking alternative ways to earn a living forced them to address their artistic textile heritage. Simplifying the earlier traditional embroidery, and blending modern commercialised methods and new colours and patterns with ancestral techniques has provided a means of restoring their tribal identity, and revitalising Otomi embroidery as an art form, winning international interest and acclaim. Fortunately, in tune with the mood and aesthetics of the time, its popularity really began to take off in the late 1960s.

Although Otomi work is clearly identifiable, designs have massively changed from the earlier pieces of the 1960s and 70s, which perhaps adds to its richness as a craft, granting the freedom for its evolution in style. Each cloth is unique and bears the thoughts and marks of its designer. Embroiderers and designers have their own distinct skills, and it is rare to find a woman whose expertise is in both. There are traditionally two ways of designing a cloth: in both cases, the overall composition is normally symmetrical and geometric. The first is a quatrefoil design, being read from all four sides. The second is in vertical linear form, where the design can be read from top to bottom, straight up and down.

Above top:
Curvaceous script is occasionally embroidered and incorporated within the work.
Photograph © Rebecca Devaney MFA, Textile Researcher, Practitioner and Educator.
Rebecca Devaney research project,- "Bordados: Embroidered Textiles from Mexico."

Above bottom:
Multi-coloured Otomi embroidery showing depictions of local flora and fauna
Courtesy of Montes and Clark. Photograph © Jorge Montes de Oca.

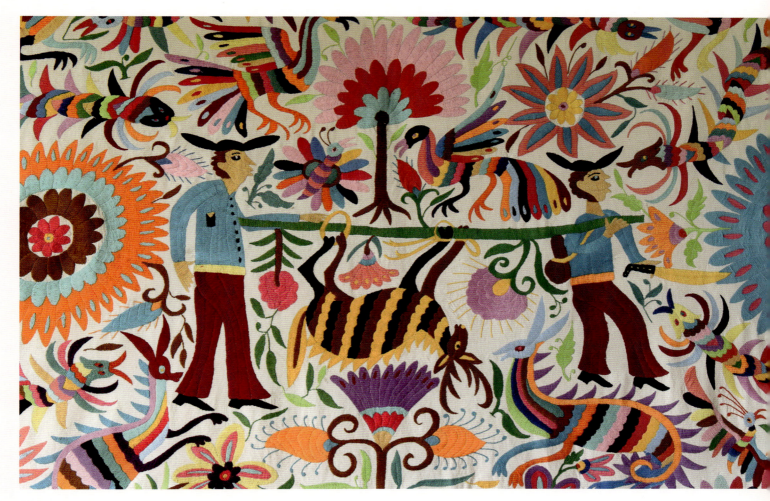

Above:
Multi-coloured Otomi embroidery, rich with an abundance of stylised motifs
Courtesy of Montes and Clark. Photograph © Jorge Montes de Oca.

The embroideries commonly feature multiple graphic, stylised, figurative motifs. However, featuring similar imagery, and with reference to their rich story-telling traditions, larger distinctly narrative embroideries are also made. The themes generally reflect daily life, folk culture and festivities, mythology, religion, and spirituality. As well as images from cave paintings, and depictions of human figures, the forms commonly relate to the region's flora and fauna in Tenango de Doria. They include chickens, turkeys, armadillos, deer, rabbits, horses, trees, flowers, and birds, as well as referencing the culture of food preparation, playing music, and even football! Additionally, some forms are influenced and adapted from the "amate" paper-cuts, made by local shamans and healers. In the Otomi world, many of the motifs are imbued with richly symbolic meaning. Animals are thought to represent bearers of important news, and various other symbols may denote help, harm, have connections with fertility, or serve as intermediaries between the Otomi people and the spirit world.

Whereas early Otomi embroideries were normally stitched in two colours: black and red, blue and black, blue and red etc, individual forms are now bright and vibrant, rather than realistic, and include yellows,

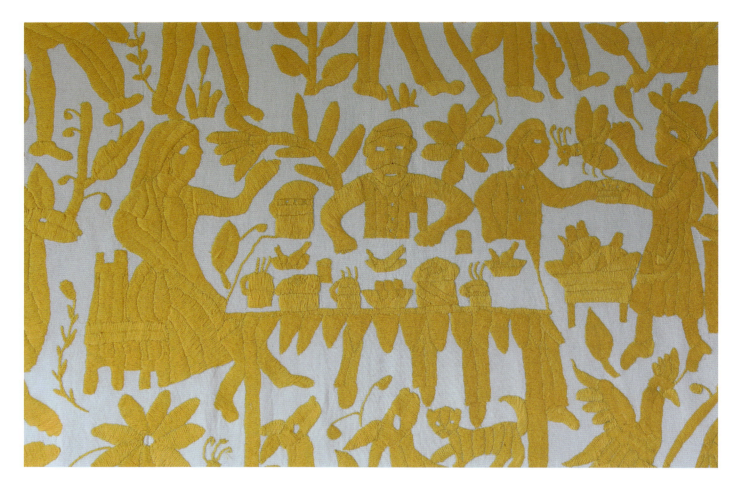

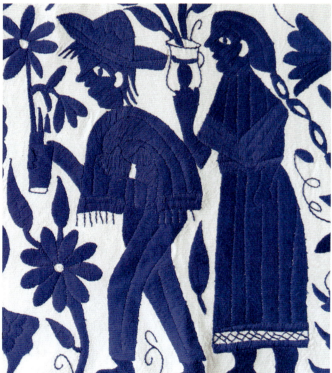

greens, purples and oranges as well as fuchsia pinks. Although finding it difficult to comprehend the choice of a decorative item devoid of bright colour, in an effort to satisfy Western tastes, more subdued subtle shades of beiges and greys have also been introduced by Otomi designers, along with entirely monochrome pieces. Whole designs might either be multicoloured and frequently arranged in stripes, or composed of one single colour throughout. Background colours of the cloth are commonly white or cream, and very occasionally black or brighter colours.

Above:
Single coloured Otomi embroidery illustrating the festive meal.
Courtesy of Montes and Clark. Photograph © Jorge Montes de Oca.

Left:
The typically narrative quality of Otomi embroidery.
Courtesy of Montes and Clark. Photograph © Jorge Montes de Oca.

Opposite:
The reverse side of the fabric showing perfect lines of backstitch.
Photograph © Rebecca Devaney MFA.

Otomi women trace the designs onto the factory-woven cotton cloth or "manta" with a pencil or pen, or more frequently now with a fabric pen, so that the primary drawings can be washed out in water, once finished. Using a regular embroidery needle, and six ply embroidery cotton, which is then divided into three ply, the designs are worked with a closed herringbone stitch as the main filler. Economically, this only appears on one side of the cloth, revealing perfect lines of backstitch on the reverse side, and allowing an even rhythm of sweeping satin-like stitches to be built up quickly. For a finer line, a type of stem stitch is used. The embroidery is worked on a small wooden ring frame or hoop, which is then moved around the cloth as each section is worked. Eventually the fabric is turned at the edges, and hand-finished with a running stitch, or now, more commonly, a machine-finished edge.

Most of the embroidery is done within families, although women's co-operatives also exist, where they are able to be more proactive in the promotion of their work. The most superior and large-scale Tenangos can take up to six years to complete, characteristically revealing the precision of tight, neat, small stitching. A large cloth, measuring 2m x 2m can average three months to make, being worked on as time allows. For practical reasons, many of the cloths are embroidered by mother and daughter together in the same domestic setting, allowing for less visible difference in tension throughout, due to the close family relationship.

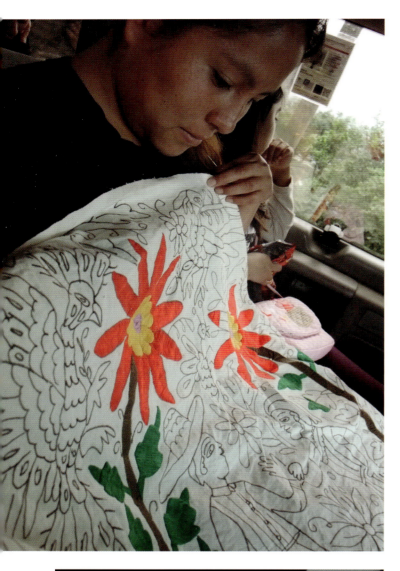

Left:
The making process showing its traced design.

Below:
The design being stitched using a small wooden hoop frame.
Photographs © Rebecca Devaney MFA.

Although commonly the original intention was to create traditional garments, such as "pepenado" blouses, with the characteristic embroidered embellishment, this was soon discovered to be too time-consuming and labour-intensive to be commercially viable. With no particular function, the embroidery was then simply worked onto cloth; and although still not achieving adequate remuneration until the work became better-known, transferring the idea onto flat pieces of cloth for domestic items such as napkins, runners, tablecloths, bedcovers, and pillowcases became a viable solution.

Traditionally, women have stitched their pieces and sold them locally or in the markets of Mexico. Middle men also frequently sell the work, for a considerable mark-up in price. However, increasingly there has been a growth in the co-operative movement, with the realisation that marketing themselves through digital media and through team work they are able to access interested buyers and potential customers, and command better prices and better wages. In Tenangos itself, some families have even set up their own shops. Otomi designs have become so popular that imitation and cultural appropriation is hard to prevent, and in various parts of Mexico, work can be seen that has either not been made by the Otomi people, or has involved child labour and unscrupulous practice.

Lucy Montes de Oca and Kate Clark founded Montes & Clark in 2015. Kate trained as an embroiderer at the Royal School of Needlework in the UK, and developed a love of Mexican textiles whilst teaching there, giving her a deep understanding and empathy for the techniques and processes employed by these artisan embroiderers. Through their shared passion for colour

and craft and their love of Mexican textiles, their prime focus was initially to promote women-led textile co-operatives and craftspeople, by commissioning cloth and embroidery from them. In 2017, together with their friend Emily Pinsent, a master at sourcing unique and beautifully crafted objects, they opened their shop in Wiltshire, UK; and with increased success were able to move to larger premises in 2018. Although the business has expanded to include exquisitely sourced crafts from various parts of the world, Lucy, who initially discovered her love of Mexican textiles when marrying her Mexican husband, now makes regular visits throughout the year, actively working with and supporting the growth of the women's co-operative movement.

During Lucy's earliest attempts to source Otomi cloth, a meeting was set up for her in a school playground, where many of the local embroiderers brought their work for her inspection. Ensuring that she bought work from each woman, she returned home with an array of pieces of varying standards. There are now approximately 20 women of all ages involved in the relatively small co-operative Montes & Clark have been working with for the last five years. Whereas most finished Otomi textiles will smell of washing powder, having been brought down from the mountains to the co-operative headquarters in the village, where the cloth can be prepared for sale, Montes & Clark frequently receive the work smelling of wood smoke, with the drawn designs still visible. Their women embroiderers live more simple lives, and do not own washing machines, but are aware that they can be relieved of this final process, since the pieces will be washed in Montes & Clark's workshop.

Through maintaining regular communication, and articulating their expectations and requirements with their designers and embroiderers of choice, Montes & Clark have reached the position of being able to commission pieces, and have complete confidence in the eventual quality of the finished article. The women meet once a month at the head office to discuss business, and those who live locally are able to assist in co-ordinating aspects of the co-operative members' work. Particularly with its ever-increasing national and international appeal, the ability to achieve increased sales, fulfil larger commissions, and consistently guarantee money for their finished pieces is recognised as an achievable goal, contributing a much-needed additional income to the family.

"I started embroidering age six, taught by my mother, who was taught by her mother in a long thread back through women. Mariela, who started the Tenango embroidery co-operative, came to our village and helped us form a group. We learn together what new things we can embroider that we can sell, and we teach each other. I love my work and being part of a co-operative group."
MARIBEL RODRIGUES, FROM THE SAN PABLO EL GRANDE VILLAGE IN TENANGO DE DORIA

PET LAMP PROJECT

Every corner of the earth is being permeated by an ever-increasing amount of plastic waste. In many places there is an unwillingness to acknowledge responsibility for the extent of the problem, and insufficient resources to cope with collection and recycling. Polyethylene terephthalate or PET is the clear plastic resin commonly used for making beverage bottles and food containers. Although their advantages in terms of practicality and price are indisputable; and being polyester, they are recyclable into more bottles or consumer items, PET plastic bottles remain high-energy consumers in their production, and have a very short useful life, in comparison with the time taken to degrade. If left to decompose outdoors, the process can take hundreds of years, and once discarded, particularly in tropical zones, a high percentage are washed into the rivers, and then out to sea.

Alvaro Catalan de Ocon was born and raised in Madrid, where he completed his Business Management studies at Madrid Complutense University. Following this he studied Product design in Milan, and in 2004 graduated with Honours from Central Saint Martins School of Art and Design in London. The same year he set up his own studio in Barcelona, winning Frankfurt's Design Plus Award for his design of the "La Flaca" lamp. In 2009 he moved his studio to Madrid, where he also teaches at the Instituto Europeo di Design.

With an approach embracing both aesthetic perfection and practicality, Alvaro's interest in materials and making, client interaction, and cultural meaning, are key to his practice. Through intensive research, he achieves a pared-down simplicity and integrity in his designs. Exhibiting at renowned museums and galleries worldwide, winning numerous design awards, and with work held in permanent collections in Paris, Melbourne and Hong Kong from 2007 onwards, Alvaro conceived the PET Lamp Project in 2011. This has since earned the studio considerable acclaim since its initial presentation at Rosana Orlandi in Milan.

Initially addressing the plastic waste issue endemic in the Colombian Amazon, the starting point of the PET Lamp Project was the dichotomy between the bottle's useful life and its degradability. With a confirmed belief in reuse as the viable alternative to recycling, particularly in Colombia, without the infrastructure for recycling, between 2011 and 2016 PET Lamp has successfully developed its collections of unique, hand-made pendant lampshades, in collaboration with talented artisans from countries of every continent: Spain, Colombia, Chile, Thailand, Japan, Ethiopia, and Australia, and now Ghana.

"We don't have to worry about how we are going to sell them.... working on the PET Lamps ensures us a consistent income."
SALEM KASSAHUN- HANDICRAFT WORKSHOP AND SHOP OWNER, ADDIS ABABA

Above and right:
Hotel installation.
Photographs © Robbie Wolfson.

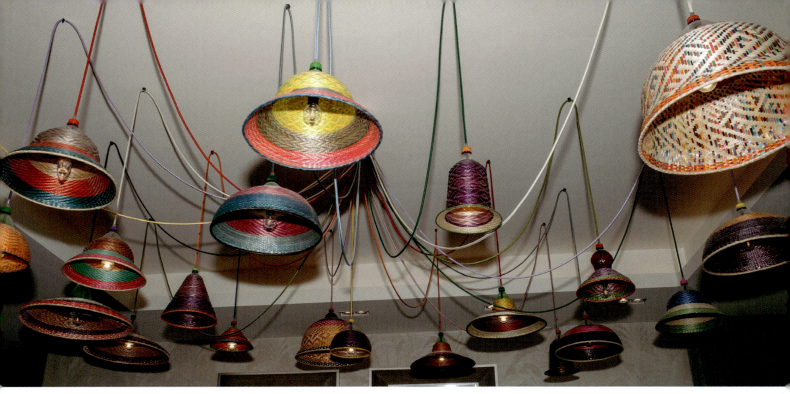

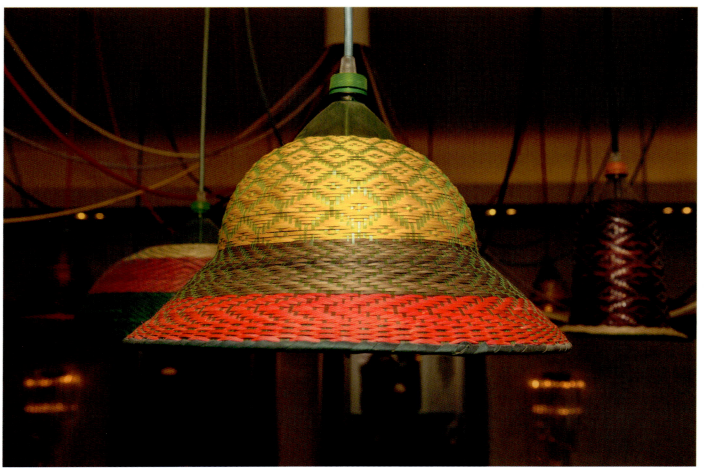

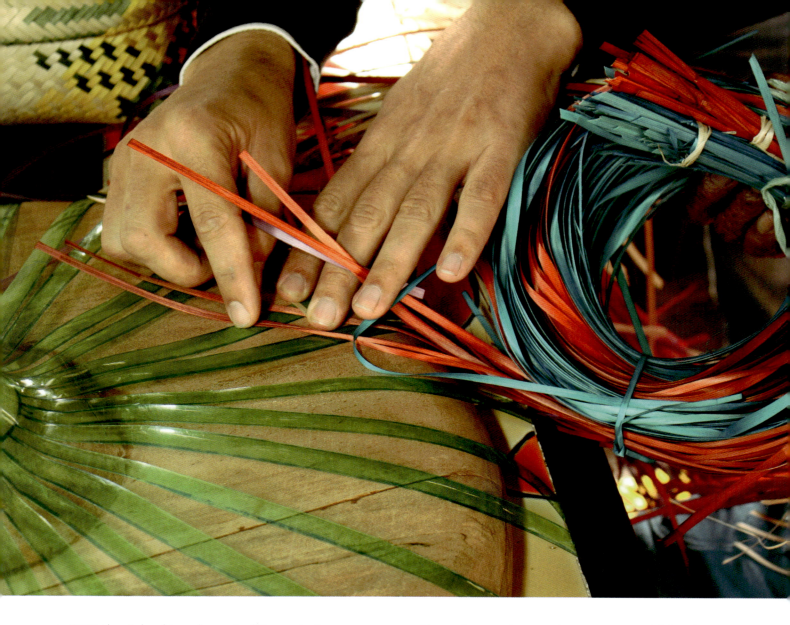

In 2012, the Colombian element of the project was launched, followed the next year in Chile, then in 2014 in Ethiopia. In 2016 PET Lamp travelled again to Chile, to work with the people of the Mapuche community, whose day-to-day existence in an area of conflict is normally fraught with problems. The project's true global potential was further endorsed by the involvement of Kyoto's talented bamboo artisans in 2015, and followed by PET Lamp Pikul in Thailand. Most recently, in 2016, the National Gallery of Victoria in Melbourne commissioned PET Lamp to undertake a collaboration, working with Australian indigenous artists in Ramingining.

Expansion to other continents to work with local artisan cultures involved the concept's adaptability and cross-cultural potential being put to the test, together with familiarisation of regional vegetation, available raw materials, visual language, and local anthropological knowledge. As an industrial designer, Alvaro's ability to reconsider and repurpose the plastic bottle, by combining local weaving traditions and techniques with industrial lighting, exposed an added dimension of the project's capacity for exploring, reflecting, revitalising, and preserving the breadth of indigenous craft knowledge and tradition, and its impact upon local culture.

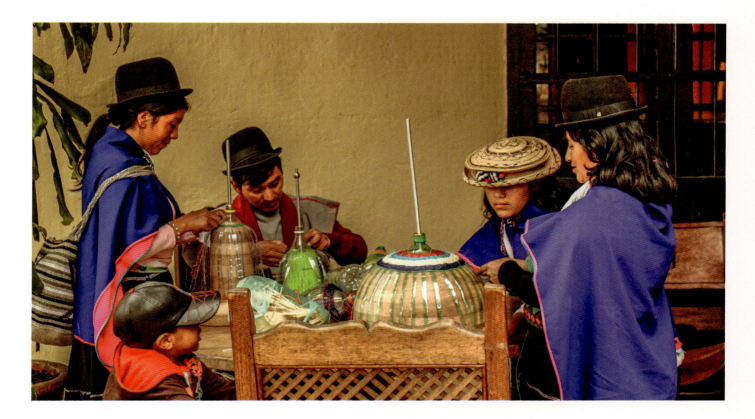

PET Lamp is produced and distributed by the edition brand of Alvaro's studio, ACdO. Each project embodies a developed design methodology, addressing the integration of physical, earthly, human, and sacred elements. Each project is given a specifically artist-centred focus, in terms of choice of colours, patterns and designs, careful not to impose its own ego upon the different artisan groups.

Older than stone carving or pottery, basketry, having been practised by tribal people worldwide, is one of the world's oldest crafts, and possibly forms the basis of all textile arts. With no substitutes introduced by mechanisation or methods of mass-production, the tools, materials, and techniques have not changed enormously since making began. A revival of interest during the last several decades, however, has given rise to new sculptural forms of expression. In addition to a period of training and apprenticeship, it is a craft requiring accuracy, precision, perseverance, and the ability for mind, hand and eye co-ordination.

Opposite:
PET Lamp Colombia Eperara Siapidara (the weavers).
Photograph © studio Alvaro Catalán de Ocón.

Above:
PET Lamp Colombia Guambianos (the weavers).
Photograph © studio Alvaro Catalán de Ocón.

"Thanks to the craft work I've been to other places. For example I went to Poland to a wicker work camp there. Here the authorities don't do much for artisans."
WEAVER, SEGUNDO RODRÍGUEZ

COLOMBIA

With assistance by Artesanias de Colombia, an organisation dedicated to the preservation of traditional Colombian crafts, during August 2012 PET Lamp Project Colombia was launched, in collaboration with the Eperara Siapidara and the Guambianos indigenous ethnic communities. Originating in the Cauca region of the Pacific coast, but displaced by guerilla warfare to Bogota, bad forest management and illicit cocoa plantations have additionally contributed towards the isolation of the groups. This situation has, in turn, helped to ensure the preservation of their exclusive customs, concepts, and traditional craft skills. The Guambianos are situated in the central mountain range of the Andes. With a tradition preceding the Inca civilisation, their richly coloured wool and cotton weaving is reflective of their culture.

In the Cauca region's hot and humid climate, its rich bio-diversity of flexible rushes, palms, bamboos, rattans, and grasses are dyed with locally found natural pigments, and used as both the stakes and the wefts for weaving plaited baskets. Requiring considerable manual dexterity, this method of basket-making can be employed to achieve great pattern complexity. With deep-rooted environmental and handicraft knowledge, during their wanderings through the area's jungles and forests plant fibres are habitually gathered for making baskets on a daily basis, for both personal, functional and ceremonial use, as well as for selling. As is commonly the case with many indigenous tribes, traditional weaving structures, with their linear patterns and geometricity, are also intrinsically linked with mathematical, scientific, and spatial concepts, and are passed down from generation to generation.

The Eperara women artisans apply common principles to their basketry methods, both in the use of their heritage symbols, including the spider, shrimp, frog, crab, butterfly, and monkey, and by consistently beginning the weaving at the centre in a latticed manner, with alternating interlaced colours, allowing the weaving to start to determine the structure's shape. With this same system, weaving wide, ribbon-like tapes of the local "paja tetera" palm tree with strips of plastic bottles, the artisans of the group are able to create individually formed and coloured basket-shaped lampshades.

Traditionally, although the men use palm fibres to weave the roofs and walls of their homes, it is the women in the Eperara Siapidara community who are the basket weavers. Once a little girl reaches the age of five, an adult woman within the tribe begins to teach her to make her first trial baskets. When the first basket is finished, the remnants from the end tips of the "paja tetera" are cut with a knife, and placed inside the basket, which is then placed like a hat upon the child's head. Tradition dictates that if some of the remnants remain on her hair, once the hat is removed, the girl will attain superior knowledge of basket making. Conversely, if they fall to the floor, regardless of the teaching, it is believed that she will neither have the memory or the sensitivity for basketry. Making baskets commercially generates a small extra income for many women.

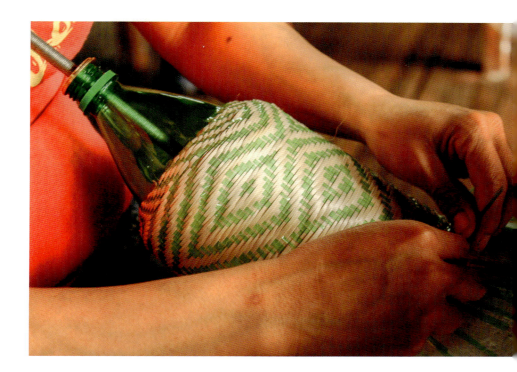

Right:
PET Lamp Colombia Eperara Siapidara.

Below:
PET Lamp Colombia Eperara
Siapidara (the weavers).
Photographs © studio Alvaro Catalán de Ocón.

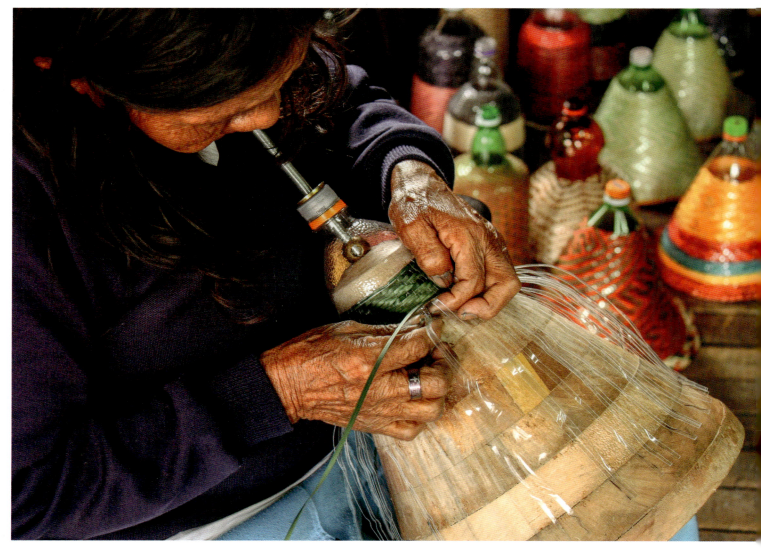

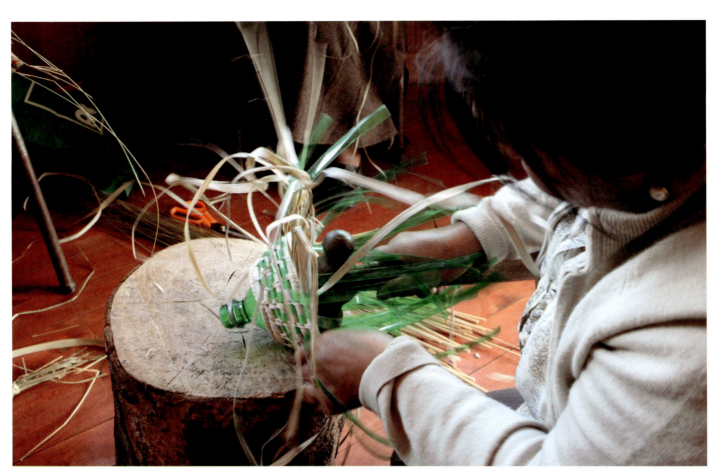

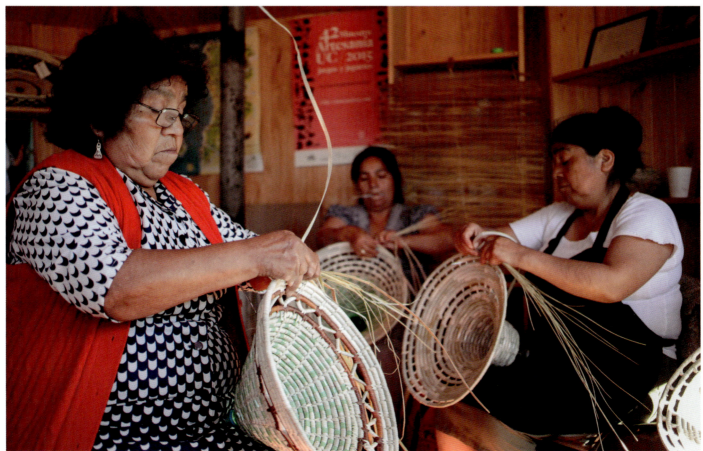

CHILE

The Mapuche people live 400 km south of Chimbarongo, the so-called "wicker capital" in the Araucania region of Chile. Integration with the rest of the population is slow, and the economy of its 35,000 inhabitants is largely generated by fruit cultivation, viniculture, and wickerwork, the latter culminating in an annual fair showcasing the most exquisite examples of this heritage craft. Increasing admiration and marketability has encouraged many professional craftswomen to inspire their families' involvement in basketry, creating small individual artisan workshops.

In 2016, having been shown a copied prototype of a PET Lamp made in Ethiopia, and attracted by the contemplative nature of the people, and the professionalism and sobriety in their work, PET Lamp, with local partners, SiStudio and Ideartesana, discovered a group of women from the Nocha Malen tribe who, although stigmatised and experiencing problems, were eager to share their traditions and basketry skills. Using 500-year old techniques, and the boiled and then dried leaves of the ñocha fibre, each basket is imprinted with the maker's individual story. Once the makers achieved satisfactory results with PET bottle cutting, in order to maintain and preserve the desired shape, they began the weaving process around a wooden mould, previously designed in Madrid.

Top and bottom opposite:
Making of PET Lamp Chile.
Photographs © studio Alvaro Catalán de Ocón

ETHIOPIA

The African country with the most UNESCO World Heritage sites, its own calendar and time zone, Ethiopia is full of geographical, cultural, and linguistic contrasts. The ethnic groups in southern Ethiopia are amongst the oldest in the world, maintaining much of their traditional culture, which includes their handicraft expertise and methods of bodily adornment.

The Muslim city of Harar remains at the forefront of Ethiopia's long-held tradition of basket-weaving. Commonly practised by women in rural parts of the country, the intricate, colourful, "coiled" baskets are used for functional, decorative, and sacred purposes, and have an important role in Ethiopian culture. Without instructions as design aids, the women, having learned the skills from their mothers, are otherwise solely reliant upon their own imaginations and memory. The materials used are usually grasses and palm leaves, which are dyed with other natural materials. A slow process, which requires both strength and patience, the coiling technique involves the continual attaching of a stationary horizontal foundation tube or long rolled bundle of fibres, with vertical stitches of a single fibre, gradually expanding and defining the basket's shape.

Salem Kassahun owns a shop in Addis Ababa, which specialises in traditional Ethiopian basketwork.

"For those who come to work, they like it because they have created a sort of community. It is a sense of pride. They have a job and a place to go to instead of staying home."
SALEM KASSAHUN

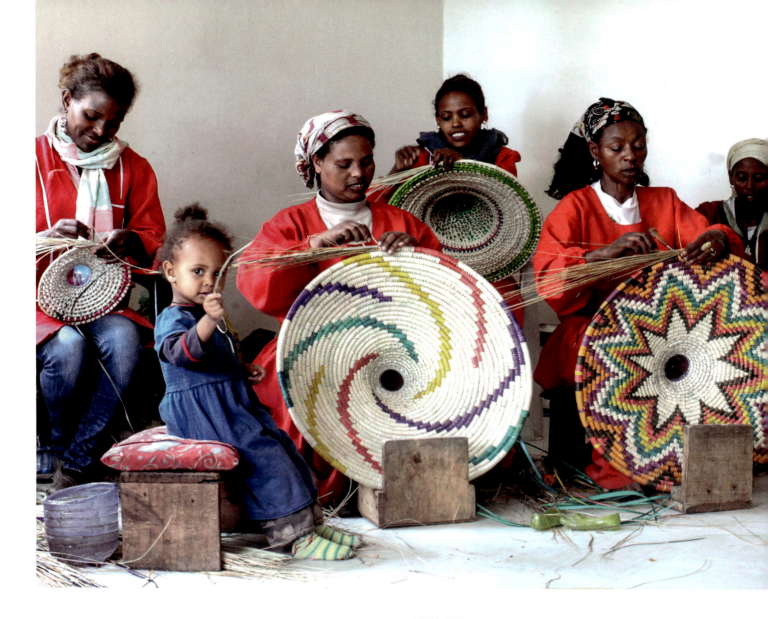

Having created her own group of workers, and encouraging flexibility and experimentation in their work, together with the challenge of contemporising the craft, and giving it international recognition, proved ideal criteria for forming a collaborative venture with the PET Lamp Project. Mainly working with mothers of twins, a very stigmatised category of women in Ethiopia, the workshop and ongoing activity accomplishes a social purpose in addressing their victimisation, helping to facilitate both their integration into society, and the practise, preservation and transfer of their traditional weaving skills for the next generation.

JAPAN

Historically, bamboo has been a significant material in Japan, used for building, making tools, weapons and tea ceremony items. Bamboo craftsmanship was one of the most important industries in Kyoto, the ancient capital and centre of artisanal excellence, with master artisans passing on their skills to the next generations. Its durable and pliable properties encouraged its planting in Japan's forests, gardens, and mountains. However, with modernisation, industrialisation, and the tradition of the tea ceremony's decline, plastic has replaced many bamboo items, depleting bamboo cultivation, and resulting in the fine skills of bamboo artisans becoming extinct.

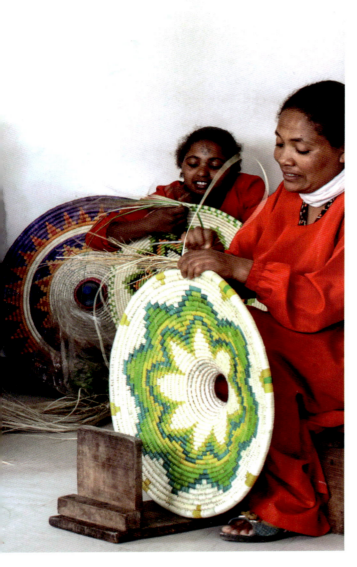

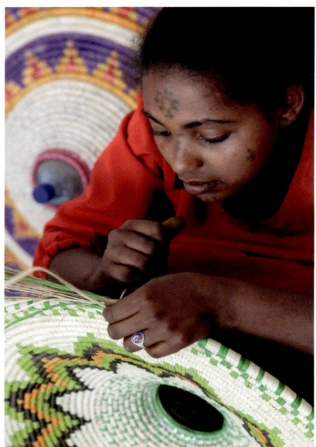

Left and above:
Making of
Photographs © studio Alvaro Catalán de Ocón

Particular to Kyoto, such perfection in basketry takes elaborate preparation and lengthy training, with the entire process usually being done by a single artisan. Traditionally, bamboo artisans apprentice under a master artisan for up to ten years before pursuing their own work. However, due to a decrease in demand, apprenticeship training in bamboo craft diminished, and today the majority of artisans are learning the skills at professional craftsmanship schools, without the benefit of the master's guidance beyond graduation.

The PET Lamp Project initially struggled to find skilled and independent artisans to create prototypes for the Japanese series; but eventually discovered two young innovative craftspeople, Chiemi Ogura and Hideaki Hosokawa. Having recently studied under Shoich Ishida, the grand master of Kyoto basketry, at the Traditional Arts School of Kyoto, these two makers, with their own strong signature styles, were already establishing markets in Japan's department stores and elsewhere. They had been taught by the third artisan in the group, Ayako Hosogaki, Ishida's former lead apprentice.

In the making process, the bottles' necks were incorporated upside down, in an attempt to expose the contrasting object and its material. After a primary soaking to give it flexibility, each Japanese artisan works his bamboo strips by using a special tool. Having removed its interior, each wide bamboo stalk is repeatedly split in half lengthwise, until the required width is achieved in a long, thin piece. Preserving the characteristics of Kyoto's fine crafts whilst combining two essentially different materials: slippery transparent plastic and leathery bamboo, presented a challenge, resulting in intricate work reflecting the creativity, care, and precision of the artisans' personalities. Although the long-term viability of this collaboration proved to be insufficiently commercial, and unlike those elsewhere incapable of generating significant female employment, it served well as an investigation workshop, informing the subsequent bamboo project in Thailand.

"...we tell them about the PET Lamp, about the fact that they are going to be shipped to Spain... they get excited. It gives us a chance to explain what it is and how it is a global project, that other people are doing the same in other countries with the same material. They like the idea that it is a global project and we do feel part of it!"

AUSTRALIA

Until European arrival at the end of the eighteenth century, Australia's Aboriginal population had lived in complete isolation for almost 65,000 years, maintaining their unique culture and their world view of spirituality, or "Ancestral Realm", incorporating their belief systems, life forces and cosmologies, expressed so vividly in their songs, dances, paintings and textiles. Acknowledging the gap between Aboriginal and non-Aboriginal communities, and compatibilities between the recurring rhythmic patterns of 1970s Aboriginal paintings and the essential techniques of woven textiles, PET Lamp sought communities where the traditions and world view are conserved in their purest form. Contemplating the area's satellite maps further inspired an imaginary Australian map, in which plastic bottles would represent the urban cores, with the surrounding fibrous weaving constituting the Aboriginal culture.

Ramingining is an indigenous young community in the Northern Territory, Australia, 60 km east of Darwin, and part of Arnhem Land. Accessible by both car and plane, and in spite of having an airport terminal, a shop and a school, its community still fiercely maintains old practices. These are exemplified by its carefully managed fires inside the bush, to encourage the growth of new species, and to improve access.

During the six weeks' duration of the project, involving eight indigenous artist weavers from two different territories of Billabong and Ramingining, workshop time

Right:
PET Lamp Australia. Betty working on the community piece.
Photograph © studio Alvaro Catalán de Ocón.

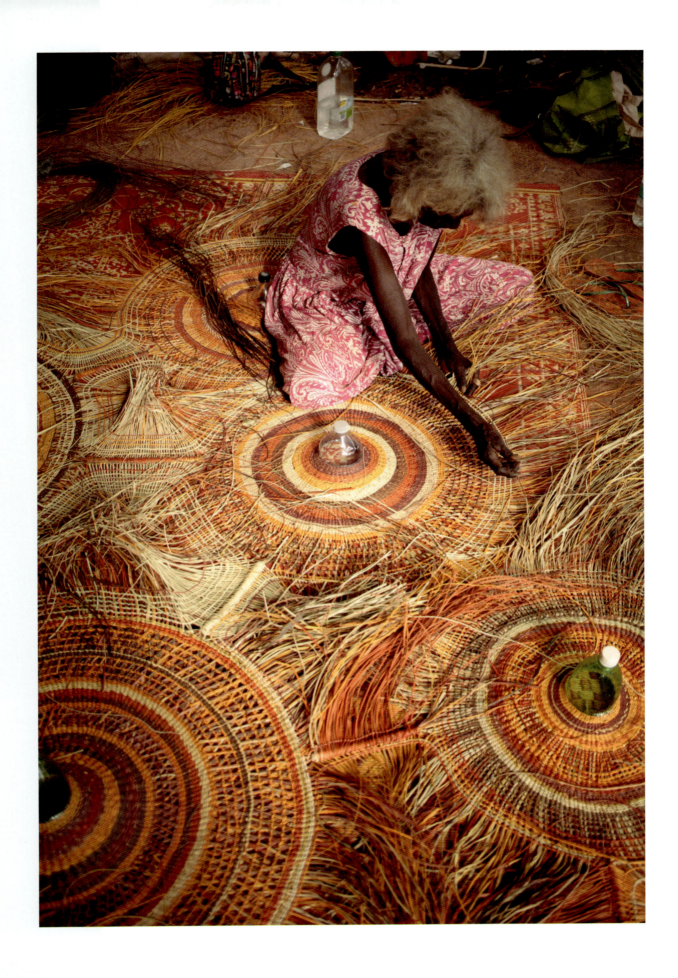

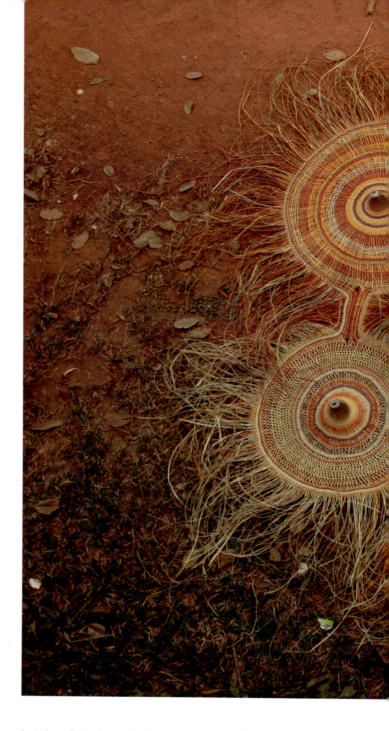

and cultural engagement alternated, providing a rich experience of the region's Aboriginal culture. The artisans use a natural fibre called pandanus, which is peeled off the leaves of palm trees with cutting tools, and after dyeing is left to dry in the sun. Boiling the fibre together with fresh roots, barks, and plant materials for their pigments, the palette achieved is seasonal, and echoes the hues of the surrounding territory. The entire process of mat-making is normally completed on the same day, giving them an immediate quality.

Without a clear idea of the outcome, each single lampshade acquired its shape by reflecting the round shapes of Aboriginal traditional mats, and by managing to integrate the PET bottle's form within their weaving technique. New ideas of bonding them together arose, suggesting weaving or tightly plaiting together the nine lamps' loose fringed ends to form one single lamp, reminiscent of the land's topography. "Yukuwa", a mixed-media artwork created in 1984 by Frances Djulibing, evoking the family tree and kinship lines, inspired the concept and collaborative design process of the lampshades' bonding. Connecting them in umbilical fashion emphasised Aboriginal kinship, transcending even blood ties. Mary, one of the weavers, explained that as the twin sister of David Gulpilil, the famous Aboriginal actor, each of her creations is made twice, owing to her dual vision.

The Ramingining inhabitants' territory, totems, and rich graphic symbolism of concentric circles, meandering lines and spirals are expressed in the visual language of the piece. Paying further homage to Djulibing's artwork, with clever spotlighting and experimentation with the height of the hanging bulbs to create shadows and reflections, a tensioning system was developed. Each PET bottle was suspended by a steel cable, keeping all areas balanced, and enabling the lampshade's vast surface to flatten and float in the air.

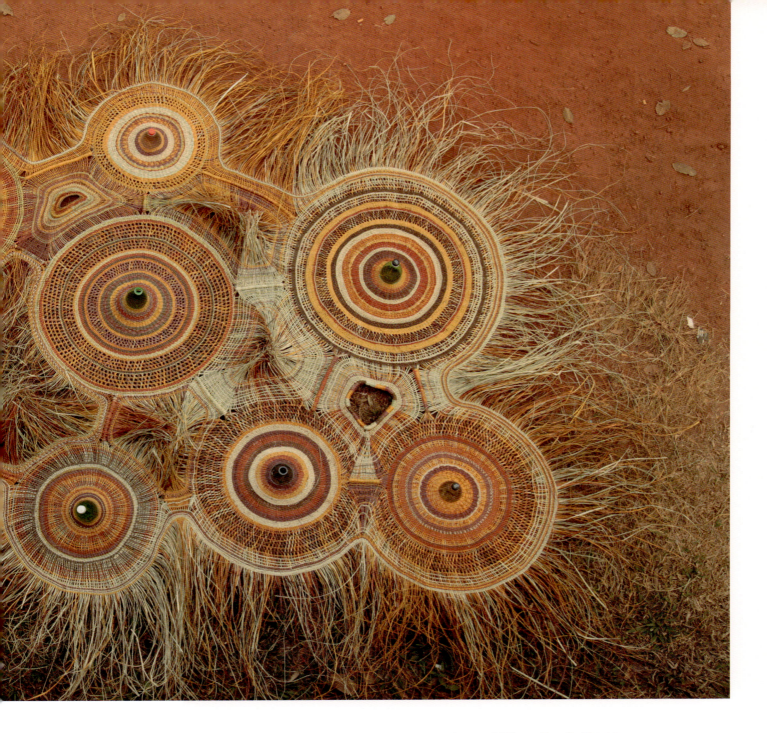

During a remarkable experience of cultural immersion, family bonds were extended, with Mary, Lynette, and Evonne, three of the talented weavers, adopting Alvaro and his partners, Enrique and Sebastian. Able to replicate the process, two unique "Bukmukgu Guyananhawuy" ("Every Family Thinking Forward") lampshades were created. One is held in the permanent collection of the National Gallery of Victoria, and the other by PET Lamp Studio in Madrid.

THAILAND

Craftsmanship has an important role in Thai society, and has long been a reflection of Thai peoples' creativity, ingenuity and perseverance, with meticulous and intricate skills that are passed down for generations. In a country with an abundance of natural materials such as coconut, rattan, bamboo, and palm leaves, Thai people are able to produce a range of beautiful handicrafts.

In 1978, assisted by Her Majesty Queen Sirikit's support Foundation, the Traditional Bamboo Handicraft Center was established in Phanat Nikhom, to preserve traditional folk arts and crafts, including the skills of bamboo-weaving techniques. The project was embraced by the wife of the town's mayor, who established a weaving workshop at her own residence, seeking out the community's expertise in wicker weaving. Today, under her son's management, and with support from the British Council, the project employs an increasing number of women, and has developed and expanded the heritage of wicker work, achieving national recognition.

In 2018, involving a very well-structured group of women weavers working closely together for two generations, and maintaining the highest standards of craftsmanship, PET Lamp Pikul was named after the flower of the tropical Mimusops elengi tree, from the region's forests. The flower grows in a geometric pattern, inspiring the traditional Pikul pattern which can be found in many of the crafts around Thailand. This type of bamboo basketry requires the skill of three craftspeople,

each one specialised in one of the techniques of the making process. The first calibrates the dimensions of the strip to achieve the required shape, which is partly determined by the nature of the fibre. A hexagonal base frame is created as a warp, upon which a second artisan weaves the traditional Pikul pattern with coloured bamboo strips. Once the design is applied, a third artisan creates two rigid rattan rings, forming the lamp's pattern template.

In order to transform the artisans' lampshades to a marketable state, and offer individual lamps as well as large installations, ACdO, as an industrial design studio, designed a central cylindrical rosette, from which the different cables fall. Compatible with each lamp's ethnicity and material, the choice of cable colours and materials, and the protagonism of the bottle top and its neck within the lampshade's structure, are important aesthetic considerations in communicating the lamp's history to the client. In each collaboration, it is evident that rather like cooking, passing on cultural basket-weaving methods amongst female family members imparts a sense of cohesion. The work, as well as facilitating flexibility with childcare, and contributing to economic independence, has provided distraction and respite from the restraints of very masculine controlling societies, and an excuse to leave the home. Having successfully developed a contemporary cross-cultural design product, the personal stories and dreams of its predominantly female artisans have been imprinted onto PET bottles with each woven stitch.

Left:
PET Lamp Pikul. Making of hexagonal basketry pattern of the pikul flower.
Photograph: © studio Alvaro Catalán de Ocón.

SIYAZAMA PROJECT "STORY VASES"

Amongst the nine provinces in South Africa, KwaZulu-Natal's population has been the worst affected by the HIV/AIDS pandemic, with one quarter of its population suffering from the disease, and many more women than men becoming infected. In 1999, after running a series of creative workshops with small groups of rural craftswomen, using textiles, basketry and beadwork, Dr Kate Wells, then Research Professor at the Durban University of Technology, with a keen interest in arts and health, founded The Siyazama Project. In isiZulu the word means "we are trying"; a title chosen by its project members and poignantly expressive of their circumstances.

This arts-based strategy was initially devised as a means of providing accurate information and education about the transmission and prevention of HIV/AIDS. It served as an outlet and visual metaphor for creative expression and communication, and sought to address the potential of their long-held traditions in the craft of beadwork, and to impact positively upon the empowerment of women in rural communities. Today, the Siyazama Project operates as a bead craft collective. By creating marketable work, which is positioned mainly for the souvenir market, the main, if not sole, source of income is generated for many of its members.

Most of the rural women bear the responsibility of the smooth running of their households; caring for chickens and cows, growing their vegetables, working their fields, and ensuring that their children are fed and go to school, as well as, when time permits, passing on their traditional beadwork skills. Many of the Siyazama mothers have daughters who work alongside them, particularly when projects and new orders dictate the need. However, more recently, young people are opting for a different way of life from their parents in towns or cities, creating a further challenge to maintain and preserve these traditional skills.

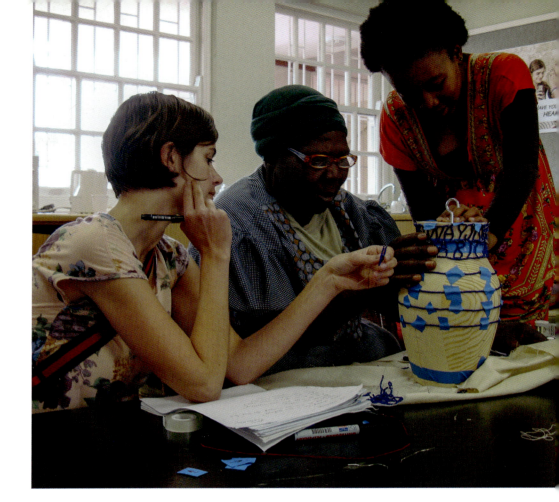

Opposite:
Story Vase by Siyazama Project + Front.
Workshop DUT, with Tholiwe Sitole,
Durban 2010.
Photograph courtesy of Front.

Right:
Story Vase by Siyazama Project + Front.
with Thando Mchunu, Tholiwe Sitole,
Charlotte von der Lancken.
Photograph courtesy of Front.

Zulu cosmology, its cultural taboos, and the concept and practice of respect, known as "hlonipha", which forbids discussion about personal, intimate and sexual matters, are extremely powerful factors amongst the rural communities within the region. It is obvious that the implications of a very male-dominated "hlonipha" culture verbally constrains and disadvantages women in any number of different circumstances. These include their position within the family, providing testament in a court of law, and articulating physical ailments in order to receive the appropriate healthcare. Ancestral spirits, known as "amadlozi", are still regarded as having

powers of intervention, and many rituals and prayers incorporate this belief and their ancestors' potency in the ability to prevent or guide one's actions.

With the aid of Swedish grant funding, the initial approach for the Siyazama Project's collaboration with Kate was initiated by Ikko Yokoyama and Renée Padt of Stockholm-based Editions in Craft, a curatorial platform linking traditional skills with contemporary design practice. Editions in Craft then invited the involvement of Front, a Swedish design collective of three women, Sofia Lagerqvist, Charlotte von der

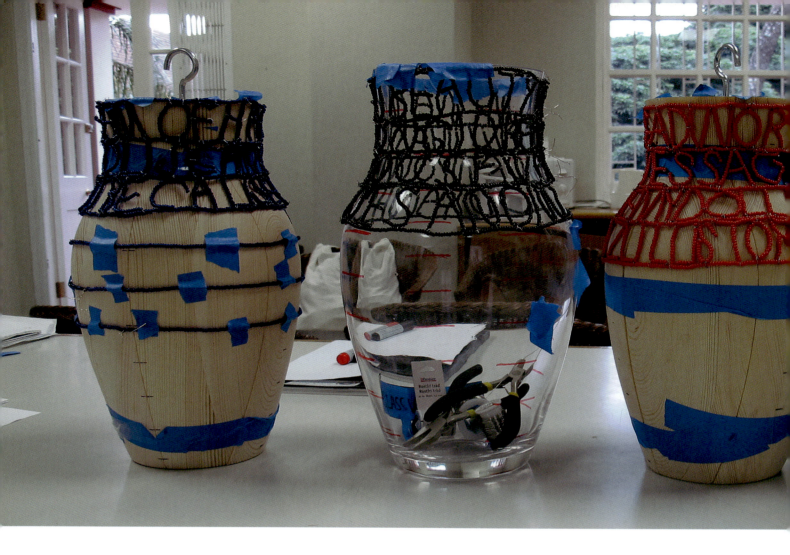

Lancken, and Anna Lindgren. Their concept and role was to employ a preliminary interviewing and recording process, whilst exploring the narrative potential of beadwork, in order to translate their stories into beaded sentences, which could then be blown into glass vases.

In 2010, a small group of approximately ten rural beaders from Muden, Msinga, Bhohononu, Siyanda and Tugela Ferry, in KwaZulu-Natal, who had been making the beaded cloth dolls for The SIyazama Project, were selected for participation in a ten-day workshop programme. Recognising limited abilities in speaking or reading English, and wishing to retain respect for their

Zulu cultural traditions and codes of communication, conversations were encouraged. Questions were posed that addressed the women's responses to living with AIDS, the meaning of beadwork, and such issues as their hopes and wishes, career choices and desires for change.

With assistance in interpreting from Zulu to English provided by Jean Shange and Thando Mchunu, the personal stories of Beauty Ndlovu, Thokozani Sibisi, Kishwepi Sitole, Tholiwe Sitole and Lobolile Ximba, are testament to the experiences of women's rural life in post-apartheid South Africa. The women, now accustomed to and at ease with being interviewed, have

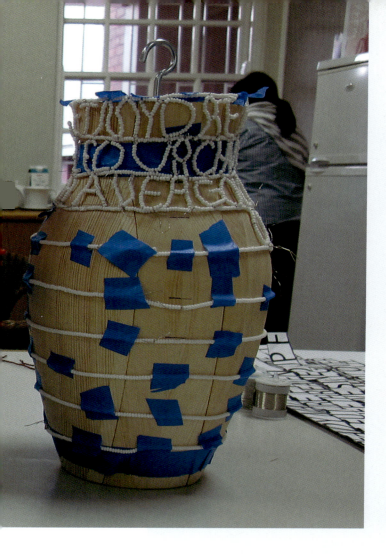

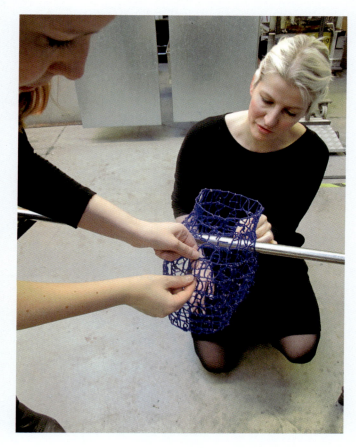

been surprising when revealing some of their aspirations and preoccupations. Amongst others, Lobolile had expressed the desire to become a doctor, and Kishwepi shared her unhappiness about a change in her family situation, when a new wife was recently introduced.

The making process involves selection of the individual responses, in the form of continuing sentences, being printed onto paper, cut to fit, and pasted snugly around a vessel-shaped wooden form, serving as a template for the eventual glass vase shape. The beads are then threaded onto twisted metal wire, mirroring exactly the printed words. Completion of the sentences can take up to two weeks, and using the correct wire is crucial,

Opposite:
Story Vases by Siyazama Project + Front. Workshop DUT, Durban 2010. Photograph courtesy of Editions in Craft.

Above:
Story Vase by Siyazama Project + Front. Glassblowing with Sofia Lagerkvist and Anna Lindgren, Konstfack, Stockholm, 2011. Photograph courtesy of Front.

because of its later exposure to heat in the glassblowing process. Once assembled, the wooden block is removed, and the vase net left intact. The work is then sent to specialist master glass blower Reino Bjork at Konstfack, in Sweden.

Craft product quality is constantly addressed, and as the women have gained increasing knowledge about the HIV/AIDS disease, this seems to have been evident in their work, and has also provided a vehicle to share their stories and experiences within the family. Preferring their independence, they tend to both create and deliver their work separately, only managing to do their craft when they have finished their chores at home. When workshops are based at the university, most of the beaders, living in different remote villages, come into Durban individually, in so-called "mini bus taxis".

Beadcraft has always been an important part of Zulu tradition, and is a medium which is comparable to the written language in its narrative and communication capacity. Historically, the colours and motifs within the work have had the power to convey a range of sentiments to family members, lovers and friends. It has been widely used for creating jewellery and souvenirs for the tourist market. In the Siyazama Project, the rural bead dollmakers involved used the medium to both tell traditional ancestral tales, and also to communicate their current personal stories and concerns.

Before the concept for the Story Vases was conceived by Editions in Craft, fully beaded vases had been made successfully for an Australian client, created using solely white beads over ready-made vases of differing sizes. Since it is always Kate's task to queue for the bead supply amidst other local beadworkers in a tiny Durban shop, the women have been quick to express their preference for the best Czech glass beads for the current Story Vase series. Being made of 100% glass ensures that the vases can safely be blown at high temperatures. They are also stranded, so that each bead has consistency of size and a hollow centre for threading, which, although making for speedier production, means that they are far more expensive than the glass beads from the East.

To ensure an increased income for the beaders, Kate and her students have actively created marketing campaigns. The Siyazama Project also originally obtained funding support from The British Council; and although they had initially been sceptical about the marketability of beaded creations conveying such disturbing messages, the generation of wider markets

"I believe my beadwork can get the message across. Some of my dolls tell old Zulu stories, others tell their own personal story. I once made a doll of a mother beating up her child because she had HIV. This doll was to tell people not to hit people who have HIV."
KISHWEPI SITOLE

Left:
Story Vase by Siyazama Project + Front. (detail)
Photograph © Anna Lönnestan.

and new audiences became quickly apparent, and ultimately resulted in the Project's methodologies being adopted for projects further afield, in Kenya and Uganda.

The explosion of tourism in South Africa has created a substantial increase in the interest and marketability of crafts. In 2018 the Siyazama Project, already having received extensive international exposure, had its beaded dolls included in an exhibition with Native American and Australian aboriginal dolls, at two large shows in Durban, which the women beaders also attended. The Story Vases is a limited-edition ongoing series, produced by Editions in Craft. Every beaded item created within the Project is a unique piece, and has a certificate attached bearing the maker's name.

From the outset, the impact upon the economic aspects, health and well-being of the women in The Siyazama Project has been the paramount intention. It has been clearly demonstrated that change in society can be most effected when traditional knowledge systems are respected, and the energy, passion and commitment of several collaborating partners is harnessed. The creative arts can be a potent force on health and well-being, both individually and collectively, resulting in a measurable increase in self-esteem, confidence and wealth. The Siyazama Project has ensured that, particularly during the AIDS crisis, the women are regarded as esteemed citizens, with their views worthy of being heard.

"The last time I bought something for myself was in 2007. I bought myself a skirt and a pair of red All Star sneakers that I love. My dream is to go overseas to have the experience of an aeroplane. When I would be up in the air I would close my eyes and relax."
THOLIWE SITOLE

Below:
Story Vase by Siyazama Project + Front.
Photograph © Anna Lönnestan.

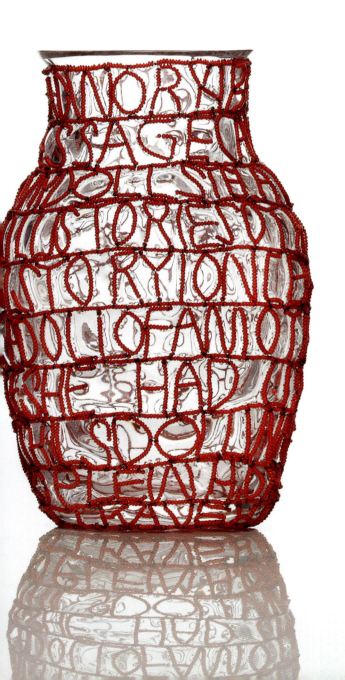

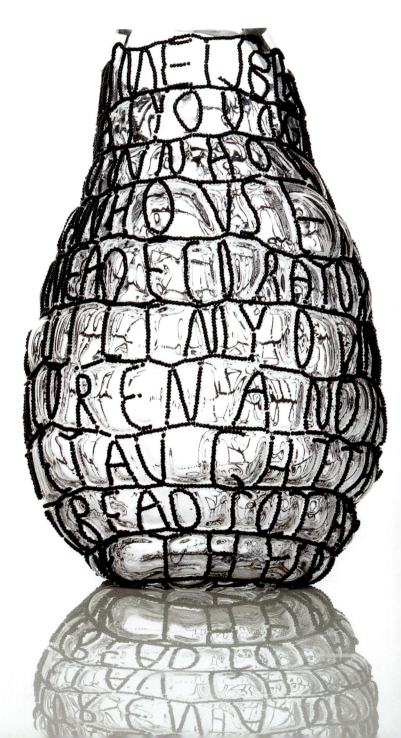

SUJUNI EMBROIDERY

Although also seen in Chattisgarh, Jharkand, and parts of Uttar Pradesh, the drawn stitched work of Sujuni was initially developed in the small village of Bhusara, 85 km from Bihar state's capital, Patna. Maithili being the local language, and Hindi the predominant religion, it lies in relatively close proximity to Mathila, famed for its Madhubani narrative painting traditions. Although Northern Bihar is particularly fertile and scenic, the lush landscape belies an area otherwise fraught with the complexities and tensions that exist within its population, and tainted by the despair and depression experienced by many of its women.

A predominantly patriarchal culture still persists in many rural and urban areas, with overt gender discrimination, regarding male children as assets, and females as a liability, and playing a significant role in the practices of female foeticide and infanticide. The violent acts of dowry deaths, bride burning and other crimes against women all contribute towards the fact that women in many sections of Indian society suffer from low status and lack of recognition. An attempt was made in 2015 by Prime Minister Narendra Modi to launch an initiative aimed at changing mindsets towards gender issues. However, due to disproportionate funds being spent on publicity rather than the scheme's implementation, little progress has been made.

Since its earliest function as a blanket or swaddling wrap for a newborn baby, bearing religious symbolic imagery,

the term "sujuni" is said to derive from "su" meaning "facilitating" and "juni" meaning "birth". However, an alternative meaning for the term possibly comes from the Persian word for needle, "sozni". With their origins dating back to the 1800s, they were once dismissed and ill-documented, possibly due to their weight and bulk making them difficult to carry, and being regarded as functional rather than prized decorative objects. Their layered fabrics and running stitches somewhat resemble the Kantha work of Bengal and Bangladesh, predominantly practised by Muslim women. However, the essential differences between "sujuni" and "kantha" lie in their different storytelling traditions and depictions, with the surface of "sujuni" being filled with straight lines of running stitch, as opposed to the multi-directional and circular running stitch of Kantha.

In the early 1990s, Sujuni's revival as a craft practice was thanks to Nirmila Devi, of Mahila Vikas Sahayog Samiti (Women's Co-operative Development Organisation) and to Viji Srinivasan, who, prior to starting Adithi, the non-profit women's organisation, had been with the Ford Foundation for five years. Discovering a ready market for themes connected with AIDS awareness and female empowerment, Viji was responsible for encouraging the women of Bhusara to include social and political themes within their work. With the aim of preserving its original style whilst incorporating creativity and diversification, the earliest work was commissioned by the Handlooms and Handicrafts Centre in Delhi.

Right:
Women creating Sujuni.
Archana Kumari, 2008.
Photograph © Dr Skye Morrison.

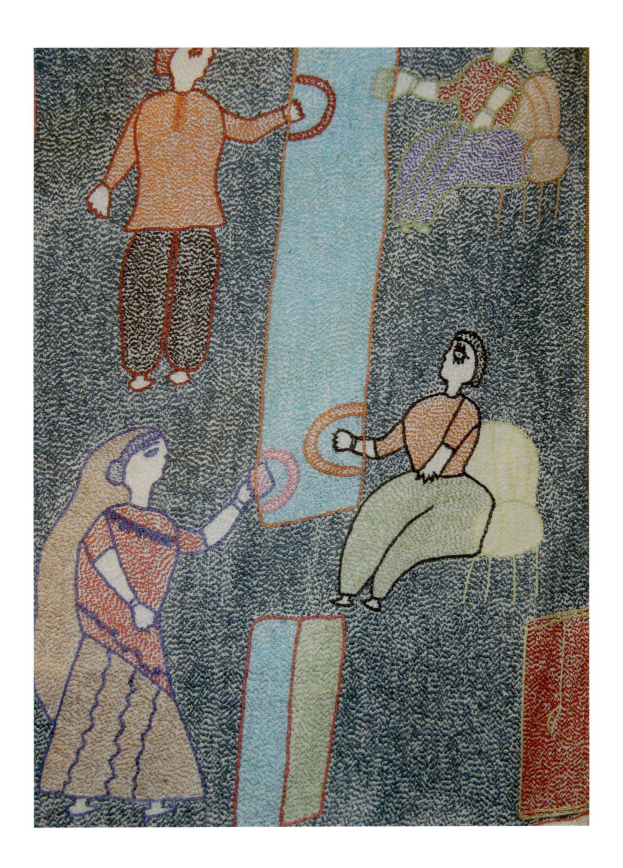

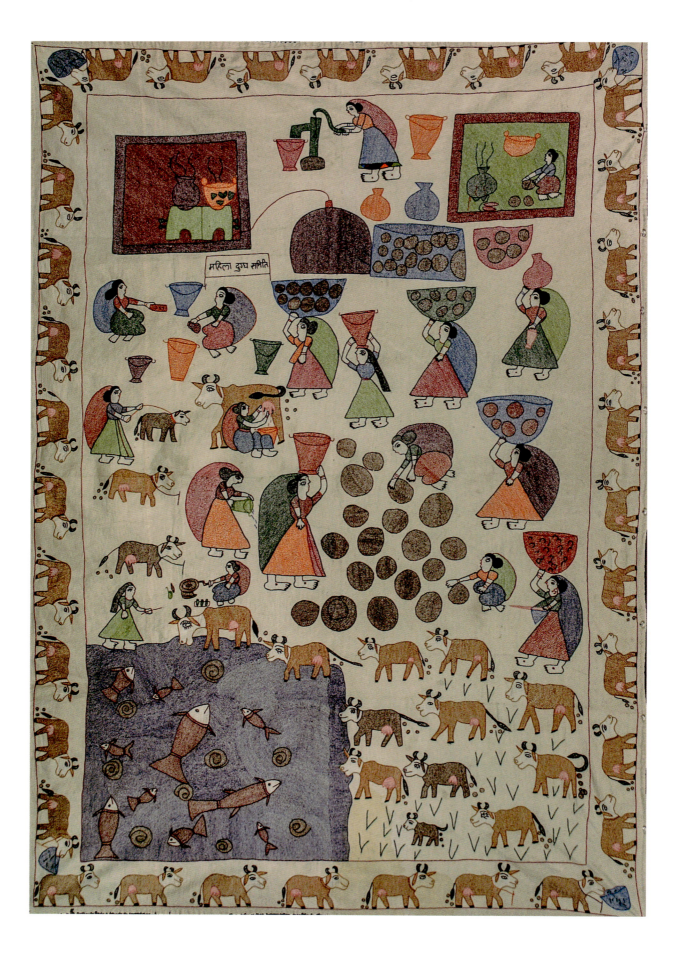

In 1996 Canadian design researcher and educator Dr Skye Morrison, together with her friend and colleague, fibre artist Dorothy Caldwell, began working with "sujuni" whilst conducting a textile research trip, aided by designer and activist Shurshindu Ghosh as guide and interpreter. In 1998, returning to Bhusara, they ordered 20 "sujunis" and five "khatwas" (appliqué works), and with funding from the Ford Foundation, co-curated a "sujuni" exhibition with the Asia Society in New York, highlighting the role of women and their related issues within that community. Around the same time, Laila Tyabji, one of the founders of Dastkar, a Delhi-based NGO promoting the revival of traditional crafts in India, began working with them. Travelling each year to India, Skye was accompanied by "sujuni" women artists to Mumbai in 1999 for an exhibition of their work; and together with Dorothy, organised the first international exhibition at the Canadian Museum of Textiles in Toronto, entitled "Stitching Women's Lives", consisting of "khatwa" and "sujuni" textiles created in Bihar. This was followed a few years later by an exhibition in London.

During that period from 1996-99, quilts were commissioned based upon specific themes which had poignancy and particular relevance to the women's lives. All work was stitched on new fabric, and by 1998 Skye insisted that only Bihar "khadi" (woven handloom) was used, to increase the work's value in foreign markets. On one trip Skye brought with her the NFB film, "Who's Counting? Marilyn Waring on Sex, Lies and Global Economics". A Patna screening of the film, translated into Hindi, informed the imagery, developed by Nirmila Devi ("drawing Nirmila") in the "Cow Dung" "sujuni". Dung's function as the provider of fuel, fertiliser, and building material, and, collected and carried by women, so central to their daily relentless work and their very means of survival provided excellent subject matter for a heavily stitched "sujuni". Domestic everyday items and tools are evident in the stitched designs, as well as instructional narratives concerning the nuptial chamber, and the dangers of unprotected sex. Always needing external prompting and specific direction, stories of violence and day-to-day toil, but also those embodying their future aspirations are revealed, referencing the wish for education, travel, family well-being, autonomy, and self-sufficiency. However, rather than being politically motivated, the impetus for the collection was based purely upon ensuring guaranteed payment for the women, and achieving their ultimate economic independence.

Tragically, following the embezzlement of their entire wages for their exhibited work in London, the group fell apart. In 2005 Viji insisted that Skye move to Bhusara with her, to undertake a 40-day NABARD (National Agricultural Bank of India) funded project to restart "sujuni" with a group of 35 women, led by Sanju Devi, forming Sujuni Mehila Jeevan, (Stitching Women's Lives) echoing the title of their exhibition. In addition to stolen wages, it was soon discovered that the group's centre,

Left:
Cow Dung sujuni. Nirmila Devi, 1999.
Photograph © Dr Skye Morrison.

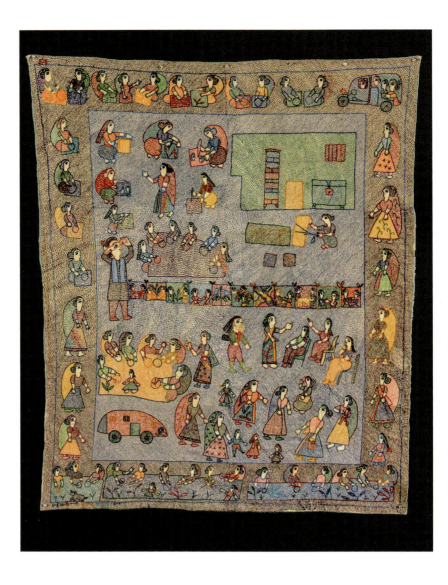

Right:
NABARD workshop.
Photograph © Dr Skye Morrison.

Opposite right:
Sujuni workshop with
Sanju Devi, Jaipur.
Photograph © Dr Skye Morrison.

built for them by the Swiss Red Cross, had also had all its supplies and materials raided. Facing numerous problems, including abandonment of the group by Viji after only 12 days, leaving Skye stranded and without an interpreter, and invasion by election crowds, the group managed to complete the project and become the enterprise which is flourishing today.

Never having been to school, and consequently being non-literate, rural Hindu village women are neither used to telling their own stories, or expressing personal viewpoints. Men are the storytellers at traditional gatherings, women being left to listen passively, prevented from experiencing life outside their own homes, and heavily restricted in their movements, especially as young brides in arranged marriages. Their visual language originates from their physical environment, their cultural and religious symbolism and iconography. Both artistically and in terms of her ability to translate ideas, Nirmila Devi ("Drawing Nirmila") had been a leading member of the group, drawing many of the designs of larger works onto the cloth for multiple

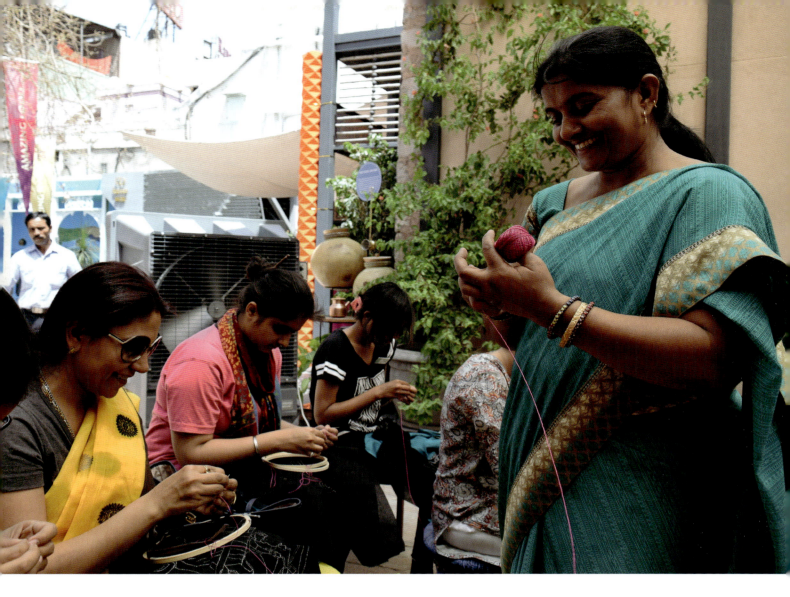

women stitchers. In 2003, Dorothy and Skye bought the women an auto rickshaw, serving as inspiration for Nirmila Devi's drawing of "Women Driving Rickshaws". Sadly, Nirmila died from tuberculosis in 2009.

Now in her mid-forties, having been married at 13, and with three children, gifted embroiderer Sanju Devi received both a UNESCO award in 2018, and recognition by the Crafts Council of India and the State government. Having rediscovered the embroidery traditions of older female family members, she began working with Bihar-based ADITHI craft groups, and regularly attending craft fairs in Delhi. Acknowledging the need for providing women with a facility for exchanging mutual emotional support, and a sanctuary away from their four walls, together with the aim of reviving a dying craft lacking in adequate government marketing support, Sanju runs Sujuni Mehila Jeevan from her home. Formerly, commercial aspects of "sujuni" had been controlled by men; but as role model, mentor, and marketing manager, and with support from her policeman husband, she oversees the running of the enterprise.

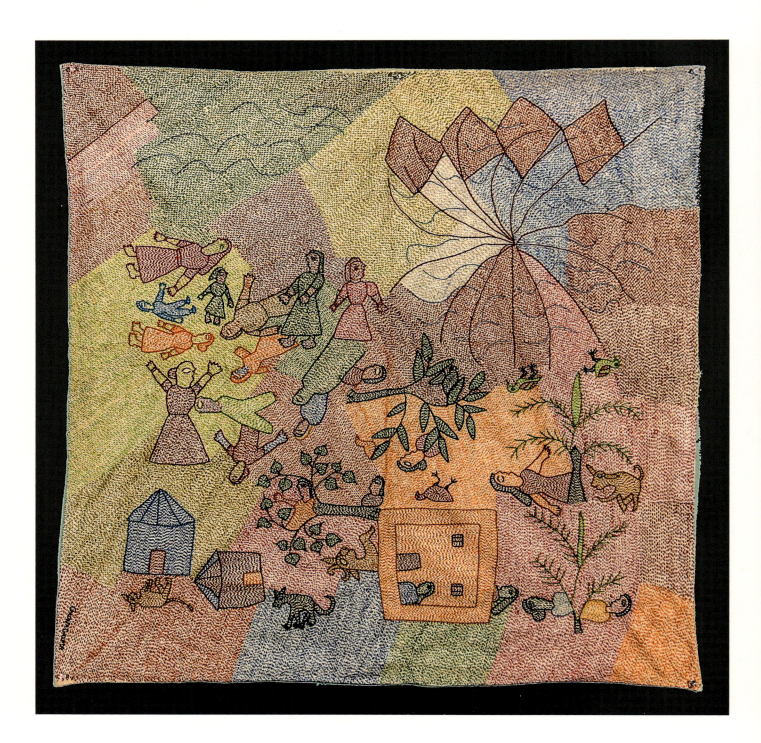

Archana Kumari was born in the neighbouring village of Ramnagar, Bihar. Taking up "sujuni" embroidery for Adithi, she was selected to take part in the exhibition organised by the Asia Society. Meeting Laila Tyabji around this time, they developed a close relationship with Laila becoming her mentor and inspiration. Dispensing with her society's norms and conventions, at the age of 14, barely speaking a word of English, she left to study in the US. Back in her village, both her studies and "sujuni" work continued, collaborating with several NGOs, including Dastkar. She formed a particularly close bond with Skye, who took her for one week to the National Institute of Design in Delhi, where she eventually undertook a degree in Fashion. Recognising her talent and determination, she received, in addition to understandably limited parental help, financial assistance from ADITHI, NGOs, the Crafts Council of India, Skye, and Laila, who acted as her guardian in Delhi. In 2010 she had her own stall at Dastkar's "Nature Bazaar", and from this success has continued taking part in regular exhibitions, expanding her base of regular clients stretching as far as Japan and USA. Based in Delhi, she started her small company, Aunam, and with her own designs, has around 45 girls stitching "sujuni". Making decisions that were regarded as blasphemous and unacceptable within such a conservative society, Archana Kumari, the female entrepreneur, whose earnings possibly exceed those of many males, is now a figure of awe in her village.

Traditionally women used recycled saris and dhotis as the base cloth for "sujuni". More recently these have often been replaced by new or recycled cream-coloured material. With the images in their designs first being outlined, they are then filled in with coloured stitches depicting different layers of Indian village life. The outlines of the design are transferred onto the cloth with the aid of a tracing wheel and paper, and a mixture of kerosene and blue chalk powder. Using an embroidery frame, the entire surface of the fabric is covered, with the number of stitches varying between 100 and 210 per square inch, embroidered in straight lines with cotton thread which, if not bought at the local market, has often been unpicked from the borders of saris. Using only three or four variations, the stitches are sometimes worked through a single or double layer of cloth. The outline or ornamentation is normally chain-stitched in a dark colour, whilst the background is heavily worked with thread of a similar colour to the cloth, producing a slightly undulating surface. In the same-sized running stitch, the motifs are filled in with colourful threads.

Originally having depicted village tales, Hindu religious themes, and stories from the Ramayana, with flowers, birds and rich symbolism, such as the fish for fertility, and the peacock's protective qualities, many of the motif drawings were traced onto the cloth by girls specifically trained to do so. Making decisions about colours, composition, images and their proportions

Left:
Tsunami sujuni. Archana Kumari, 2004.
Photograph © Dr Skye Morrison.

remains a somewhat alien concept to many of the women. The charm of "sujuni's" spontaneous curvaceous, child-like qualities, and its potential for adding new motifs, colours and design elements has helped some women, however, to gradually gain confidence in the initial drawing stages. As both designs and female clusters have developed, "sujuni" has further evolved as wall-hangings, and found its way into fashion embroidery and furnishing textiles.

Saris, stoles and kurtas, cushion covers, bedspreads, and wall-hangings are made for selling at exhibitions and fairs in Tamil Nadu, Patna, Delhi and Jaipur. Currently the production of "sujuni" is done in at least 15 villages around the district, involving approximately 400 women and girls, who are now able to earn extra money: between 3,000 and 4,000 Indian rupees each month, substantially helping with the running of their households. However, Sanju is fully aware of the difference that could be made in the lives of village women if full government support was given, allowing the craft to gain well-deserved global recognition.

Paradoxically, in an increasingly high-tech globalised economy, women's handicraft still risks being undervalued and negatively associated with a primitive culture. Commercially, "sujuni's" medium and contemporary themes have scope for expansion through well-organised craft collectives. In 2005, as a result of Skye's NABARD workshop intervention, the use of two contrasting coloured fabrics on the textile's front and reverse was developed, emphasising its quilted appearance and consequent increased marketability.

In 2006 "sujuni" received a GI (Geographical Indication) tag denoting its specific origins and reputation. The Asian Heritage Foundation has hosted exhibitions and outreach empowerment programmes, aiming to bring together artisans and craft clusters, to showcase their work. Sujuni Mahila Jeevan had an exhibition of their work in Chennai in 2009, entitled "Selvedged Voices", curated by Skye Morrison, to commemorate the visit of Michelle Bachelet, President of Chile.

Compared with abysmally low average rates of pay for female agricultural labour, "sujuni's" modest equipment and narrative capacity paired with their stitching ability bestow many women of the Bihar area with an essential alternative to disempowerment and possible starvation. With pride in their work, and in some cases motivating them to travel beyond the confines of their homes, even with exhibition possibilities abroad, it provides a viable means of entry into the economic mainstream. With additional assurance provided by organisations, such as SEWA (Self Employment Women's Association) "sujuni" has the potential to continue supporting rural women and their aspirations economically. Just as importantly, with the right encouragement it has the expressive and communicative power to facilitate the transformation and emancipation of women's lives in the stitching process.

Right:
A simplified example emulating sujuni's style and subject matter. Photograph © Robbie Wolfson.

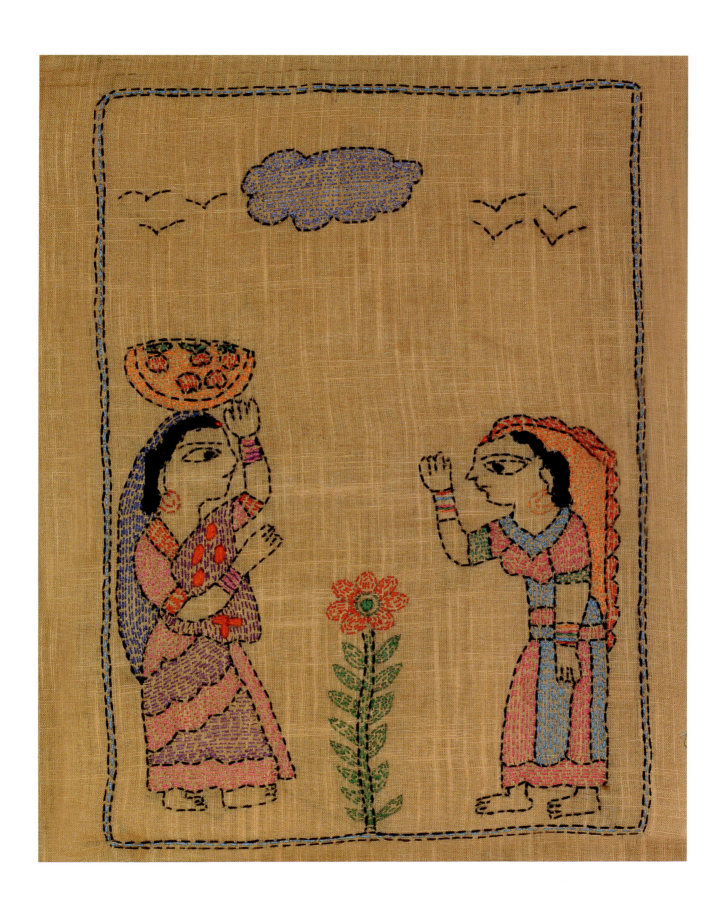

WAYUU MOCHILAS

Scattered in disperse communities across the arid desert peninsula of La Guajira, more than 200,000 Wayuu live in their "rancherías" (townships). The Wayuu's ancestors, of Amazonian descent, having learnt to survive such extreme circumstances, gradually started settling along the Caribbean coast and the Antillean islands north of Venezuela thousands of years ago. Several cultures developed in the peninsula; today they are Colombia's largest indigenous group. Still speaking their own language, maintaining many aspects of their particular culture and traditions, and living by their own indigenous laws, they maintain both nationalities of Venezuela and Colombia. La Guajira is amongst the driest and hottest places in Colombia, situated at its northern tip and next to the border with Venezuela. It experiences harsh weather patterns, with lengthy droughts, blistering midday heat and extreme rains.

The Wayuu's existence in La Guajira is hugely determined by the two principal forces of nature: water and earth. Access to a clean water supply for drinking, cooking, bathing, and irrigation is a constant endeavour. Increasingly being forced to buy both water and food instead of continuing to be able to successfully grow their own crops, such as yucca, beans and fruit, there is a relatively high rate of malnutrition, disease, and infant mortality. Various factors such as poor government organisation and decisions, corruption, drought, the re-routing of rivers, dam building, contamination and pollution caused by local large-scale open-cast coal mining, have all contributed to the diminution of crops and livestock.

Additionally, racist attitudes and an extremely limited education system have created pitifully few opportunities for the Wayuu people, especially women. Some communities have benefitted minimally from the provision of training in more efficient agricultural practices, financed by the World Bank and other organisations. Although there has been a degree of assistance by government, NGOs, mining and other corporations, with the implementation of improved access to water, electricity, education, and healthcare, this has, as yet, been far from adequate.

Although they have always maintained contact with western society, the preservation of their language, Wayuunaiki, and their customs, cosmology, and art, continue to play an important role in Wayuu culture. "Sukuaipa Wayuu", the intangible behavioural code of their heritage, acknowledged by UNESCO, is their normative system whereby disputes are settled by the Wordsmith or "Palabrero" within the community, issuing an in-kind compensation agreement, and restoring harmony.

The Wayuu believe in the connectedness of all earthly living things, each possessing a soul and a language. Historically, their expertise in horticulture and their hunting and fishing skills account for their survival. Today, with difficulty, their main economic activities are fishing, goat breeding, and small-scale subsistence farming prior to the rainy seasons. Typical homes are small, constructed from clay made from the surrounding red earth and vertical and horizontal pieces of wood. They normally consist of two rooms, with hammocks instead of beds for sleeping.

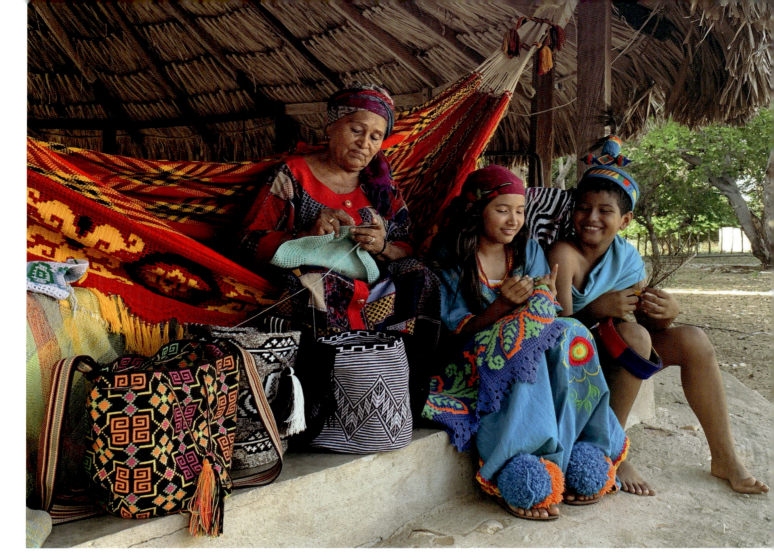

Above:
Three generations of Wayuu.
Photograph © Danis Cohen, Wayuu community.

The lineage system within Wayuu culture is determined by the maternal line. Women are the community leaders, setting the rules and responsible for decisions. Girls inherit their maternal surname, and are taught everything by their mothers. Many traditions and rituals are connected to female initiation rites and the passage from adolescence to womanhood. From around the age of ten, Wayuu girls are sent to live with their maternal kin, their aunts or grandmothers. Being descendants of the Caribs and Arawak peoples, known for their strong weaving and oral traditions, most women have particular expertise in weaving traditional "mochilas" (bags), and "chinchorros" (hammocks). According to certain traditional female legend versions within the Wayuu community, the origins of their ancient crochet techniques are believed to derive from the teachings of a spider named Walekeru.

"I have been working for six years. I have done very well with the SENA. I have managed to teach many displaced people."

SENAIDA PANA. SENA INSTRUCTOR.

One of the versions tells how a Guajiro hunter named Irunúu met a disadvantaged girl named Walekeru on his way home. Taking pity upon her, and regarding her as the daughter of his soul, Irunúu took her to his family home. However, this greatly displeased the rest of the family, who treated her badly when Irunúu was out of sight, oblivious of the fact that she was, in fact, a master weaver. Every night when the rest were sleeping, she transformed into a beautiful girl, and pulling colourful threads from her mouth, wove the most exquisite work. One night, Irunúu discovered the beautiful woman and her woven masterpieces, and fell deeply in love with her. Walekeru insisted that the secret must be kept. One day, Irunúu was invited to an event by well-disguised evil spirits. On arrival, the spirits asked him where the beautiful fabrics he was wearing had come from. Knowing he must stick to his promise to Walerkeru, he refused to tell, until intoxicated with drink by the spirits, he revealed his secret. On waking the following morning, aware of his broken promise, he returned home. Attempting to embrace Walekeru, she instantly turned into a spider, disappearing to the mountains. Meanwhile, his sisters had been turned into bats. Heartbroken, but having saved Walekeru's threads and beautiful work, Irunúu sent them to a woman who could imitate the techniques and pass them on to generations of other Wayuu women, who, it is believed, have continued the traditions until the present day.

At the onset of the first menstrual cycle, when they are regarded as most vulnerable, it is customary for girls to enter a period of seclusion, either within a different section of the house, or in a separate hut.

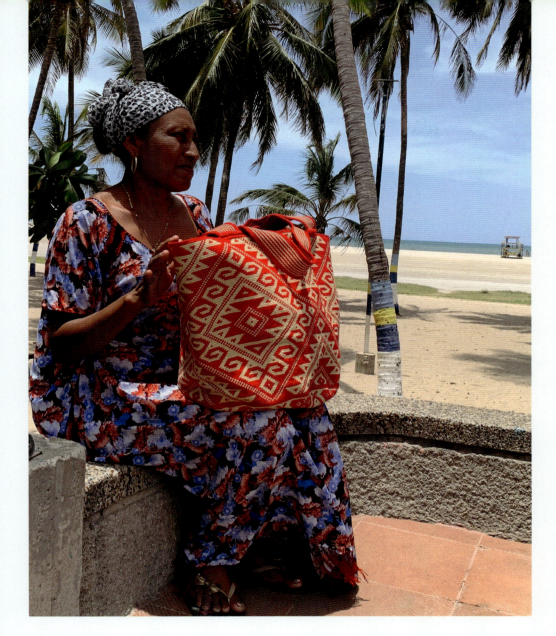

If still practised, although the duration of the rite can occasionally range from a few days to a few months, a period of one year is standard. Emphasising women's position in Wayuu society, during this "Puberty Rite", or "majáyüráa", her female elders represent the caregivers and teachers. The only gender permitted to have contact with her, they instruct her in all aspects of the Wayuu traditions, customs, culture and domestic tasks, and most importantly in the art of weaving, a symbol of creativity and wisdom, from which additional respect and status is gained within the community.

All childhood clothes are discarded, never to be worn again, and hair is cut short. The girl must lie completely still in a "chinchorro", after which she is made to vomit by being given medicinal drinks, in order to rid her of her child spirit. At the end of the confinement, the girl, although possibly still nine years of age in some cases, is recognised both physically and psychologically as a young woman, with a soul that has matured in the process. Formally introduced into society as such, ready to perform an adult role within her community, she is regarded as being responsible and respectful towards her matrilineage, and suitable for marriage,

subject to the offer of an appropriate dowry or wedding gift by a Wayuu man. Worthy of note is that no corresponding rite of passage is imposed upon a male. These traditions, and negligible formal training of teachers undoubtedly deny women of equal human rights, including access to adequate education.

Polytheistic in their belief system, with most of their spirits deriving from nature, Mareiwa is one of the Wayuu's principal deities. The appearance of ancestral spirits in the dreams of family members is a common experience for Wayuu people, carrying warnings or information about future events, and revealing the necessary course of action required by the dreamer. In such circumstances, for that person's protection, confinement rituals or "encierros" are also enforced, during which they are treated by a healer or family member with medicinal plant potions, and are cleansed and purged by enforced fasting and being repeatedly bathed.

Displaying evidence of their inherent creativity, bags and hammocks are almost exclusively made by women, but, having been trained early on to make fishing nets, Wayuu men very occasionally create the straps. Each bag is unique, historically with its "kanasú" or pattern expressive of a woman's way of life, her dreams, beliefs and values. The ancient, intricate, crocheted geometric motifs represent elements found within the familial and matriarchal structure of the society. Inspired by the Wayuu's cosmology

and their relationship with nature, the patterns reveal motifs such as fish eyes, animal tracks and stars, and symbolic states of being, such as the frog for fertility.

With the advent of younger generations of Wayuu women seeking jobs in urban areas of Colombia and Venezuela and absorbing aspects of western culture, certain ancient techniques have, however, been lost or forgotten. Although mochilas are cultural objects transmitting their history and tradition, contemporary versions with their vivid patterns, vibrant colours, and pompom adornments, have definite potential appeal to a wider global market. Though not yet achieving this, the aspiration and indeed necessity is for these to become their means of generating an income.

Wayuu women weave their mochilas within their communities once they have completed their household chores. Because the work is very transportable, it accompanies them everywhere, and they are able to continue stitching whilst having a conversation. Dependent upon the intended use and function, there are a number of different types and sizes of mochila. They were originally made for women to carry their textile threads, personal items, or for carrying work tools and equipment. When a man and woman are intending to marry, the future wife creates two bags, one for each of them, symbolising their union.

The technique is done with a crochet hook, its size determined by the scale and pattern. Either a single

or double thread is used to create the stitches, which in turn will determine its intricacy, durability, and the length of time to make the piece. It can take a week to weave a double thread bag, around 25 days to weave a large single thread bag, and more than a month to weave a hammock. Shaped rather like a bucket bag with a strap, each mochila has a circular base.

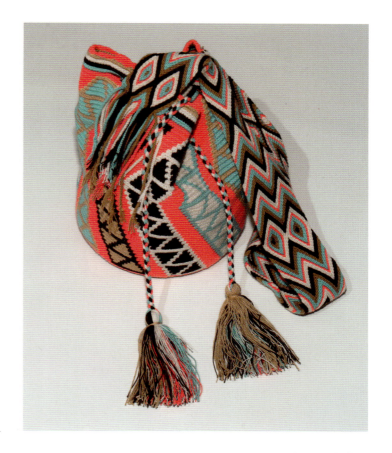

Right:
Zig-zag and diamond shapes within the mochila's pattern.
Photograph © Robbie Wolfson.

Below:
Some of the typically vibrant colour ways.
Photograph © Jade Longelin/Lombia + Co.

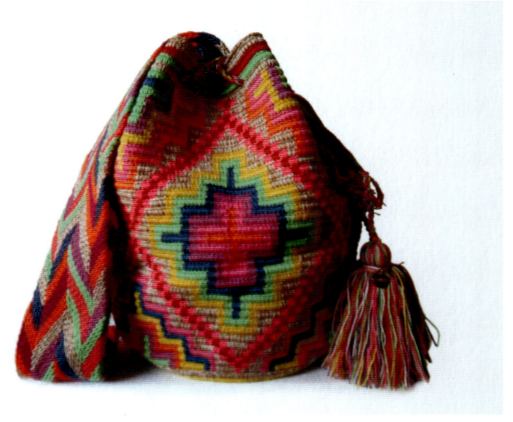

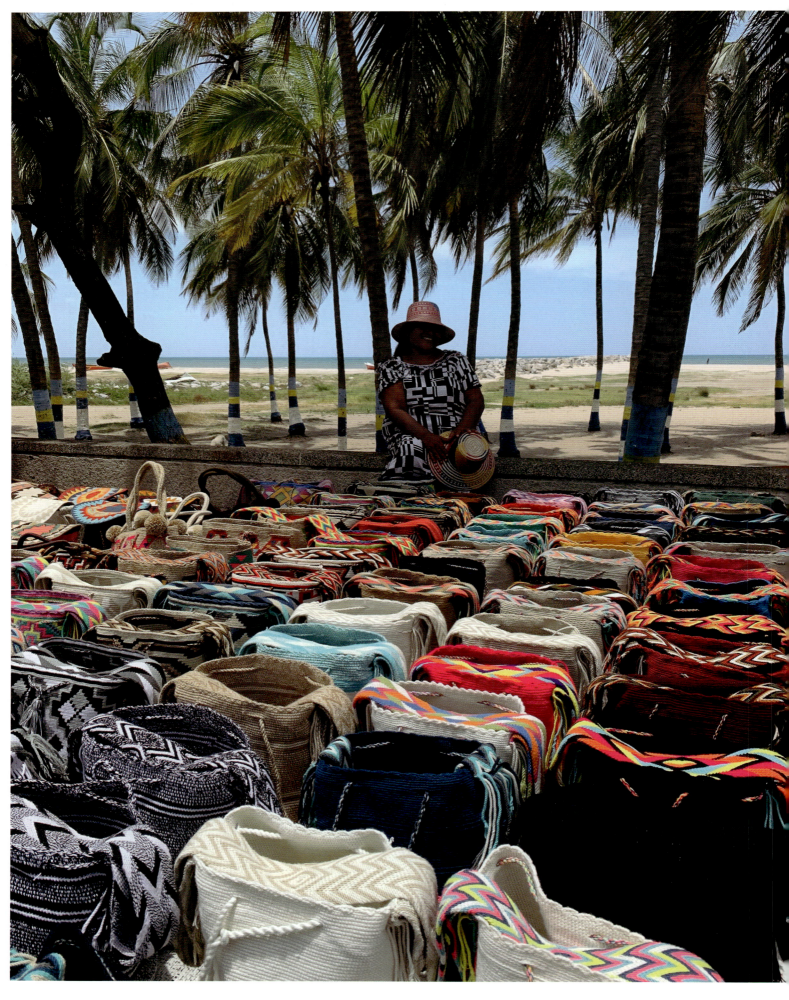

Dye pigments were once limited to available sources within nature, and typically included a limited range of mainly earthy colours, such as various tones of red, yellow, brown, and black. Quite some time ago, natural fibres such as agave and cotton were replaced by more durable acrylic yarns, bought in cities such as Riohacha and Maicao, which are able to hold synthetic dyes in a broad and striking spectrum of colours, and do not fade easily.

Wayuu artisans travel from their own communities to the cities and tourist areas, and sometimes a clan member will take the community's entire production to sell. They are often purchased by market sellers at an unreasonably low price, and then ultimately seen in retail stores bearing disproportionate sums on their price tags, confirming the lack of respect and recognition of Wayuu culture and the skill, creativity, and patience displayed. Since 2011 the term "Wayuu" has been used to affirm its origins and long-held traditions, attempting to avoid exploitation and cultural appropriation, and protect the intellectual rights belonging to the indigenous artisans, who otherwise might not have the means to do so. Some e-commerce sites respectfully acknowledge the artisans and their culture, pledging donations to charities or NGOs involved in helping Wayuu communities. However, sadly this is not always the case. On some websites, patterns and tutorials are offered to encourage the creation of one's own "Wayuu mochila", and in some cases, designs are plagiarised.

Government entities such as SENA and Handicrafts of Colombia, and certain private companies have helped the Wayuu women with training workshops aimed at improving design, trend forecasting, marketing, and pricing structures. With plentiful resources, and with a modicum of success, Chevron have supported the constitution process of the Wayuu Federation of Artisans, aiming to strengthen groups in the management of their resources, and ensure they receive increased payment for their products. They have also supported the publication of the book "Kanaso'u Wayuu Ancestral Drawings, Wayuu Art Iconography Library" which is the compilation of designs maintained in Wayuu memory for generations, and worthy of protection and preservation.

Amongst fairtrade enterprises such as Hilo Sagrado, Genesis, and Fundación Talento Colectivo, there is a concerted effort to encourage the continuation and quality of this specialised craft practice, and in so-doing, granting full-time employment to an increasing number of artisans, ensuring that every woman is fully acknowledged, and paid above the market price for each piece of completed work. Their main objectives are creating conversations about sustainability, global consciousness, human development, equality, women's rights and empowerment. These include the improvement of social and environmental standards, women's and children's education, including Spanish lessons, and the provision of school uniforms and materials, without all of which the Wayuu community could be cast adrift.

Left:
A variety of patterned and plain mochilas
intended for contemporary appeal.
Photograph © Danis Cohen, Wayuu community.

WOMEN'S CRAFT CO-OPERATIVES OF SOUTHERN MEXICO

The distinctiveness and strength of Mexico's textile production has been instrumental in shaping the country's visual identity. Already aided by the mechanisation of weaving, it has potentially provided the means of generating income for its indigenous population. With a gradual resurgence of interest in its culture after the Mexican Revolution of 1910-20, the country's unique visual vocabulary has also played a role in its re-entry into the tourist market. With a wealth of natural resources including timbers, plant materials, clay, minerals, animal hides, wool, cotton, and insects for the extraction of dyestuffs, the Mexican states of Chiapas and Oaxaca both produce a rich diversity of folk art, ethnic costume, and craft.

Home to the Tzotzil and Tzeltal-speaking Maya, the Highlands of Mexico's southernmost state of Chiapas has one of the largest indigenous and distinctive communities in Southern Mexico. Most Tzotzil families have traditionally made their livings by subsistence farming, growing corn, coffee, beans, chillies and squash, and by raising domestic animals. However, the viability of sustaining their communities through agriculture has diminished. Indigenous women have increasingly come to rely upon their textile expertise in spinning, dyeing, weaving and embroidery, as important contributors to the Maya economy. As well as producing traditional textile items for their own use, and as a means of preserving their personal and community identity, weavers create textiles commercially, as "artesanias" or handcrafted commodities, to satisfy the demands of the tourist industry, and increasingly the global market.

As well as being expected to help with domestic duties, girls are often taught how to extract natural dyestuffs, and to sew, embroider and weave, at a very young age. Practising first on a toy loom, at her mother's side, by the age of 12, a girl is normally sufficiently skilled to be able to contribute to the family income through the sale of her textiles. Before she is ready to weave her first "huipil", or tunic, a number of practice samplers are made. Patterns are relearnt from worn-out huipils and inherited samplers.

Although the fibres for making cloth rely less frequently now on being hand spun, the production of handmade textiles, in cotton, silk or wool is labour intensive. The foot pedal loom was introduced at the end of the colonial period, and is still in use amongst Maya communities in the Highlands. In Chamula, with its cold climate, sheep are reared for wool for the necessary manufacture of warm clothing, including the costly and time-consuming creation of women's skirts. The same pattern is seldom repeated, and It is not uncommon for a particular motif to be adopted, denoting the weaver's personal signature. Dependent upon the size and complexity, it can take between three days to six months to complete an article.

In sacred Maya tradition and mythology, and as shown in depictions of IxChel, the goddess and patron of weaving, brocaded cloth is also woven on a traditional backstrap loom, which is attached to the weaver's waist with a leather strap and passed around her back. With the advantages of being light and transportable, the far

end of the loom is fastened to a tree, so that according to the weaver's movements, the tension of the warp threads can be adjusted. A shuttle transports the weft thread through the space between the warps, or sheds, and a batten beats the lateral weft threads against the warp. Symbolising and portraying the Mayan vision of the cosmos, many pre-Columbian brocaded designs have survived to this day.

Both the wearing of traditional garments or "traje", and their adherance to the region's aesthetics are considered to strengthen communal solidarity and beliefs. Indigenous textile production is vibrantly colourful, and intricately decorated with cosmological, geometric, and locally inspired zoomorphic and anthropomorphic motifs on skirts, belts, rebozos, blouses, huipils and shoulder wraps, created for daily and ceremonial use. Women's huipils are still handwoven in separate panels which are sewn together. Elaborate borders around the neck, sleeves and hem vary in style, according to Chiapas's different regional cultures, with certain European-influenced design elements, and those dating back to pre-Columbian times.

Tzotzil religious and cultural customs and celebrations blend traditional, pre-Hispanic and shamanic practices with Catholicism. Their customs and mythology, seasonal rhythms, weather patterns, reverence for animal and plant life, all connected with the fertility of their land, closely relate to the patterns and intertwined threads within their textiles. Indicative of their Maya identity, and according to myth, Chiapas women have,

for centuries, woven the obligatory iconographically precise sacred gowns for the Virgin and saints. Deposited in the saints' coffers, these intricate robes still remain the very source of their unique art.

Although ancient hieroglyphic codices have been destroyed, remaining temple wall panels and ceramics occasionally reveal traditional patterns of extravagantly embellished and accessorised ceremonial garments, worn by noble men and women on special occasions. In accordance with the Maya calendar, sacred numerical systems associated with night and day and the underworld, have held a practical significance through the centuries, aiding weaving reproduction by the recollection of mathematical sequences and formulae.

Within contemporary Tzotzil designs, around 100 different symbols are in evidence, represented in approximately 1,500 elemental variations, all with metaphorical and symbolic significance. The four basic shapes are: diamonds, conveying the unified earth and sky, at the heart of which is occasionally a butterfly, representing the sun; undulating forms, such as snakes, symbolic of the fertile earth; three vertical lines, representing the ancestral foundation of the community; and toad-like figures, denoting patron saints.

Because of high levels of poverty, Chiapas has suffered a male migration crisis. Based on a system of reciprocity and promotion, Tzotzil men in the community are required to perform a periodic "cargo" duty, or community service, involving the additional

contribution of money or goods. During this time, they live in the town, rather than at their family homes. Tzotzil men and boys frequently compete with lower-paid neighboring Guatemalan immigrants for work within agriculture and the construction industry. These issues, together with the government's unwillingness to address male alcoholism, female discrimination, and domestic violence have contributed towards women joining forces and becoming more politically active and economically independent. Between the 1950s and 1960s, the National Indigenous Institute founded the first co-operatives. The rise in female craft co-operatives has since become a central part of the economy for indigenous municipalities. These economic artisanal projects are often supported by government programmes, or organisations associated with resistance movements, such as the Zapatistas.

Although thriving commercial markets exist in San Cristóbal de las Casas, San Juan Chamula and Zinacantán, indigenous women in the region's highlands are still vulnerable, being somewhat isolated geographically, culturally, and linguistically, and have suffered from the lack of economic opportunities. Amongst their other aims, interventions by anthropologists, NGOs, and government organisations attempt to avoid the exploitation of artisan groups by designers who, often ignorant or in denial of the fundamental history of indigenous artisanal work, have a tendency to pay low wages and make their own inferior copies.

As well as providing women with full board, Kinal Antstetik educates and mentors young women apprentices with skills in weaving on the pedal loom. The group also offers professional opportunities to engage in new projects with clients, inspiring positive futures in textile production. With additional progressive sources of support, indigenous techniques and traditional methods continue to be explored and developed, whilst keeping true to the Maya culture.

Jolom Mayaetik, meaning "Women Who Weave" was founded in 1996, and is one of the most progressive and democratic weaving co-operatives in Chiapas, promoting sustainable economic development for indigenous women; and, through its educational programmes and political engagement, devoting its energy to enhancing human rights.

Natik works with grassroots Mayan organisations, with a focus on economic development and education, including setting up micro savings and loan programmes, and often mediating between artisan groups and the voluntary sector. Through improving their traditional techniques, and developing business skills, artisans are more able to generate fair and prompt payment, gain better understanding of global market demands, and produce work that addresses ethical and fairtrade issues, as well as the capitalist sector's requirements.

Mujeres Sembrando la Vida is a successful non-profit weaving co-operative in Zinacantan who have

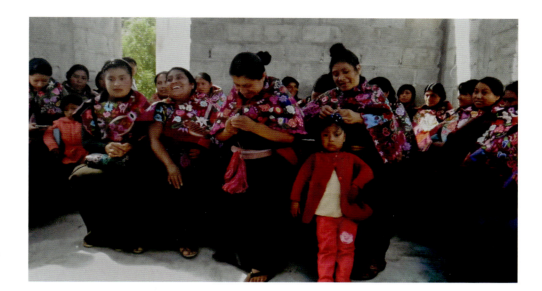

Right:
Women of the co-operative in traditional dress.

Below:
Artisan weaving at her backstop loom.
Photographs © Cooperativa Mujeres
Sembrando la Vida. Courtesy of Natik.

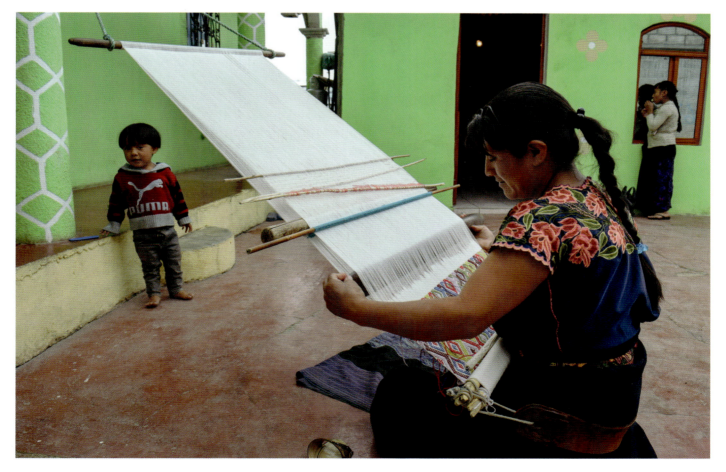

expanded their sales and production enough to engage some 200 indigenous women from seven different communities, 70 of whom weave on backstrap looms from their homes. In most cases they are using the skills that have been passed down to them from their mothers and grandmothers. Originally founded by Doña Magdalena Gomez Perez, it is now run by her two daughters, Yoli and Xunka, who have, respectively, studied business and languages at university, giving them an educational advantage over intermediaries, in terms of their domestic production. Dividing their skills, Xunka oversees the entire project, whilst Yoli leads one of the groups, and designs most of the textiles, buying the necessary threads in San Cristobal.

Each woman has her own textile specialisation. When Joli visits the weavers' homes, she exchanges payment and the provision of new threads for the completed pieces, whilst discussing additional designs. Women are paid at an hourly rate, at around 20 pesos per hour, affording them a greater degree of autonomy within their families. Zinacantán, with its innovative inhabitants, has seen recent changes in its textile production, including the use of machine embroidery and synthetic, metallic threads. Having researched historic Zinacantan designs, Yoli and Xunka are both aware of the increasing opportunities within the global textile market and outside of Chiapas, with the integration of older techniques, and increased use of natural threads and dyes.

"When people ask me how did you learn to embroider, it reminds me of my mom and how difficult it was for me to achieve the first stitched deer-I got to do it right after two years of trying."
SEBASTIANA

In its fertile valley pastures, Zinacantan's major commercial enterprise is flower growing and export, mirrored in the abundance of vibrant floral motifs in their textiles, which include huipils, blouses, bags, table runners, napkins, shawls, scarves, and cushions, all made from locally bought cotton, or from the spun yarn of locally bred sheep. Together with support from other NGOs such as Corazon Verde and Impacto Textil, since 2010 Natik has provided financial and mentoring support for MSV, and aids their participation in US textile and craft fairs, as well as helping to market their products through online portals, such as Etsy.

Sna Jolobil, meaning "The Weaver's House", in Tzotzil, has now been running for more than three decades, and was founded by Pedro Meza, a Tenejapa weaver, and Walter Morris, textile expert, author and anthropologist. Having received a UNESCO award in 2002, it is known for the superior quality of its indigenous handcrafted textiles, and is one of the most successful artisan co-operatives in Latin America, showcasing the work of more than 800 female weavers from many Tzotzil and Tzeltal communities, in the Highlands of Chiapas. The co-op

Above left:
Weaving in progress.

Above right:
Woven brocade detail.

Right:
The finished woven article.
Photographs © Cooperativa Mujeres Sembrando la Vida Courtesy of Natik.

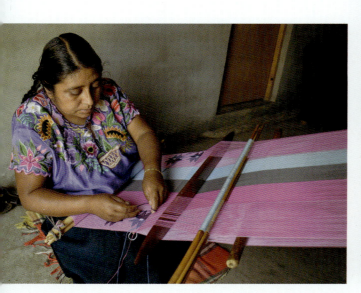

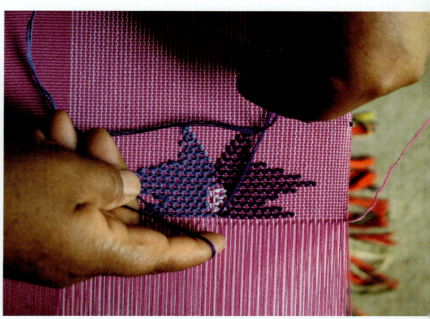

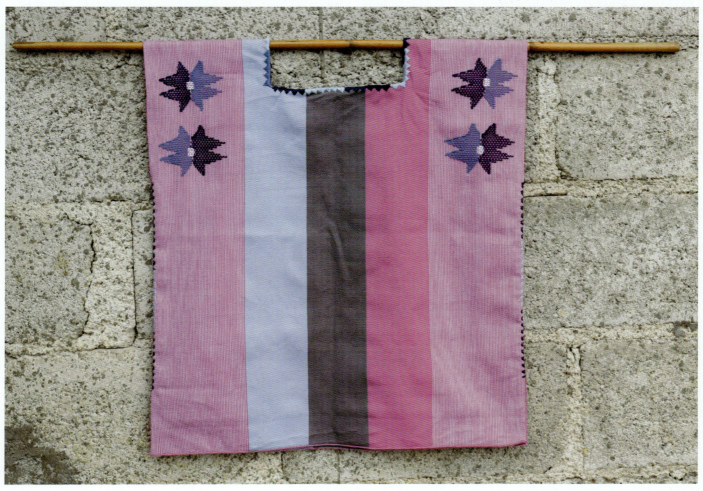

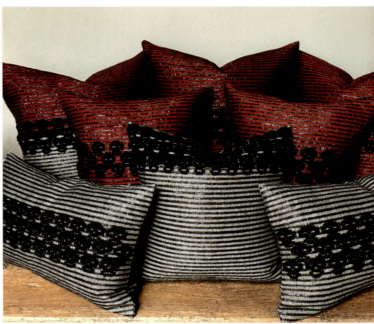

is also a study centre for the backstrap loom brocade method, or supplementary weft technique, whereby the designs are woven into the cloth by adding coloured yarn into the warp and weft of their looms. Women receive great admiration and respect within their community for their mastery of brocade. Incorporated as a not-for-profit organisation, Sna Jolobil's main objective is to encourage the study and preservation of ancestral Mayan textile techniques and natural dyeing methods, in order to create and rekindle fresh and original work.

Margarita Cantú is a conceptual artist and designer. Born in Monterrey, Nuevo León, she studied design in New York, specialising in weaving and fibre arts. After a series of research trips focusing upon waist and pedal loom techniques in Chiapas, she left New York in 2009 to live and work in San Cristobal de las Casas, in Chiapas, where to date she successfully maintains her workshop. With her emphasis upon social and environmental concerns and sustainability, her work blends traditional techniques from the highlands of Chiapas with a rich range of local waste materials, which might otherwise be dismissed as "trash".

Above left:
Feathers. Weaving in progress on loom incorporating chicken feathers in the weft.

Above right:
Pillows. Woven pillows incorporating VHS videotape in the woven fabric.

Right:
"We All Look the Same in the Dark". Weaving in progress on the loom. Photographs © Margarita Cantú.

Honouring historic tradition, and with a nod to the preservation of local culture, its colours, methods and motifs, some of her most recognised woven pieces incorporate plastic scraps of political ads, fallen wood recovered from the jungle, the reuse of magnetic cassette tapes, and copious quantities of cock feathers, the latter having been key elements of pre-Hispanic dress, and still in use for the region's many indigenous rituals and ceremonies. She collaborates creatively with more than 100 artisans in the communities of Nachig, La Hormiga, San Andrés Larráinzar, Tenejapa, Chenalhó and the Selva Lacandona, who share particular expertise in a range of traditional weaving techniques, to construct her innovative, contemporary, tactile art pieces and decorative domestic objects.

Oaxaca is Mexico's fifth largest state, but one of its poorest. The largest indigenous group in Oaxaca are the Zapotecs, who historically have enjoyed a highly advanced culture. Their fine reputation for their weaving traditions dates as far back as 300-600AD and is still in evidence today. Its prolific production of locally hand-made artifacts and textile items, displaying embroidery and weaving techniques and patterns, continues to be the evidence of a legacy passed down from generation to generation. With a population of around 6,000 inhabitants, and famed for its rugs and other textiles, the small, peaceful town of Teotitlán del Valle is situated approximately 29 kilometres from Oaxaca city.

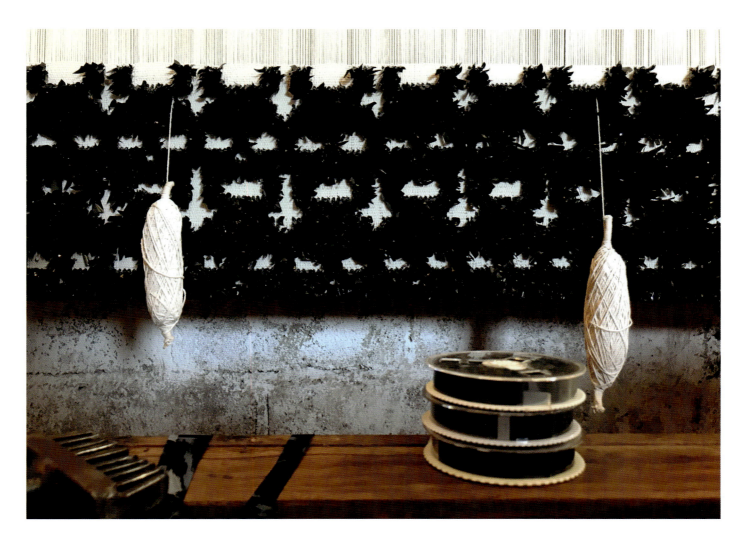

As in Chiapas, the ingrained culture of male chauvinism and female marginalisation in the region is common across all classes, resulting in a similar level of female solidarity amongst its artisans. Chiapas women have been unused to recognising the value of their work or themselves. Machine embroidery is seen increasingly, but much of the work is still hand-stitched. Prices vary accordingly, but seldom truly reflect recognition of the artisan's heritage or skill in the processes of dyeing, spinning, weaving and embroidery.

Although most weavers use pre-mixed commercial dyes, or buy pre-dyed yarns, a growing number are going back to their roots and employing sustainable technologies and the time-consuming natural dyeing process to produce a rainbow palette. This involves the gathering and crushing of cochineal bugs, nuts, pomegranates, persimmons, wild marigolds, indigo and wood bark for the dye pot. The two-harness pedal loom, the flying shuttle loom and the backstrap loom are used to weave cloth from wool, cotton and silk for a variety of items, including blankets, ponchos, lightweight garments, pillow cases, tapestry carpets and wall hangings.

For young unmarried indigenous women of the region, the embroidered huipil is part of their daily attire. The stylised embroidered patterns on the sleeves resemble earthly and astral symbols such as mountains and stars, and the front is embroidered with images of animals. Some regionally codified textiles may bear ancient designs dating back thousands of years. Frequently recurring motifs include leaves, diamond shapes, representing community, and the butterfly, symbolising freedom.

Connections between isolated municipalities, and tourism both within and outside of Mexico expanded with the creation of the Pan-American Highway. Increased government, banking and corporate funding, and sponsorship to museums, as well as assistance by FONART, has given Zapotec textile culture a bigger platform, gradually increasing public interest. However, the global explosion of handicraft in the region is sometimes met by its inhabitants with mixed response.

In their recognition of the income and employment value of "artesanias", a number of NGO organisations collaborate with artisan groups in the region, leading workshops on personal and professional development, gender equality, women's rights, learning English, advising on problems of fashion industry exploitation, and organisational issues for the co-operative. Carefully balancing culture and commerce, the methods learned from their elders are still cherished and employed. Weavers are encouraged to explore a degree of creative freedom, and advised on the making and selling of their rugs from their homes, attaining increasing independence from markets and dealers, and avoiding heavy transportation costs. When work is displayed

communally, there is equal promotion involved in direct sales to customers. Contributing a percentage of the sale price to the co-operative's shared fund, the weaver receives full payment for each piece of her work sold.

In 1994, Vida Nueva Women's Co-operative was started by Pastora, Sofia, and Angelina, three generations of the Gutiérrez Reyes family, together with a small group of women. Addressing the limited opportunities of widowed, divorced and often abandoned females, they felt the need to develop strategies for shaping their own lives and the life of their community. Facing considerable initial resistance and intimidation, from a male-dominated social system, which places restrictions on women meeting together for more than 30 minutes, Vida Nueva's ability to hold its democratically run meetings and workshops in the family home has been hard won. Initially sharing their secret plans whilst attending festivals, the women, in spite of educational and linguistic limitations, have more than succeeded in their mission.

Vida Nueva provides care for the elderly, toys and school uniforms, health education and emergency aid, including drugs misuse and domestic violence information, and environmental awareness and action. Recognising their weaving as a means to preserve their heritage, other women have gradually joined the co-operative. Through their shared fund, they complete an annual community project, delivering workshops in schools and within the community, and encouraging the establishment of new women's co-operatives.

In its collaborations with artisan communities, in Chiapas and Oaxaca, the CADA Foundation spends a great deal of time with each group, communicating, analysing and documenting their concepts, skills and creative processes; mindful of respecting and carefully retaining the context of their cultural identity. Emphasising the essence and continuity of their particular traditional techniques, its ultimate aims are to aid the development and creation of socially designed contemporary artifacts, which are capable of communicating the cultural heritage of their artisans, and addressing both local and global markets.

CADA works with the Mixtec communities of San Pablo Tijaltepec and Tonaltepec, supporting embroiderers and potters and connecting them with local and global markets. Learning from and sharing the processes with other artisanal organisations, rich in their particular craft traditions, it is able to facilitate the successful launching of their artifacts, within what might otherwise seem an overwhelming globalised market.

"When we started the project with CADA I was shy, but now after I've travelled to other places outside my village and outside Oaxaca to promote the embroideries of my community, I feel fearless and now I know that people value what we make."
ROSALIA

The artisan weavers of Ñaa Ñanga Tijaltepec Colletivo use specialist embroidery methods, and "pepenado fruncido" (pick-up weave and gathered pleats) weaving techniques to create their characteristic cloth. Highly marginalised, and living in an area of precarious access, the women of San Pablo Tijaltepec have nevertheless developed their elaborately graphic and sophisticated creative processes that have been transmitted matrilineally through the generations, without the use of any pattern or formula. Historically, the textiles were produced for the women themselves and their families, as well as for ceremonial purposes. Today the techniques are being meticulously repeated, with their folk-art flavour suiting the bold, decorative patterns on blouses and the stitched and embellished forms of their charming textile toys.

Most civilisations historically share a rich tradition of making pottery, and Oaxaca is no exception, with its practices dating back over 3,000 years, and a diversity of styles being employed by ceramicists from approximately 70 villages in the area. Since pre-Hispanic times, indigenous Zapotec women in San Marco Tiapazola, a region rich in its raw materials, have hand-built and fired their own cooking vessels on outdoor wood fires, using the red clay dug from the local mountains. Mujeres del Barro Rojo ("Red Clay Women"), a co-operative consisting of 16 families, is led by Macrina Mateo Martinez, whose skills have been learned from preceding generations of women in her family.

As a child, she remembers when the arduous production process barely provided a bartering system for a minimal amount of food; corn or beans. At the age of 16, facing criticism and alienation from her community, Macrina travelled independently to sell her wares, eventually going as far afield as Portland, Santa Fe, and New York, where they are now sold at the Museum of Modern Art, as well as other parts of the world. A Japanese-designed smokeless kiln was built for the co-operative, enabling them to fire their pots at higher temperatures, increase their output considerably, and most importantly, protect their respiratory health. This intervention was made possible with support from a number of organisations, including Andares del Arte Popular, which provides a sales outlet for the co-operative's ceramics. A school for the craft has also been established to teach and ensure the craft's preservation.

Above left:
Fabric toys employing the specialist embroidery methods.

Left:
Typical blouse decoration bearing its sophisticated graphic imagery.
Photographs © Ñaa Ñanga Colectivo Tijaltepec.
Courtesy of CADA Foundation.

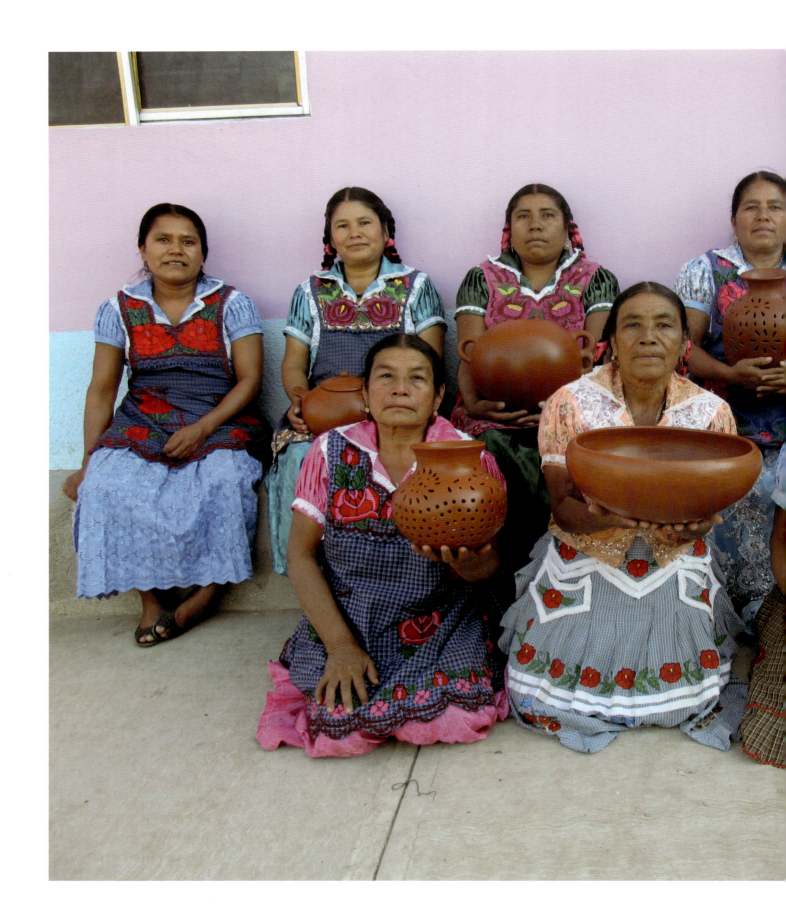

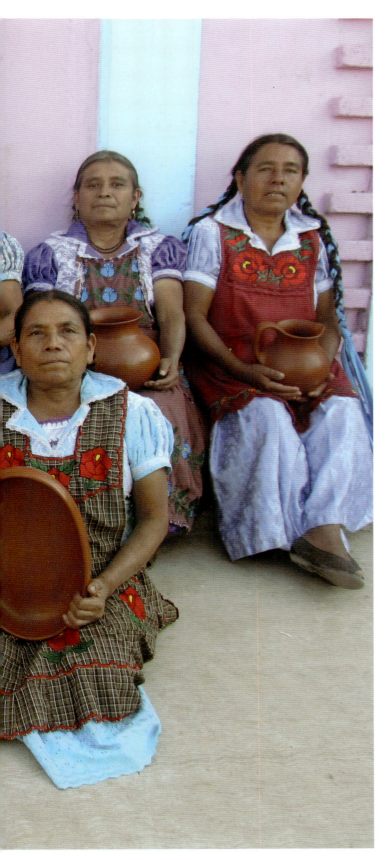

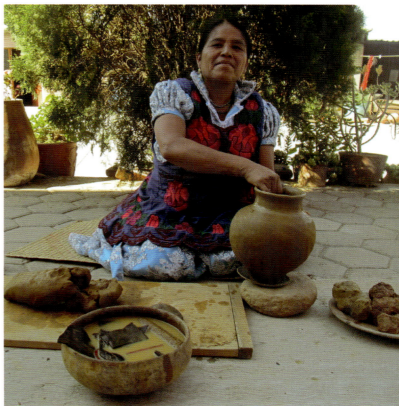

Left:
Women of the Mujeres del Barro Rojo with their individual ceramic creations.

Above:
Artisan creating one of her pots.
Photographs © Mujeres del Barro Rojo.

Possibly owing to its numerous indigenous groups and ethnic diversity, predominantly Tzotzil, Tzeltal, Zapotec, and Mixtec, the region is home to the most skilled producers of an exotic spectrum of folk art and craft. Although facing competition from cheaper goods and imitations made in China, for example, the textile and handicraft industries have experienced a resurgence of interest, and remain a significant part of the economy. Addressing the continuation of indigenous weavers' livelihoods and their practices, several organisations are working to protect and mark the authenticity of indigenous designs, granting them intangible cultural heritage status.

GLOSSARY OF TERMS

ancestral realm –the quest for meaning and guidance from deceased family members.

aniline dyes – synthetic dyes..

anthropomorphic – having human attributes.

apotropaic – having the power to avert evil.

appliquéd – fabric shapes applied and stitched to another fabric surface.

artesanias – handcrafted items for commercial purpose

auto rickshaw – a common vehicle in India, also known as a tuk tuk, resembling a covered bicycle with a lawn mower engine.

"bakkie" – pickup truck

Bauhaus – revolutionary art school and movement, unifying art, architecture and design. founded by Walter Gropius, in Weimar, Germany, 1919-33.

bobbin lace – a method of making lace by pinning the pattern onto a pillow, and weaving the pattern with threads held on bobbins.

boho chic – Bohemian-influenced aesthetic style, embracing individuality.

CADA Foundation – platform fostering and facilitating local artisanal entry into the local and global market.

cargo – Mexican system of periodic enforced civil and religious duties, performed by males, according to rank.

charoseth – sweet mortar-like paste made symbolically for the Passover meal.

codices – manuscript books.

cosmology – theory of the origins of the universe.

cultural appropriation – adopting aspects of another, often minority culture, without understanding, referencing or respecting its origins or context.

decorticating – stripping the skin, bark or rind from organic material.

dhoti – loosely draped cloth pants which taper towards the ankle hemline.

en plein air – the act of painting or creating outdoors.

feminocentric – focused on women.

FONART – National Fund for the Development of Arts and Crafts.

flying shuttle loom – mechanised loom allowing a single weaver to create wider fabrics.

foot pedal loom – frame loom operated by foot pedals, which lift the warp threads, leaving hands free to work with the weft thread.

fractal – curved or geometrical figure, such as a snowflake or crystal, with each part having smaller-sized recurring patterns, which emulate the entire shape.

gefilte fish – traditional Ashkenazi Jewish recipe, predominantly made from a mixture of well-seasoned minced fish.

graffiti knitting – a more recent activist form of collaborative street art, covering elements of the cityscape with knitting and crochet, rather than chalk or paint. Also known as yarn bombing, yarnstorming, guerrilla knitting.

herringbone stitch – a series of crisscrossed diagonal stitches.

huipil – sleeveless tunic worn by Mexican women in certain regions.

iconography – the interpretation of symbols, themes, and subject matter within visual works.

intellectual rights – exclusive rights given to individuals or groups regarding the use of their creations.

Irunúu – hunter's name in the Wayuu legend.

Junta – (with particular regard to Chile) revolutionary seizure of power and group control of the government.

kerosene – or paraffin, derived from petroleum, and used as a household fuel.

kurta – long, loose, collarless shirt.

loom – rigid apparatus used for weaving cloth.

lurex – yarn or cloth with a metallic glittery appearance.

matrilineage – descent traced through the maternal or female line.

Maya – indigenous people of Mexico and Central America.

metier – specialism.

meisters – lead practitioners or advisors.

methodology – a particular systematic way of doing, teaching or studying something.

Outsider art – art created by naïve or self-taught makers, who have had minimal or no contact with formal art education or the mainstream art world.

painterly – akin to and celebrating the medium of painting.

quatrefoil – a symmetrical, decorative shape consisting of four partially overlapping circles of equal diameter.

Ramadan – observed by Muslims worldwide during the ninth month of the Islamic calendar, as a period of fasting, prayer, reflection and community.

Ramayana – ancient Sanskrit epic.

rebozo – long, flat garment often worn by Mexican women as a scarf or shawl.

Rizlas – cigarette rolling papers.

satin stitch – a series of juxtaposed, long, flat embroidery stitches.

SENA – National Learning Service, taught by Wayuu women in La Guajira.

sikki grass – a grass used for handicraft, and grown in Bihar and Uttar Pradesh, India.

sisal – a stiff natural fibre, extracted from the leaves of the agave plant species.

social enterprise – a business that has specific socially beneficial objectives serving its primary purpose.

souk – marketplace or bazaar.

stem stitch – basic surface embroidery stitch for creating a thin line, or outlines for other embroidered shapes.

subversive – agitating or disrupting an established system.

synthetic dyes – industrially produced artificial chemical dyes.

talisman – an object believed to be endowed with powerful, magical properties.

tatting – textile process composed of yarn knotting and looping techniques.

"tempo" trucks – small goods carriers.

totems – symbol or sacred objects specific to clan, tribe, or family.

traje – traditional dress.

tsavorite – a rare member of the garnet variety of gemstone, found in Africa.

two-harness pedal loom – each harness on the loom features a set of heddles accommodating the warp threads, and increasing the scope of the weave's complexity.

Ubuntu – African philosophy of humanity towards others.

upcycled – creative reuse and transformation.

warp – a series of lengthwise yarns extended in a loom and traversed by the horizontal weft yarns in the creation of woven cloth.

Wycinanki – Polish art of papercutting.

Yoruba – African ethnic group inhabiting Western Africa.

Zapatista – Mexican Chiapas-based indigenous armed revolutionary group.

FURTHER READING

Every Woman is a World. Interviews with Women of Chiapas – Gayle Walker and Kiki Suarez
publ. University of Texas Press

Weaving Chiapas. Maya Women's Lives in a Changing World – Castro Apreza, Woodcock, K'inal Antsetik
publ. University of Oklahoma Press

Maya Threads: A Woven History of Chiapas – Walter F. Morris Jr., Carol Karasik.
publ. Thrums

Zapotec Women: Gender, Class, and Ethnicity in Globalised Oaxaca – Lynn Stephen
publ. Duke University Press

Oaxaca Stories in Cloth: A Book About People, Belonging, Identity, and Adornment – Eric Mindling
publ. Thrums

Threads of Life – Clare Hunter
publ. Sceptre

A Map of Hope. Women's Writings on Human Rights – edited by Marjorie Agosin
publ. Penguin

The Subversive Stitch – Rozsika Parker
publ. Bloomsbury

Speaking with Beads: Zulu Arts from Southern Africa – Jean Morris, Eleanor Preston-Whyte
publ. Thames and Hudson

Surviving the Bosnian Genocide: The Women of Srebrenica Speak – Selma Leydesdorff
publ. Indiana University Press

Wayuu: People of the Columbian Desert – ed. Benjamin Villegas
publ. Villegas Editores

Madhubani Art – Bharti Daya
publ. Niyogi Books

Garbology: Our Dirty Love Affair with Trash – Edward Humes
publ. Penguin Group

Basketry – Bryan Sentence.
publ. Thames and Hudson

The Moment of Lift: How Empowering Women Changes the World – Melinda Gates
publ. Pan Macmillan

Siyazama. Art, Aids and Education in South Africa – ed. Kate Wells, Marsha McDowell, C. Kurt Dewhurst, Marit Dewhurst
publ. University of KwaZulu-Natal Press

Craft Art in South Africa – Elbé Coetsee
publ. Struik

In Her Hands: Craftswomen Changing the World – Paola Gianturco, Toby Tuttle
publ. The Monacelli Press

The Spirit of Folk Art – Henry Glassie
publ. Museum of New Mexico Press

Imazighen: Vanishing Traditions of Berber Women – Margaret Courtney-Clarke
publ. Thames and Hudson

Bead by Bead – Dion Viljoen, Martine Jackson
publ. Jacana Media

The Born Frees: Writing with the Girls of Gugulethu – Kimberly Burge
publ. W.W. Norton & Co.

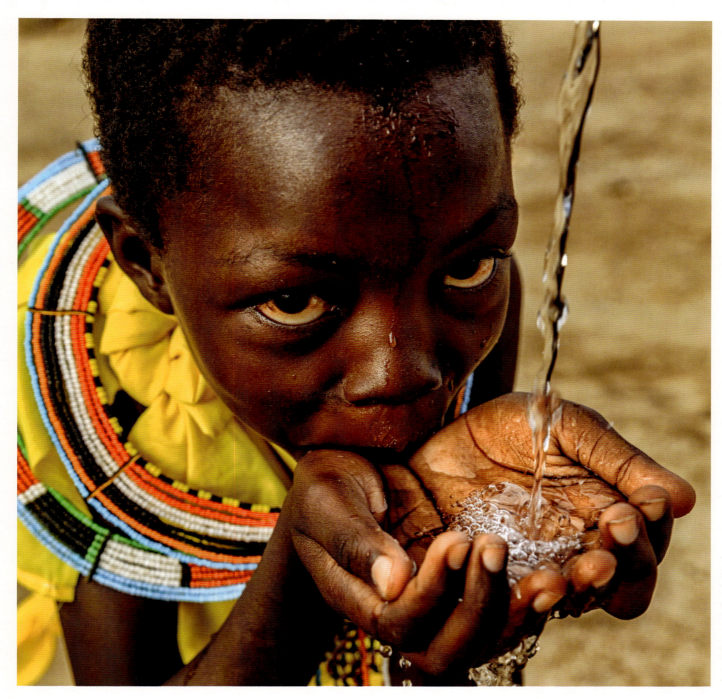

ACKNOWLEDGEMENTS

With thanks to my skillful editor, Jayne Parsons, whose response to this project, right from the start, has been so encouraging.

Thanks also to Andy and Dave at Plum5 for their artfully designed book production, and for their patience!

My gratitude to Henrietta Drane for her meticulous proof-reading.

With huge appreciation to my husband Robbie Wolfson, for his long-suffering patience and his tech support, travel companionship, photographic skills; and to my lovely, loyal family and friends for their continual interest and enthusiasm, their valued feedback, their provision of love, sanity, stability... and food!!

Thank you to David Sufrin and Bev Zadikoff for pointing me in interesting directions, to Tamara Shneck for her social media and PR skills, and to Joel Stein for his consistently incisive reading skills and comments.

And to all my amazing contributors, who have given so generously of their time, being hosts, tour guides, translators, answering countless emails, questionnaires, and phonecalls, and who have supplied me with so many wonderful images for this book.

They are:
Alice Kettle, with contributions from Pipka/ Lesvos Solidarity; Ahmed Ali, Somaya Hossaini; Yakob & many other residents at Calais refugee camp working with Suzanne Partridge; Nahomie Bukasa, Sahira Khan and Ai Ling with Linda Leroy at the Helen Bamber Foundation; Nisrin Albyrouty, Khouloud Alkurd, Heba Almnini, Heidi Ambruster, Marwa Ammar, Amal Ayoubi, Stella Charman, Susan Colverson, Jenny Cuffe, Lama Hamami, Miriam Jones, Asmaa Kamar Aldin, Ruth le Mesurier, Vanessa Rolf, Samar Sobeih, Chaymae Yousfi and many children from English Chat Winchester; Farhia Ahmed Ali, Nawad Hersi Duale, Amran Mohamud Ismail with Refugee Action working with artists Jenny Eden and Richard Harris; Shahireh Sharif with Travelling Heritage Group; Julie Firman, Victoria Hartley, Louise Jung, Susan Kamara, Saamiullah Khan.

Alvaro Catalán de Ocon, PET lamp artisans, Dr Kate Wells, Renée Padt, Editions in Craft, Front, Lore Defrancq, Hadithi basket weavers, Chloe Bartron, Dadaduka basket weavers, Janine Pretorius, Kaross artisan stitchers, Ann Conway, Norma Schafer (oaxacaculture.com) Carlota Duarte, Anita Smart, Natik, Jolom Mayaetik, Kinal Antstetik, Yoli Hernandez, Cooperativa Mujeres Sembrando la Vida, Daisy Margarita Cantú, Carol Karasik, Sna Jolobil, Ana Paula Fuentes, CADA Foundation, Centro Textiles del Mundo Maya, Alejandra Mora Velasco, Museo Textiles de Oaxaca, Vida Nueva

Cooperativa, Macrina Mateo Martinez, Mujeres del
Barro Rojo, Ñaa Ñanga Tijaltepec Colletivo, Kate
Clark, Rebecca Devaney, Dr Skye Morrison, Sanju
Devi, Lucia Lienhard-Giesinger, the quilters at
Bosna Quilt Werkstatt, Gebhart Blazek, Kate Carlyle,
Monkeybiz beaders, Jade Longelin, Danis Cohen,
Paula Restrepo, Celia Pym, Johanna Schweizer,
Lauren O'Farrell, Lauren Sagar, participants from
Styal Women's Prison, Claire Wellesley-Smith,
Dr Robert Garson, Peter Darjes, Nada Debs, FBMI,
Linda Rae Coughlin, Roberta Bacic, Breege Doherty,
the late Gala Torres, Mare Mätas, Meelis Mereäär,
Eda Maripuu, Shuichiro Matsuura, Dr Harold Platt,
Liza Lou, Durban women beaders, Lehmann
Maupin Gallery, New York, Margaret Wertheim, the
Institute for Figuring, crochet participants of the
Fohr Reef, Matthias Oppliger, KitePride stitchers,
the late Judith Scott, Creative Growth Art Center,
California, Talya Tomer-Schlesinger, Craftspace
(craftspace.co.uk) Shelanu, Hla Day, Yasuko
Arakawa, Lily Handicraft, Reform Studio.

AUTHOR'S BIOGRAPHY

Lynne Stein is a UK-based textile artist, and originally trained as an exhibition and display designer, and as an art therapist. Frequently running workshops, and giving talks and demonstrations, she has taught extensively in a variety of community, educational, and healthcare settings, and within museums and galleries. Lynne's work has, for the past 30 years, been widely exhibited; and as a recipient of support from Arts Council England, she has undertaken commissions for numerous public, corporate, and domestic spaces. She has also run an ongoing interfaith community textile project within a children's dental clinic in Jerusalem. Lynne's work has received substantial media coverage. She has been a contributor to several books, magazines and journals, and has been featured on BBC radio and television broadcasts. Lynne has also authored *Rag Rug Creations: An Exploration Of Colour And Surface.* (publ. Bloomsbury).